William Morris
on Art and Design

William
MORRIS

on Art & Design

edited by Christine Poulson

Sheffield
Academic Press

Copyright © 1996 Sheffield Academic Press

Published by Sheffield Academic Press Ltd
Mansion House
19 Kingfield Road
Sheffield S11 9AS
England

Printed on acid-free paper in Great Britain
by The Cromwell Press
Melksham, Wiltshire

British Library Cataloguing in Publication Data

A catalogue record for this book is available
from the British Library

ISBN 1-85075-611-2

CONTENTS

INTRODUCTION

In 1880 Morris wrote to his close friend, Georgiana Burne-Jones, that he thought of publishing his lectures on art and architecture, 'as it will be about what I have to say on the subject, which still seems to me the most serious a man can think of; for 'tis no less than the chances of a calm, dignified, and therefore happy life for the mass of mankind'.[1] The volume appeared in 1882 with the title, *Hopes and Fears for Art: Five Lectures Delivered in Birmingham, London, and Nottingham 1878–1881* and contained 'The Lesser Arts', 'The Art of the People', 'The Beauty of Life', 'Making the Best of It', and 'The Prospects of Architecture in Civilisation'. Morris's lectures, and indeed most of the texts in this collection, were not produced primarily for publication and he was too busy to spend much time polishing them. Only a few, such as his essays on stained glass, for *Chambers's Encyclopaedia*, and on dyeing, for the exhibition catalogue of the Arts and Crafts Exhibition Society, began life in print. As for Morris's letters, publication was not thought of in his lifetime: he was not the kind of letter-writer who had an eye on posterity.

Through his letters and lectures we come closer to capturing the authentic tone and speech patterns of Morris than would be possible in more formal writings. Often there is a directness, an immediacy, even an intimacy, that is arresting. The tone is very varied. The letters to Wardle are brisk and pragmatic; they are primarily business letters which by chance allow us to follow the course of Morris's work in reviving vegetable dyeing. In other

letters, like the one to Georgiana Burne-Jones in which Morris
explores the contradiction between his socialism and his position
as factory-owner, the tone is more confidential and reflective. As
for the lectures, they are often eloquent and rhetorical, some-
times humorous and self-deprecating, sometimes chatty, often
passionate. Equally remarkable is Morris's range. On the one
hand, he was intensely aware of the social and political signifi-
cance of art. On the other, no aspect of the aesthetics of everyday
life was too trivial to be given due weight, whether it was the
problem of finding a walking-stick with a 'good heavy end' that
will swing out as one walks ('The Revival of Handicraft'), the
layout of type on a page ('The Ideal Book'), the right colour for
one's drawing-room walls, or the best flowers to have in one's
suburban garden ('Making the Best of It'). Since, for Morris 'the
true secret of happiness *lies in the taking a genuine interest in all the
details of daily life*',[2] every detail is important, and not only as a
matter of aesthetics. 'It is not possible to dissociate art from
morality, politics and religion' (p. 180). The way one's house is
furnished can never, therefore, be a morally neutral choice.

His early lectures were typically addressed to Schools of Art,
to the Trades' Guild of Learning and, in the case of 'Some
Hints on Pattern Designing', to the students of the Working
Men's College in Bloomsbury, London. The audiences were
overwhelmingly male and consisted of men with a professional
interest in the arts, often on the artisan level. They reflect the
longing of working class men for education and the consequent
proliferation of institutes and evening classes from the mid-
nineteenth century onwards. Morris was very conscious of the
difficulties of addressing an audience less educated than himself
and was self-deprecating about his powers as a public speaker.
'[I]t is a great drawback that I can't *talk* to them roughly and
unaffectedly ... you see this great class gulf lies between us,'[3] he
told Georgiana Burne-Jones after speaking to some working-
class socialists in Stepney in 1885. She was aware that 'in his early

addresses the difficulty was painful, but sheer weight and volume of meaning burst the barriers at last'.[4] All the same Morris often made a considerable impact on his audience. Philip Webb was moved to tears by the lecture published as 'The Lesser Arts', which for him was 'full of truths and knock-me-down blows'.[5] The reminiscences of Bruce Glasier are those of a hero-worshipper, but nevertheless give a vivid account of Morris's style as a lecturer:

> His unconventional dress, his striking head, and his frank, unaffected bearing at once favourably impressed the audience ... He read his lecture, or rather recited it, keeping his eye on the written pages, which he turned over without concealment ... and every now and then walked to and fro, bearing his manuscript, schoolboy-like, in his hand. Occasionally he paused in his recital, and in a 'man to man' sort of way explained some special point, or turned to those near him on the platform for their assent to some particular statement.[6]

Even in cold print there are moments at which one feels Morris's voice coming off the page with a strong, invigorating force. Raymond Williams felt, with some justification, that '[t]here is more life in the lectures, where one feels that the whole man is engaged in the writing, than in any of the prose and verse romances'.[7]

What comes across too, both in Glasier's account and again and again in the lectures themselves, is Morris's tact as a speaker and his anxiety not to patronize or antagonize his social inferiors. He was all too conscious of the hardships endured by many of the urban working class: 'If I were to work ten hours a day at work I despised and hated, I should spend my leisure I hope in political agitation, but I fear in drinking'.[8] This empathy is also evident in his letter to Thomas Horsfall in which he discusses the problem of how a working-class man might furnish his home. He becomes indignant at the thought of trying 'to make a poor man's art for the poor while we keep a rich man's art for ourselves: not to say, there, that suits your condition, I wouldn't have it myself but 'tis good enough for you' (p. 125). This fellow

feeling sprang from a keen awareness that it was only the chance of birth which kept him from similar circumstances:

> ... [A]s I sit at my work at home, which is at Hammersmith, close to the river, I often hear go past the window some of that ruffianism of which a good deal has been said in the papers of late, and has been said before at recurring periods. As I hear the yells and shrieks and all the degradation cast on the glorious tongue of Shakespeare and Milton, as I see the brutal reckless faces and figures go past me, it rouses the recklessness and brutality in me also, and fierce wrath takes possession of me, till I remember, as I hope I mostly do, that it was my good luck only of being born respectable and rich that has put me on this side of the window among delightful books and lovely works of art, and not on the other side, in the empty street, the drink-steeped-liquour shops, the foul and degraded lodgings.
>
> ... I know by my own feelings and desires what these men want, what would have saved them from this lowest depth of savagery: employment which would foster their self-respect and win the praise and sympathy of their fellows, and dwellings which they would come to with pleasure, surroundings which could soothe and elevate them; reasonable labour, reasonable rest. There is only one thing that can give them this, and this is art.[9]

Morris was not the first to come to this conclusion. Much of his thinking about the social and political significance of art has its genesis in the writings of John Ruskin (1819–1900). Morris acknowledged this debt. In 'The Lesser Arts' he tells his audience,

> ... if you read the chapter in the 2nd vol. of his "Stones of Venice" [1851–53], entitled 'On the Nature of Gothic, and the Office of the Workman therein,' you will read at once the truest and the most eloquent words that can possibly be said on the subject.

Morris first read it as an undergraduate and was so impressed by it that forty years later he published it as one of the Kelmscott Press books. 'On the Nature of Gothic' is a coruscating indictment of industrialization and the 'degradation of the operative into a machine':[10] 'We have much studied and much perfected, of late, the great civilised invention of the division of labour; only we give it a false name. It is not truly speaking, the labour that is divided; but the men'.[11] Ruskin went on to offer a critique of

capitalism in works such as *Unto This Last* (1860) which reaches its magnificent climax with the words:

> THERE IS NO WEALTH BUT LIFE. Life, including all its powers of love, of joy, and of admiration. That country is the richest which nourishes the greatest number of noble and happy human beings; that man is richest who, having perfected the functions of his own life to the utmost, has also the widest helpful influence, both personal, and by means of his possessions, over the lives of others.[12]

Ruskin goes on to say that 'luxury at present can only be enjoyed by the ignorant; the cruelest man living could not sit at his feast, unless he sat blindfold'.[13] It was part of Ruskin's greatness, and Morris's too, that they could not sit blindfold at the feast. Morris was Ruskin's natural successor and it could be said that he picked up the torch as it dropped from Ruskin's hand. 1877, the year of Morris's first lecture on art and society, was also the year that Ruskin suffered a humiliating defeat in a suit for libel brought against him by Whistler. Already tormented by the death of Rose de la Touche, whom he had loved for almost twenty years, he soon succumbed to the first of a series of attacks of insanity. The next decade or so saw the gradual eclipse of his intellectual powers.

Unlike Morris, Ruskin never played an active role in contemporary politics. Despite his astringent criticism of the economic system, Ruskin never went so far as to consider demolishing the class structure. His ideal of social organization remained essentially patriarchal. Whereas Ruskin worried about how the servants were treated, Morris wondered if there should be servants at all, this in spite of, or perhaps because of, his closer involvement with the workings of capitalism.

This accounts for another difference between them. Morris wholeheartedly agreed with Ruskin that handicraft was both morally and aesthetically superior to the machine-made. But Morris was a man of business, as well as a theorist. The foundation of Morris, Marshall, Faulkner, and Company in 1861

had directly involved him with the world of commerce and manufacture. Although he felt that the machine should be subservient to the worker, he did not totally rule out its use:

> We ought to get to understand the value of intelligent work, the work of men's hands guided by their brains, and to take that, though it be rough, rather than the unintelligent work of machines or slaves, though it be delicate; to refuse altogether to use machine-made work unless where the nature of the thing made compels it, or where the machine does what mere human suffering would otherwise have to do.[14]

His son-in-law, Henry Halliday Sparling, thought that '[W]here the employment of the machine entailed no detriment to the work, either directly or through the enslavement of the men who did the work, he was willing to accept and adopt it without reluctance or scruple'.[15] He goes on to record Morris saying:

> Whatever gives pleasure in the doing—say weaving a jolly pattern—should be reserved for the hand. A weaver at the handloom, as long as he's turning out something that's worth doing, is decently paid and not over-driven, has no hard time of it, I can tell you! But the other sort of thing, long stretches of calico or unpatterned cloth or fleck-speckled commercial tweed, give that to a machine, and be damned to it! But mind you, even then, there's a danger. You've got to have somebody to look after the machine, and if he does that all the time, he soon becomes less of a man than part of the machine.[16]

Morris himself did several designs for machine-made carpets (and even one for linoleum) in the mid 1870s, and used a certain amount of mechanization in his own workshops. It was the wholesale and indiscriminate use of machinery to which he objected and which he came to see as an instrument of capitalism:

> [i]t is necessary for the system which keeps them [the workmen] in their position as an inferior class that they should either be themselves machines or be the servants to machines, in no case having any interest in the work which they turn out (p. 185).

Morris felt that pleasure in labour was natural to human beings and that the destruction of this pleasure was detrimental

to the user as well as the maker: 'How can we bear to use, how can we enjoy something which has been a pain and a grief for the maker to make?' (p. 182). This question is as hard to answer now as it was in the nineteenth century, perhaps harder. Today, the gulf between maker and consumer is, in geographic terms at least, wider than it has ever been. What do we know about the maker of the cheap pair of shoes imported from the Third World?

Morris's distrust of mechanization and disgust at the cost of industrialization in terms of human misery and the blighting of the natural world has antecedents which go back beyond Ruskin to Romantic painters and poets, such as Blake. In his rhapsodic response to the English countryside and his love of its humble scale and domesticity there is something of both Constable and Wordsworth:

> ... there are no great wastes overwhelming in their dreariness, no great solitudes of forests, no terrible untrodden mountain-walls: all is measured, mingled, varied, gliding easily one thing into another: little rivers, little plains, swelling, speedily-changing uplands, all beset with handsome orderly trees; little hills, little mountains, netted over with the walls of sheep-walks: all is little; yet not foolish and blank, but serious rather, and abundant of meaning for such as choose to seek it: it is neither prison nor palace, but a decent home (pp. 169-70).

Similarly, Wordsworth's emphasis on the language of the common people finds a counterpart in Morris's love of vernacular architecture and furniture. This was reflected in some of the products of the Firm: the 'Sussex' chair, rush-seated and made of ebonized beechwood, was adapted by Webb from a traditional design. For Morris, art had its roots in the earth, and took its character from the countryside from which it sprang, hence the predominance of organic forms in his designs, and his dislike of abstract design:

> I, as a Western man and a picture-lover, must still insist on plenty of meaning in your patterns; I must have unmistakable suggestions of gardens and fields, and strange trees, boughs, and tendrils, or I can't

> do with your pattern, but must take the first piece of nonsense-work
> a Kurdish shepherd has woven from tradition and memory; all the
> more, as even in that there will be some hint of past history (pp. 75-6).

This sense of art as expressing accumulated human experience is
further developed in 'Making the Best of It':

> ... I believe I am not thinking only of my own pleasure, but of the
> pleasure of many people, when I praise the usefulness of the lives of
> these men, whose names are long forgotten, but whose works we still
> wonder at. In their own way they meant to tell us how the flowers
> grew in the gardens of Damascus, or how the hunt was up on the
> plains of Kirman, or how the tulips shone among the grass in the
> mid-Persian valley, and how their souls delighted in it all, and what
> joy they had in life ... (pp. 118-9).

Morris's ideal was that 'all the works of man that we live amongst
and handle will be in harmony with nature' (pp. 117-8). His
conviction that people and their art cannot flourish without
respect for the natural world has made him a sympathetic figure
for today's ecologists.

In 'The Lesser Arts' Morris told his audience at the Trades'
Guild of Learning that their teachers should be 'Nature and
History'. He loved medieval art and architecture, considering
that 'the only work of art which surpasses a complete medieval
book, is a complete medieval building'.[17] However, he never
advocated the copying or imitating of medieval art. Indeed, the
founding of the Society for the Protection of Ancient Buildings,
in which he was the prime mover, was intended to put a stop to
that very thing when it took the form of attempts to recreate
medieval architecture. Burne-Jones wrote of him, 'All his life, he
hated the copying of ancient work as unfair to the past and stupid
for the present, only good for inspiration and hope'.[18] This is
very much the point about the art of the past that Morris makes
in 'The Lesser Arts': 'Let us ... study it wisely, be taught by
it, kindled by it; all the while determining not to imitate or
repeat it; to have either no art at all, or an art which we have
made our own' (p. 168). What is needed is 'an art that should be

characteristic of the present day' (p. 168). In discussing stained glass he is contemptuous of that aspect of the Gothic Revival which involved

> mere copying of medieval designs; it has been forgotten that the naïvetés of drawing of an early stage of art which are interesting when genuine and obviously belonging to their own period, become ridiculous when imitated in an epoch which demands at least plausibility of drawing from its artists (pp. 48-9).

It is worth noting that after the foundation of the Society for the Protection of Ancient Buildings in 1877 Morris would not allow the Firm to supply glass for medieval churches.

On the other hand, Morris felt that

> if we do not study the ancient work directly and learn to understand it, we shall find ourselves influenced by the feeble work all round us, and shall be copying the better work through the copyists and *without* understanding it, which will by no means bring about intelligent art (p. 168).

The importance for the designer in understanding and respecting the medium for which he designs is a theme which runs thorough everything that Morris wrote:

> [It is] of capital importance that a pattern-designer should know all about the craft for which he has to draw. Neither will knowledge only suffice him; he must have full sympathy with the craft and love it, or he can never do honour to the special material he is designing for.[19]

In wood-engraving, for example, he felt that though illustrators need not 'necessarily always cut their own designs' ... 'they should be able to cut them.'[20] One should design with the special qualities and character of the material in mind:

> [W]hatsoever art there is in any of these articles of daily use must be evolved in a natural and unforced manner from the material that is dealt with: so that the result will be such as could not be got from any other material; if we break this law we shall make a triviality, a toy, not a work of art.[21]

It was a cardinal rule that one must work within the limitations of the material, indeed, enjoy them even. Morris illustrates

this point with a lively description of the wrong way to go about
designing for mosaic or woven cloth:

> [Y]ou have a heap of little coloured cubes of glass to make your
> picture of, or you have some coloured thrums of worsted wherewith
> to build up at once a picture and a piece of cloth; well, there is a
> wrong and a right way of setting to work about this: if you please you
> may set to work with your cubes and your thrums to imitate a brush-
> painted picture, a work of art done in a material wherein the limita-
> tions are as few and pliable as they are many and rigid in the one you
> are working in; with almost invisible squares or shuttle-strokes, you
> may build up, square by square, or line by line, an imitation of an oil-
> painter's rapid stroke of the brush, and so at last produce your
> imitation, which doubtless people will wonder at, and say, "How was
> it done? we can see neither cubes nor thrums in it." And so also
> would they have wondered if you had made a portrait of the Lord
> Mayor in burnt sugar, or of Mr. Parnell in fireworks. But the wonder
> being over, 'tis like that some reasonable person will say, "This is not
> specially beautiful; and as to its skill, after all, you have taken a year to
> do what a second-rate painter could have done in three days. Why
> have you done it at all?" An unanswerable question, I fear.[22]

How far did Morris carry out his ideas in his own work? His
life was not without its inconsistencies, even paradoxes. The
most obvious was the contrast between his dedication to social-
ism and his position as a well-to-do businessman. However, it
cannot be stressed too much that in no sense was Morris's
socialism a question of dilettantism or a fashionable pose. He
paid dearly for his convictions. Mackail felt that '[t]he work and
all the load of toil and obloquy it involved had been almost too
much even for Morris's immense energy and abounding
vitality'.[23] He even suggests that it was this kind of strain which
was responsible for the stroke that disabled Morris's friend,
Faulkner, and led to his death. Morris's socialist allegiance was
deplored by the press and many of his own class regarded him
as a traitor. At public demonstrations he risked physical assault
and even imprisonment. Worst of all he was, to a large extent,
estranged from friends and peers for the sake of what was a very
unpopular cause. The number of socialists in Britain was tiny:

even in 1885, two years after he had joined the Social Democratic Federation, it had only about 500 members. Yet Morris threw himself into the cause: he lectured 120 times between 1885 and 1886, travelling all over the country. In 1884 he founded the Socialist League, played a full part in its campaign of open-air speaking, acted as its treasurer, from 1885 to 1890 edited its journal, *The Commonweal*, and was one of its most important contributors. It should also be borne in mind that it was Morris's money in the form of profits from the Firm which underpinned much of the work of the Social Democratic Federation and then the Socialist League. He was driven on by his deep sense of the injustice of the present state of society. He wrote to C.E. Maurice in 1883,

> ... in looking into matters social and political I have but one rule, that in thinking of the condition of any body of men I should ask myself, 'How could you bear it yourself? what would you feel if you were poor against the system under which you live?' ... the contrasts of rich and poor are unendurable and ought not to be endured by either rich or poor. Now it seems to me that, feeling this, I am bound to act for the destruction of the system which seems to me mere oppression and obstruction; such a system can only be destroyed, it seems to me, by the united discontent of numbers;· isolated acts of a few persons of the middle and upper classes seeming to me ... quite powerless against it ...[24]

This suggests one of the reasons why Morris did not introduce more co-operative elements, such as profit-sharing for his workmen, except to a very limited degree, into Morris and Company. In a letter written the following year to Georgiana Burne-Jones he works through the consequences of reorganising the Firm on such lines and rejects it, for 'it would not alter the position of any one of them, but would leave them still members of the working class with all the disadvantages of that position' (p. 32). Another factor, one that weighed heavily in the balance, was the responsibility of providing for his wife and children—in particular Jenny, whose epilepsy meant that she could never

marry or support herself and would need to be looked after for
the rest of her life.

Morris paid his workers more than average and Merton
Abbey, in its country setting, was very unlike one's usual idea of
a nineteenth-century factory: 'even upon the great sunk dye-vats
the sun flickers through leaves, and trout leap outside the
windows of the long, cheerful room where the carpet-looms are
built'.[25] Visitors were impressed by the pleasant atmosphere and
good working conditions. Nevertheless Morris's relationship
with his workmen was paternalistic, rather than egalitarian. It is
true, also, that Morris's own workmen did not generally engage
in the kind of creative labour which in his lectures he argues is
essential for a happy life. There was division of labour in many
aspects of the Firm's work (p. 39) and it must often have been
monotonous. On the other hand, most of the work involved the
exercise of a skill; it was not simply a question of operating a
machine. A few of Morris's workers did rise in the ranks of the
firm, most notably John Henry Dearle, who started as an errand
boy and ended as manager of Merton Abbey and a designer in his
own right. Generally, though, Morris regarded his workmen as
quite unfitted to be designers, because of their lack of education,
particularly in technical skills such as drawing, and their lack of
knowledge of their own culture, in particular, the art of the past.
In 'The Lesser Arts' he stresses the need for both these elements
to be part of the training of a designer. In the meantime he would
not allow anything to compromise the standard of the Firm's
work. As he explains to Wardle,

> I can never be contented with getting anything short of the best, and
> ... I should always go on trying to improve our goods in all ways, and
> should consider anything that was only tolerable as a ladder to mount
> up to the next stage—that is, in fact, my life (p. 59).

This never changed and was the principle to which Morris
unwaveringly adhered. It was not only a temperamental necessity.
It was also vital to the Firm's reputation and profitability, which

rested on the quality and stylistic coherence of its products, which in turn depended on Morris's own taste, colour sense, and perfectionism. Many of his ideas were taken forward and developed by others: C.R. Ashbee, for example, introduced a profit-sharing scheme for his workers in the Guild and School of Handicrafts in 1898, and the Guild's move out to the Cotswolds was an attempt to live and work in a genuinely communal manner. More generally, Morris was a potent influence on art and design throughout Europe and America: a vital part of his legacy is the arts and crafts aesthetic that is outlined in the texts published here.

It was no more possible, of course, for Morris to free himself entirely from the constraints of his own times and his social conditioning, than it was for Gulliver, the hero of one of his favourite novels, to free himself from the hundreds of tiny threads with which the Lilliputians bound him. Morris knew this, and it was why he argued so fiercely for social change. He could be no other than a man of his times, and yet, as E.P. Thompson concludes in his biography of Morris, he is also 'one of those men whom history will never overtake'.[26] The reader will find that Morris has far more to offer than a set of rules for design. His ability to challenge and to unsettle remains as potent as ever.

Notes

1 Norman Kelvin (ed.), *The Collected Letters of William Morris* (4 vols, Princeton, NJ: Princeton University Press, 1984–96), I, p. 579.

2 'The Aims of Art', in May Morris (ed.), *The Collected Works of William Morris* (24 vols, London: Longman, Green & Co., 1910–15), XXIII, p. 95.

3 *The Collected Letters of William Morris,* II, p. 438.

4 Georgiana Burne-Jones, *Memorials of Edward Burne-Jones* (2 vols, London: Macmillan, 1904), II, p. 194.

5 Fiona MacCarthy, *William Morris: A Life for Our Time* (London: Faber & Faber, 1994), p. 383.

6 J. Bruce Glasier, *William Morris and the Early Days of the Socialist Movement* (London: Longmans, Green & Co., 1921), p. 26.

7 Raymond Williams, *Culture and Society, 1780–1950* (London: Chatto & Windus Ltd., 1958), p. 155. I would want to exempt *News from Nowhere* from that generalisation. There Morris's vision of how the world might be is deeply, and to my mind, movingly, felt.

8 'Making the Best of It', in *The Collected Works of William Morris*, XXII, p. 115.

9 'Art and the Beauty of the Earth', in *The Collected Works of William Morris*, XXII, pp. 171-172.

10 E.T. Cook and Alexander Wedderburn (eds.), *The Works of John Ruskin* (39 vols, London: George Allen, 1905), X, p. 194.

11 *The Works of John Ruskin*, X, p. 196.

12 *The Works of John Ruskin*, XVII, p. 105.

13 *The Works of John Ruskin*, XVII, p. 114.

14 'Some Hints on Pattern-designing', in *The Collected Works of William Morris*, XXII, pp. 203-4.

15 Henry Halliday Sparling, *The Kelmscott Press and William Morris Master-Craftsman* (London: Macmillan, 1924), p. 41.

16 *The Kelmscott Press and William Morris*, p. 42.

17 'Woodcuts of Gothic Books', in May Morris (ed.), *William Morris: Artist, Writer, Socialist* (2 vols, Oxford: Basil Blackwell, 1936), I, p. 321.

18 J.W. Mackail, *The Life and Work of William Morris* (2 vols, London and New York: Longmans, 1899), I, p. 161.

19 'Some Hints on Pattern-Designing', in *The Collected Works of William Morris*, XXII, p. 199.

20 'Woodcuts of Gothic Books', in *William Morris: Artist, Writer, Socialist*, I, p. 333.

21 'The Lesser Arts of Life', in *The Collected Works of William Morris*, XXII, p. 240.

22 'Some Hints in Pattern Designing', in *The Collected Works of William Morris*, XXII, p. 182.

23 *The Life of William Morris*, II, p. 218.

24 *The Collected Letters of William Morris*, II, p. 202.

25 *The Life of William Morris*, II, pp. 58-59.

26 E.P. Thompson, *William Morris: Romantic to Revolutionary* (London: Lawrence & Wishart, 1955), p. 845.

NOTES ON TEXTS

The texts of Morris's letters are taken from Norman Kelvin (ed.), *The Collected Letters of William Morris* (4 vols, Princeton, NJ: Princeton University Press, 1984–96). Angle brackets indicate material crossed out by Morris, but still legible. Here and in the rest of the texts Morris's spelling and punctuation have generally been retained.

'Mr. William Morris on Art Matters' was first published in *The Manchester Guardian*, 21 October 1882.

'Glass, Painted or Stained' was first published in 1890 in D. Patrick (ed.), *Chambers's Encyclopaedia: A Dictionary of Universal Knowledge, New Edition* (10 vols, London and Edinburgh: William Robert Chambers, 1888–92), V, pp. 246-248.

'The Lesser Arts' was first delivered to the Trades' Guild of Learning in 1877. 'The Art of the People' was first delivered to the Birmingham Society of Arts and the Birmingham School of Design in 1879. 'Making the Best of It' was first delivered to the Trades' Guild of Learning under the title 'Some Hints on House Decoration' in 1880. All three were published in *Hopes and Fears for Art: Five Lectures Delivered in Birmingham, London, and Nottingham 1878–1881* (London: Ellis & White, 1882), from which the texts in this volume have been taken.

'Some Hints on Pattern-designing' was first delivered to the students of the Working Men's College, Bloomsbury, London in 1881. 'The Lesser Arts of Life' was first delivered at the Birmingham and Midlands Institute in 1882 under the title 'Some of the Minor Arts of Life'. 'The Aims of Art' was first

delivered in 1886 to the Hammersmith Branch of the Socialist League. 'The Revival of Handicraft' was written as an article for the *Fortnightly Review*, November 1888. The texts published here are from May Morris (ed.), *The Collected Works of William Morris* (24 vols, London: Longman, Green & Co., 1910–15).

'Of Dyeing as an Art' was first published in *Arts and Crafts Essays, by Members of the Arts and Crafts Exhibition Society* (New York: Scribner, 1893), from which this text is taken.

News from Nowhere first appeared in *Commonweal* between January and October 1890. The text here is from the first edition of the book.

'The Ideal Book' was delivered to the Bibliographical Society on 19 June, 1893. The texts used here are from May Morris (ed.), *William Morris: Artist, Writer, Socialist* (2 vols, Oxford: Basil Blackwell, 1936). 'Some Thoughts on the Ornamented Manuscripts of the Middle Ages', an incomplete and undated manuscript essay, is in the Huntington Library. The text quoted here was published in William S. Peterson (ed.), *The Ideal Book: Essays and Lectures on the Arts of the Book by William Morris* (Berkeley: University of California Press, 1982).

ACKNOWLEDGMENTS

The Society of Antiquaries has kindly granted permission to publish Morris manuscripts that remain in copyright.

I am most grateful to Nicholas Salmon for his prompt and meticulous editing and to my husband, Peter Blundell Jones, for reading and commenting on several drafts of the introduction. Linda Parry's comments have been also most helpful and I take this opportunity to thank her.

I have drawn on the work of many scholars, particularly in annotating Morris's writings. Full details will be found in the bibliography, but I would like to acknowledge a special debt to Charles Harvey, Norman Kelvin, Eugene D. LeMire, Fiona MacCarthy, Linda Parry, William S. Peterson, and Jon Press.

Alan Russell and Barrie Smith of Homerton College gave me generous assistance in scanning material onto disc: I am grateful to them and to the College.

THE FIRM

INTRODUCTION

The contribution of Morris and Company to the revival of decorative art in the second half of the nineteenth century was greater than that of any other manufacturing firm. Nevertheless, it is not quite true that the applied arts were in the 'state of complete degradation' (p. 29) that Morris suggests in his letter of 1883 to Andreas Scheu. He makes much the same point in his address at the opening of the Fine Art and Industrial Exhibition at St James's Hall, Manchester, in 1882, claiming there, too, that the Firm sprang directly from the difficulties Morris and his friends had in furnishing their houses in the early 1860s. In fact Morris, Marshall, Faulkner, and Company were not quite the first on the scene. Most notably, Pugin had been designing across a very wide range of both ecclesiastical and domestic furnishings in the 1840s and in 1847 Sir Henry Cole had established Summerly's Art Manufactures with the intention of producing well-designed everyday objects. However Morris and Company, as it became in 1875, surpassed this earlier work in the range of its products. By the 1880s it was possible to have one's home, however grand, furnished almost entirely by the Firm from tapestries down to glassware. Those on more modest middle-class incomes could order individual goods from the Firm's showroom, which moved to a prime location in Oxford Street in 1877. A northern showroom was established in Manchester in 1883.

Right from the beginning the Firm had been aware of the need to publicize its wares and owed some of its commercial

success to its skill in merchandising. Its circular offered an ambitious range of products for both domestic and ecclesiastical clients. Word of mouth and personal social contacts were even more vital in establishing the Firm; Morris's letter to the Rev. Guy represents an attempt to target a particular market, the High Church clergy, who might commission ornate church furnishings.

By the early 1880s Morris was aware that in business terms the Firm could be judged a success. Nevertheless he was conscious of falling short of the Ruskinian ideals which had been central to his thinking about the arts since the 1850s. On the purely aesthetic side he had tried to produce 'goods which should be genuine as far as their mere substances are concerned ... woollen substances as woollen as possible, cotton as cottonny as possible', as he explains to the American poet and essayist, Emma Lazarus, in April 1884 (p. 30). In this he had been successful and his influence as a designer was of vital signficance for the Arts and Crafts movement. However he had also come

to understand thoroughly the manner of work under which the art of the Middle Ages was done ... and that that is the *only* manner of work which can turn out popular art, only to discover that it is impossible to work in that manner in this profit-grinding Society (p. 30).

The tensions between Morris's views as a socialist and his position as a manufacturer and businessman are explored more fully in his letter of 1 June 1884 to Georgiana Burne-Jones.

CIRCULAR ADVERTISING MORRIS, MARSHALL,[1] FAULKNER[2] AND CO., 1861[3]

MORRIS, MARSHALL, FAULKNER AND CO.,
FINE ART WORKMEN IN PAINTING, CARVING,
FURNITURE, AND THE METALS

EDWARD BURNE-JONES[4] C.J. FAULKNER
ARTHUR HUGHES[5] FORD MADOX BROWN[6] P.P. MARSHALL
WILLIAM MORRIS D.G. ROSSETTI[7] PHILIP WEBB[8]

The growth of Decorative Art in this country, owing to the efforts of English Architects, has now reached a point at which it seems desirable that Artists of reputation should devote their time to it. Although no doubt particular instances of success may be cited, still it must be generally felt that attempts of this kind hitherto have been crude and fragmentary. Up to this time, the want of that artistic supervision, which can alone bring about harmony between the various parts of a successful work, has been increased by the necessarily excessive outlay, consequent on taking one individual artist from his pictorial labours.

The Artists whose names appear above hope by association to do away with this difficulty. Having among their number men of varied qualifications, they will be able to undertake any species of decoration, mural or otherwise, from pictures, properly so-called, down to the consideration of the smallest work susceptible of art beauty. It is anticipated that by such co-operation, the largest amount of what is essentially the artist's work, along with

his constant supervision, will be secured at the smallest possible expense, while the work done must necessarily be of a much more complete order, than if any single artist were incidentally employed in the usual manner.

These Artists having for many years been deeply attached to the study of the Decorative Arts of all times and countries, have felt more than most people the want of some one place, where they could either obtain or get produced work of a genuine and beautiful character. They have therefore now established themselves as a firm, for the production, by themselves and under their supervision, of–

I. Mural Decoration, either in Pictures or in Pattern Work, or merely in the arrangements of Colours, as applied to dwelling-houses, churches, or public buildings.
II. Carving generally, as applied to Architecture.
III.Stained Glass, especially with reference to its harmony with Mural Decoration.
IV. Metal Work in all its branches, including Jewellery.
V. Furniture, either depending for its beauty on its own design, on the application of materials hitherto overlooked, or on its conjunction with Figure and Pattern Painting. Under this head is included Embroidery of all kinds, Stamped Leather, and ornamental work in other such materials, besides every article necessary for domestic use.

It is only requisite to state further, that work of all the above classes will be estimated for, and executed in a business-like manner; and it is believed that good decoration, involving rather the luxury of taste that the luxury of costliness, will be found to be much less expensive than is generally supposed.

April 11, 1861

Notes

1 Peter Paul Marshall (1830–1900), surveyor and sanitary engineer, who probably became associated with the Firm through his friendship with Ford Madox Brown. He supplied around a dozen designs for stained glass in the early days but thereafter was to play no part in the Firm.

2 Charles James Faulkner (1834–92), who had held a mathematics tutorship at Oxford, looked after the accounts. By 1869 he had returned to Oxford. He was a lifelong friend of Morris, one of the few to follow him into socialism.

3 Authorship is unknown, although Mackail suggests that 'it is not difficult to trace the slashing hand and imperious accent of Rossetti' (*The Life of William Morris*, I, p. 152). Presumably it was approved by all the partners.

4 Edward Coley Burne-Jones (1833–98) became the Firm's chief designer for stained glass and later for tapestry.

5 Arthur Hughes (1832–1915), Pre-Raphaelite painter and illustrator, played very little part in the Firm's work, apparently contributing one stained glass design only.

6 Ford Madox Brown (1821–93), an artist associated with the Pre-Raphaelite circle, had experience in stained glass design. He also designed some remarkable furniture in the early days of the Firm.

7 Dante Gabriel Rossetti (1828–82), charismatic member of the Pre-Raphaelite Brotherhood who had persuaded Morris to take up painting. He already had experience in stained glass design but stopped producing designs for the Firm in 1864.

8 Philip Webb (1831–1915), architect, who had designed Red House. He did a variety of work for the Firm, including designs for furniture, table glass, and metalwork, and contributing animal drawings to Morris's wallpaper designs.

TO FREDERICK BARLOW GUY[1]

19 April 1861

My dear Guy,

By reading the enclosed [the Firm's circular] you will see that I have started as a decorator which I have long meant to do when I could get men of reputation to join me, and to this end mainly I have built my fine house. You see we are, or consider ourselves to be, the only really artistic firm of the kind, the others being only glass painters in point of fact, (like Clayton & Bell)[2] or else that curious nondescript mixture of clerical tailor and decorator that flourishes in Southampton Street, Strand; whereas we shall do—most things. However, what we are most anxious to get at present is wall-decoration, and I want to know if you could be so kind as to send me (without troubling yourself) a list of clergymen and others, to whom it *might* be any use to send a circular. In about a month we shall have some things to show in these rooms [8, Red Lion Square], painted cabinets, embroidery and all the rest of it, and perhaps you could look us up then: I suppose till the holidays you couldn't come down to Red House: I was very much disappointed that you called when I was out before ...

Notes

1 The High Church clergyman, who had been his tutor between Marlborough College and Oxford.

2 A firm of Gothic Revival stained glass designers established in 1855.

MR. WILLIAM MORRIS
ON ART MATTERS

*Part of an address given by Morris at the opening of the Fine Art
and Industrial Exhibition at St James's Hall, Manchester, reported
in* THE MANCHESTER GUARDIAN, *21 October 1882*

... I think we may without rashness congratulate ourselves on the
progress made in decorative art of late years. I should be loth to
speak slightingly of any of the brotherhood to which I belong,
past or present.—(Laughter.) But the plain fact is that some 25
years ago these arts of mere decorations were in such a state that
one is bound to say that they looked as if they were coming to an
end; of the traditional part of them there was, in England at least,
scarce any more left than there is now, *i.e.* nothing. On the more
obvious and self-conscious side there was nothing stirring. What
individual talent there was left could only show itself in eccen-
tricities that most often deserved to be called by any other name
rather than decoration. The public was as blankly ignorant of the
history of the art as the designers were of its first principles. The
contempt with which the whole subject was treated in those days
is shown pretty clearly by the law which relates to the copyright
in industrial designs, which strange to say is to this day all the
protection accorded to them. The framers of that law doubtless
wished to secure to manufacturers all reasonable advantages for
those designs which they had paid for or invented; yet to this day
it is only possible to protect such designs for three years; three

years seemed at the time when that law was made ample time for a manufacturer to reap all reasonable advantages from any design he might produce. I don't think I need make much comment on that. Well, really, I must say that 25 years ago it did not much matter whose design you got hold of. (Laughter) They were all much the same and did little but spoil the materials out of which they were made.—(Laughter.) I well remember when I was first setting up house, 23 years ago, and two or three other friends of mine were in the same plight, what a rummage there used to be for anything tolerable in the way of hangings, for instance, and what shouts of joy would be raised if we had the luck to dig up some cheapish commonplace manufacture, which, being outside the range of fancy goods, had escaped the general influence of the vacuity of the times. (Applause.) On the whole, I remember that we had to fall back upon turkey-red cotton and dark blue serge; since even the very self colours of fancy goods had grown to be impossible, which is the more inexcusable as at that time the beneficent march of science and commerce had not yet destroyed the ancient and worthy traditions of the craft of dyeing as it has since done.—(Applause) ...

TO ANDREAS SCHEU[1]

15 September 1883

... I went to Oxford in 1853 as a member of Exeter College; I took very ill to the studies of the place; but fell to very vigorously on history and specially mediaeval history, all the more perhaps because at this time I fell under the influence of the High Church or Puseyite school; this latter phase however did not last me long, as it was corrected by the books of John Ruskin which were at the time a sort of revelation to me; I was also a good deal influenced by the works of Charles Kingsley,[2] and got into my head therefrom some socio-political ideas which would have developed probably but for the attractions of art and poetry ... When I had gone through my Schools at Oxford, I who had been originally intended for the Church (!!!) made up my mind to take to art in some form, and so articled myself to G. E. Street (the architect of the new Law Courts afterwards) who was then practising in Oxford; I only stayed with him nine months however; when being in London and having been introduced by Burne-Jones, the painter, who was my great college friend, to Dante Gabriel Rossetti, the leader of the Pre-Raphaelite School, I made up my mind to turn painter, and studied the art but in a very desultory way for some time.

At this time the revival of Gothic architecture was making great progress in England and naturally touched the Preraphaelite movement also; I threw myself into these movements with all my heart: got a friend to build me a house very mediaeval in

spirit in which I lived for 5 years, and set myself to decorating it; we found, I and my friend the architect especially, that all the minor arts were in a state of complete degradation especially in England, and accordingly in 1861 with the conceited courage of a young man I set myself to reforming all that: and started a sort of firm for producing decorative articles. D. G. Rossetti, Ford Madox Brown, Burne-Jones, and P. Webb the architect of my house were the chief members of it as far as designing went. Burne-Jones was beginning to have a reputation at that time; he did a great many designs for us for stained glass, and entered very heartily into the matter; and we made some progress before long, though we were naturally much ridiculed. I took the matter up as a business and began in the teeth of difficulties not easy to imagine to make some money in it: about ten years ago the firm broke up, leaving me the only partner, though I still receive help and designs from P. Webb and Burne-Jones.

... Through all this time I have been working hard at my business, in which I have had a considerable success even from the commercial side; I believe that if I had yielded on a few points of principle I might have become a positively rich man; but even as it is I have nothing to complain of, although the last few years have been so slack in business.

Almost all the designs we use for surface decoration, wall-papers, textiles, and the like, I design myself. I have had to learn the theory and to some extent the practice of weaving, dyeing and textile printing: all of which I must admit has given me and still gives me a great deal of enjoyment ...

Notes

1 Austrian Socialist and furniture-designer, whom Morris had recently met through the Democratic Federation.

2 As an undergraduate Morris had admired Kingsley for his adherence to Christian Socialism and as the author of *Yeast* (1850) and *Alton Locke* (1850), novels which dealt with the sufferings of the working classes and advocated social reform.

TO EMMA LAZARUS

21 April 1884

... A word or two about the art I have tried to forward. That is a
simple matter enough: I have tried to produce goods which
should be genuine as far as their mere substances are concerned,
and should have on that account the primary beauty in them
which belongs to naturally treated natural substances: have tried
for instance to make woollen substances as woollen as possible,
cotton as cottonny as possible and so on: <all this quite apart
from> have used only the dyes which are natural & simple,
because they produce beauty almost without the intervention of
art: all this quite apart from the design in the stuffs or what-not:
on that head it has been, chiefly because of the social difficulties,
almost impossible to do more than to insure the *designer* mostly
myself some pleasure in his art by getting him to understand the
qualities of materials and the happy chances of processes: except
with a <few> small part of the more artistic side of the work I
could not do anything or at least but little to give this pleasure to
the workmen; because I should have had to change their method
of work so utterly, that <I> it should have disqualified them
from earning their living elsewhere: you see I have got to under-
stand thoroughly the manner of work under which the art of the
Middle Ages was done, <only to discover that it is impossible
to do now> and that that is the *only* manner of work which
can turn out popular art, only to discover that it impossible to
work in that manner in this profit-grinding Society.

TO GEORGIANA BURNE-JONES

1 June 1884

Dearest Georgie

Dont be alarmed: certain things occurred to me which being written you may pitch into the fire if you please.

The question of sharing of profits in order to shake off the responsibility of exploitation is complicated by this fact, that the workman is exploited by others besides his own employer: for as things now go *everything* is made for a profit, ie everything has to pay toll to people who do not work, and whose idleness enforces overwork on those who are compelled to work: everyone of us therefore, workman or non-workman, is *forced* <the> to support the present competitive system by merely living in the present society, and buying his ordinary daily necessaries: so that an employer by giving up his individual profit on the goods he gets made would not be able to put his workmen in their proper position: they would be exploited by others though not by him: this to explain partly why I said that cooperation to be real must be the rule and not the exception.

Now to be done with it I will put my own position, which I would not do to the public because it is by no means typical, and would therefore be useless as a matter of principle. Some of those who work for me share in the profits formally: I suppose, I make the last year or two about £1800, Wardle[1] about £1200, the Smiths[2] about £600 each; Debney & West[3] £400 all these share directly in the profits: Kenyon the colour-mixer, & Good-acre

the foreman dyer have also a kind of bonus on the amount of goods turned out: the rest either work as day-workers, or are paid by the piece, mostly the latter: in both cases they get more than the market-price of their labour; two or three people about the place are of no use to the business and are kept on on the live-and-let-live principle, not a bad one I think as things go, in spite of the Charity Organization Society.

The business has of course a certain Capital to work on, about £15000, which is very little for the turn-over of goods: this is nominally mine, but of course I can't touch it as long as the business is going, and if the business were wound up it is doubtful if it would realize more than enough to pay the debts, since goods always sell for less than their value at forced sales.

Now as you know I work at the business myself and it could not go on without me, or somebody like me: therefore my £1800 are pay for work done, and I should justly claim a maintenance for that work; shall we say £4 per week, (about Kenyon's screw) or £200 per annum; that leaves £1600 for distribution among the 100 people I employ besides the profit sharers; £16 a year each therefore: now that would I admit (would) be a very nice thing for them; but it would not alter the position of any one of them, but would leave them still members of the working class with all the disadvantages of that position: further, if I were to die, or be otherwise disabled the business could not get anyone to do my work for £200 a year, and would in short at once take back the extra £16 a year from the workmen.

It seems to me therefore that the utmost I could do would be little enough, nor should I feel much satisfaction in thinking that a very small knot of working-people were somewhat better off amidst the great ocean of economic slavery.

I have left out 2 matters which complicate the position: 1st I have a small literary income, about £120, and 2nd there are those other partners called my family: now you know we ought to be able to live upon £4 a week, & give the literary income to the

revolutionary agitation: but here comes the rub, and I feel the pinch of society for which society I am only responsible in a very limited degree. And yet if Janey & Jenny were quite well and capable I think they ought not to grumble at living on the said £4, nor do I think they would.

Well, so far as to my position which you will see is very different from the ordinary manufacturer's so-called; since he not only gets high pay for 'organizing labour' but also claims plunder as a sleeping partner on various absurdly transparent pretexts. On the other hand I admit that it would be much easier for me to drop some of my iniquitous overpayment, than for him, because I have personal relations with my men, while his are only machines; many or most of my men are specialists like myself, whereas his are the ordinary material to be hired in every market; so that if he were to give up his gains to them, they would notice the fact of their discrepancy from their work, would set to work to save, & would become or try to become small capitalists & then large ones: in effect this is what mostly happens in those few factories where division of profits has been tried: now much as I want to see workmen escape from their slavish position, I don't at all want to see a few individuals more creep up out of their class into the middle class; this will only make the poor poorer still: and this effect I repeat of multiplying the capitalist class (every member of which you must remember is engaged in fierce private commercial war with his fellows) is the utmost that could result from even a large number of the employers giving up their profits to their workmen—even supposing such a wild dream could be realized. The utmost, I say, because the greater number of the men kept down by years of slavery would not know how to spend their newly gained wealth, but would let it slip through their fingers to swell the gains of the exploiting tradesmen who are on the look out for such soft-heads. If you doubt this remember that even now there are at times artizans who receive very high wages, but that their

exceptional good luck has no influence over the general army of
wage earners, and that they themselves have in consequence only
two choices: the first to rise out of their class as above, the second
to squander their high earnings and remain in the long run at the
ordinary low standard of life of their less lucky brethren: the
really desireable thing that being still workmen they should rise
in culture and refinement they can *only* attain to by their whole
class rising.

This as things go, especially since England has lost her mono-
poly of trade & manufacture is *impossible*: the competition for
subsistence among workmen forbids the serious rise of the
standard of life for any long period taking labour all round; it is
true that the trades unions by combination did manage to raise
that standard for skilled labour; but their combination as on the
one hand it was not international and so allowed other nations to
undersell us and so reduce wages or threaten reduction of wages
even for them (which will certainly come), so on the other hand
it did not take in the unskilled labourers, who are scarcely in any
better position than they were 50 years ago—and in any case in a
condition which makes one almost ashamed to live—in spite of
the enormous increase of wealth of the country in general.

Here then is a choice for a manufacturer ashamed of living on
surplus value: shall he do his best to further a revolution at the
basis of society (dont be afraid of a word my friend) which would
turn all people into workers, as it would give a chance to all
workers to become refined and dignified in their life; or shall he
ease his conscience by dropping a certain portion of his profits to
bestow in charity on his handful of workers, for indeed it is but
charity after all, since they don't claim it from *him* but from his
class: (and here I must remind you that there is no possibility of
working men getting at the *class* of employers by way of
arbitration, even to the limited extent to which the employers
can get at the workmen through the Trades Unions; since the
employers unless definitely attacked are of their very nature as

above said always at war with each other:) Well I say which shall he do? The second choice, if he takes it, may save a few individuals a certain amount of suffering and anxiety, therefore if he *can* do both things let him do so, and make his conscience surer; but if as must generally be the case he must choose between the furthering of a great principle, and the staunching of the pangs of conscience; I should think him right to choose the first course: because although it is *possible* that here & there a capitalist may be found who could & would be content to carry on his business at (say) foreman's wages, it is *impossible* that the capitalist class could do so: the very point of its existence is manufacturing for a profit and not for livelihood: the instinct for profit has made the class through a series of centuries what it is today, nor can anything destroy that instinct but the instinct for combination for cooperation for the common good, the germ of which existed thousands of years ago, and is now under a new form struggling with the spirit of competition which has for so long overlaid it ...

Notes

1 George Wardle, the Firm's general manager between 1870 and 1890.

2 Two brothers, Robert and Frank Smith, Morris's commercial managers. They later became junior partners.

3 References in other letters to Lawrence Debney suggested that he was employed in a managerial role, perhaps as an assistant to the Smith brothers; his name appears on bills and estimates after 1890 when the Smiths became partners. Little is known of West, but a further reference to him in a letter of 28 December 1888 (*The Collected Letters of William Morris*, II, p. 845) seems to indicate that he was employed at Merton Abbey as a weaver, probably in a supervisory role.

STAINED GLASS

INTRODUCTION

It was through stained glass that the Firm established its early reputation in the 1860s. Demand slackened thereafter, but stained glass remained a significant element of the Firm's work; production continued right up until its dissolution in 1940. One of Morris's greatest legacies has been the stained glass which can be found in churches and cathedrals all over Britain and as far afield as Calcutta and Adelaide. Yet Morris wrote relatively little about it. The two texts here, a quick letter dashed off to Ruskin and a more formal and considered account produced for *Chambers's Encyclopaedia*, are virtually all that he wrote.

Perhaps this was, at least in part, because the quest of rescuing an ancient craft from oblivion, which so caught his imagination in his experiments with dyeing, had already been undertaken and achieved by someone else. The technique of making glass which could emulate the colour and texture of medieval stained glass had already been rediscovered by the time the Firm was established. Morris acknowledges this in a footnote to 'Stained Glass', in which he refers to 'the "ruby" glass made by Powell of Whitefriars with the help of Mr Winston about the year 1853'. Through the chemical analysis of medieval glass, Charles Winston (1814–65) had succeeded in providing James Powell & Sons with the means of producing coloured glass of such excellence that even Morris was satisfied with it and always bought the Firm's glass, both for windows and for tableware, from them. He was, therefore, never involved with the manufacture of the raw materials of the craft.

Morris must have been aware, too, of the ways in which the Firm's work in stained glass was, as Paul Thompson points out, 'an extreme example of the division of labour'.[1] Indeed it was Morris's rigorous control of its production that brought about the consistently high standard of the Firm's early stained glass and allowed it to have a readily identifiable style. The original designs would be produced by an artist, most often Burne-Jones, Morris's principal designer, who would then have no further hand in the process; the glass would be painted by the Firm's glass painters who were instructed to keep as closely as possible to the design. Morris often designed the backgrounds, always chose the colours (in later years the leading as well), and inspected every piece of glass before the windows were made up. When, after about 1880, Morris's vigilance slackened and the work was often delegated, a deterioration in the quality of the Firm's glass was sometimes apparent. After the deaths of Morris and Burne-Jones the decline is marked, for the standard of the Firm's glass was entirely dependent on Morris's eye for colour and quality and Burne-Jones's skill as a designer.

Note

1 *The Work of William Morris*, p. 119.

TO JOHN RUSKIN

15 April 1883

My dear Ruskin

I really feel very guilty for not having answered your question before:[1] & now I must add to my guilt by laying some of the blame on Ned,[2] who only gave me your note this morning: however I have got ready a sort of pattern-card of some of the glass we use which I will send you at once; & meantime I answer your todays letter thus.

We *paint* on glass; 1st the lines of draperies features & the like with an opaque colour which when the glass is held up to the light is simply <ob> so much obscurity; with thinner washes & scumbles of the same colour, we shade <so much> objects as much as we deem necessary, but always using this shading to explain form, and not as shadow proper.

2nd. Finding that it was difficult to get a flesh-coloured glass with tone enough for the flesh of figures, we use thin washes of a reddish enamel colour to stain white glass for flesh-colour, & sometimes, though rarely for other pale orange tints: N.B. this part of our practice is the only point in which we differ from that of the mediaeval glass-painters.

3rd. We use a yellow *stain* on white glass, (or on blue to make greens) this which is chiefly done by means of silver, is quite transparent & forms part of the glass after firing; it may therefore be considered rather a diffusion of the colour in the glass than a painting on it.

The body of the glass is of two kinds, first what is technically called pot-metal, in which the colouring matter is fused with the glass, & is essentially part of it; and 2ndly What is called flashed glass, in which a white body is covered with a coloured skin: this is done by the workman taking on the end of his hollow rod first a large lump of white metal, then a small dip of coloured metal; he then trundles the lot, making a disk like a small piece of crown glass: This kind of glass however is not much used except for the red coloured by copper called technically — 'ruby glass'. this owing to its make is often curiously & beautifully striped & waved: this glass is, I must tell you, perillous to fire the painted colour upon as the kiln generally changes it more or less, sometimes darkening it almost to blackness, sometimes carrying the colour away: to avoid this risk we are sometimes obliged to paint the necessary lines on a piece of thin white glass and lead up the two together: this, which is called plating I have sometimes done <to get some> with two pieces of coloured glass, to get some peculiar tint: one must be careful not to overdo the process however, or you will get a piece of glass at once cumbrous & liable to accident.

I should mention that all the glass is very thick: and that in some of the pot-metals, notably the blues the difference between one part of a sheet [and] another is very great. This variety is very useful to us in getting a jewel-like quality which is the chief charm of painted glass—When we *can* get it. You will understand that we rely almost entirely for our colour on the *actual colour of the glass*; and the more the design will enable us to break up the pieces, and the more mosaic-like it is, the better we like it ...

Notes

1 Ruskin had wanted to know 'how far you paint on glass, and how far you diffuse *in* it—a given bit of colour' (see *The Collected Letters of William Morris*, II, p. 187, where there is a full account of the background to this correspondence).

2 Edward Burne-Jones

GLASS, PAINTED OR STAINED

1890

There are two kinds of painted glass known in modern times, Enamel and Mosaic glass. In enamel glass proper certain fusible pigments are painted on a sheet of white glass, which is then fired, and the result is a picture the tints of which even in the high lights are not wholly transparent. A modification of this method produces its picture partly by enamelling on white glass, partly by the use of pot-metal glass (i.e. glass coloured while in a state of fusion, and therefore of the same tint all through), the colour of which is heightened or modified by the use of enamels. In this style, if any junction between two pieces of glass becomes necessary, the lead calms[1] used for the purpose are studiously concealed by being made to run along leading lines of drapery or other forms in the picture. The object of this enamel and semi-enamel glass-painting is the closest possible imitation of an oil or water-colour picture; and the results of it are never satisfactory. For at the best it can only do with difficulty and imperfectly what the oil-painting does with ease and perfection; while at the same time it refuses to avail itself of the special characteristics of glass, which can produce effects that no opaque painting can approach. This imitation of easel or wall pictures also leads the designer into making designs unfitted for the ornament of windows, and wandering from their true purpose of decoration. Indeed, not infrequently the work of a great master in picture-painting is taken as a model for a

stained-glass window, and laboriously and servilely imitated, with the result that a mere caricature of the great work is produced, which is as far as possible from being an 'ornament' to the building in which it is placed.

The only method capable of producing stained glass which shall be beautiful and interesting, and which at the same time can plead some reason for its existence, is that which has been called mosaic glass, the process of which very briefly stated is as follows:

A design is made wherein the drawing is given and the colours indicated, which is the working-drawing of the glass-painter. From this working-drawing a kind of map is made which gives all the various pieces of the mosaic. The glazier cuts these pieces out from sheets of glass of various colours, and hands them back to the painter, who proceeds first to paint the leading lines with a solid opaque enamel, the colouring matter of which is an oxide of iron. This being done (and the glass sometimes having been fired at once, but sometimes not), the pieces of glass are stuck together temporarily (by means of wax) on a glass easel, and the painter slightly shades his bold traced lines with the same opaque colour; using sometimes washes (in which case, of course, the colour is much diluted, and is only semi-opaque) and sometimes hatching of lightly laid-on lines, as in a black and white drawing on paper. Sometimes both washes and hatching are used, and sometimes the washed shadows are stippled—i.e. part of the colour is removed by dabbing it with the end of a broad brush. In any case the object of the methods of shading is to keep the shadows as clear, and to dull the glass as little as the *explanation* or *expression* of the subject will admit of. Two or three or more firings are necessary during the process of this painting, but as far as the painting as distinguished from the mosaic is concerned this is all that has to be done, though it must be said that to do it well requires considerable experience and artistic skill and feeling.

This painting being done, the glass goes back to the glazier's bench again, and he 'leads it up' (i.e. joins it together with lead calms soldered at the junction), and the window, after having been solidified by a stiff cement or putty rubbed into the leaf of the leads, has then only to be put in its place and strengthened by the due iron stay-bars. It may be mentioned here that in this mosaic glass-painting, so far from there being any necessity for concealing the 'leads,' it is highly desirable to break up the surface of the work by means of them, always taking care that their direction is carefully considered from the point of view of their appearance. The obvious strength which the network of leads gives to the window on the one hand, and the obvious necessity for picking out small pieces of exquisite colour on the other, take away all sense of discomfort in the arbitrary disposition of these constructive lines.

A mosaic stained-glass window, therefore, seems a very simple affair, and so it is as a process (bating some difficulties in the making of the material). Its real difficulties are all on the artistic side, and have to do with the qualities of design and the choice of material.

As to the design, it must be repeated that *suggestion*, not *imitation*, of form is the thing to be aimed at. Again, the shading is, as above said, for the sake of explanation, not to make the work look round, and also for diversifying the surface of the glass, to make it look rich in colour and full of detail. The qualities needed in the design, therefore, are beauty and character of outline; exquisite, clear, precise drawing of incident, such especially as the folds of drapery. The whole design should be full of clear, crisp, easily-read incident. Vagueness and blur are more out of place here than in any other form of art; and academical emptiness is as great a fault as these. Whatever key of colour may be chosen, the colour should always be clear, bright, and emphatic. Any artist who has no liking for *bright* colour had better hold his hand from stained-glass designing.

Consideration of the colour of the work naturally leads to consideration of the material. The ordinary machine-made window-glass, thin, and without any variety of surface, is wholly unfit for stained glass, but it should be stated in passing that a modern mechanical imitation of the unevenness of surface found in old glass, which is commonly called 'cathedral glass,' is the worst of all materials for windows, and should never be used in any kind of glazing, ornamental or plain. The due varieties of surface are those that occur *naturally* in the process of making thick cylinder or crown glass. All glass used for glass-painting should be very thick, or, whatever the pigments used for colouring may be, the effect will be poor, starved, and, if bright colours be used, glaring. The glass which has to show as white should, when laid on a sheet of white paper, be of a yellowish-green colour; for the colours in stained glass are so powerful that unless the whites are toned in the material itself they will always be inharmonious and cold.

It is necessary in addition to state briefly what the varieties of coloured glass proper for the purpose are. First comes pot-metal, in which the colour is an integral part of the glass; then flashed-glass, where the colour forms a coloured skin to a white body;[*] and lastly a transparent yellow stain (deduced from silver), which attacks the silica, and thus forms a part of the glass, is much used to colour portions of the pot-metal, for ornaments on dresses, hair, flowers, and the like.

This art of mosaic window-glass is especially an art of the middle ages; there is no essential difference between its processes as now carried on and those of the 12th century; any departure from the medieval method of production in this art will only lead us astray. It may be added that its true home was northern Europe during the middle ages, as the importance of the wall-pictures in Italy made its fullest development less necessary to the buildings in that country, and accordingly the Italians did not understand its principles so well as the artists of France and

England, and had not the full measure of unerring instinct which the latter had. And besides, as Gothic architecture lasted longer with us and the French, there was more opportunity for the development of the later styles here, since the neoclassic architecture had scarcely a place for stained glass.

The 12th century begins the real history of the art. The windows of that date that are left us are very deep and rich in colour, red and blue being the prevailing tints. They are mostly figure designs, disposed in ornamental frames, and are admirably designed for their purpose: the painting is very simple, nothing but a little washed shading supporting the traced lines; the figure are usually small, except in the case of windows far removed from the eye, as in some of the windows at St Denis near Paris. The beautiful windows in the choir aisles at Canterbury Cathedral are usually referred to the 12th century, but if they belong to it they must be of its later years.

There was a slow development of the glass all through the earlier years of the 13th century, and a great deal more work is left us of that period; a great deal of the glazing of the early pointed architecture was of mere geometrical work. The ignorant architect, Wyatt,[2] who gutted Salisbury Cathedral in 1790, found most of the windows so glazed, and destroyed the glazing except for a few fragments. The window of the north transept at York Minster, now called the 'Five Sisters,' is a well-known example of this beautiful work.

The 14th or end of the 13th century invented a very beautiful kind of glazing especially suitable to the large traceried windows then coming into vogue; in this style bands of very richly coloured figure-glass, usually framed in canopies, run across the lights, and are supported by ingenious fret-glazing in white, on which elegant running patterns are freely drawn, and this grisaille (as it is called) is connected with the richer-coloured bands by means of borders, and with medallions, little gem-like pieces all carefully patterned; the whole producing an effect of singular

elegance and richness, and admitting plenty of light. The nave aisles of York Minster and Merton College Chapel at Oxford may be cited as giving us very perfect specimens of this glazing, which may be said to be the highest point reached by the art.

With the change to the Perpendicular style in the 15th century came a corresponding change in stained glass, though, of course, that change was very gradual. The glass now had a tendency to become paler in colour; a great part of the great traceried windows of the style was oftenest made up of elaborate canopies, in which white touched with yellow stain played a great part. Some very beautiful windows of this date are almost entirely carried out in silvery whites and yellow stains. The shading of the figures and drapery, &c. was much more elaborate; the stippling and hatching above mentioned was common, especially in the later part of the style; but the luminous quality of the shadows was generally well maintained. In spite of the ravages of the Puritans both of the Reformation and of the Cromwellian episodes, examples of stained glass, usually very fragmentary, are common throughout England. The ante-chapel at New College, Oxford, the great east window of Gloucester Cathedral, many windows in the choir of York Minster, and many of the parish churches in that city, notably All Saints, North Street, are splendid examples of the work of this period.

In the 16th century the art was on the wane: it became heavier in shading, less beautiful in colour, and aimed too much at pictorial effect. As a reasonable art, stained glass can hardly be said to have existed after about 1540; a few pieces of rather pretty and fanciful glazing and a little heraldic work are in the Elizabethan period all that represent the splendid art which adorned such buildings as York Minster and Canterbury Cathedral. The windows of Fairford Church, in Gloucestershire, form a very interesting collection of the work of the earlier part of the century. King's College Chapel at Cambridge is almost entirely glazed with picture-work of this period. It has suffered

much from reglazing, and is now very hard to read; nor could the art in it have ever been of a very high order.

With the ruin of Gothic architecture stained glass was swept away entirely; and indeed it perished sooner and more completely than any of the other subsidiary arts, doubtless because its successful practice depends more on the instinctive understanding of the true principles of decorative art than any other of the arts connected with architecture.

The art of glass-painting has been revived with the eclectic revival of Gothic architecture, which is such a curious feature of our epoch, and has shared to the full in the difficulties which an eclectic style must of necessity meet with. Still it must be understood that glass-painting is no 'lost art' in the sense of its processes being forgotten: whatever the deficiencies of the modern art may be, they are the result of the lack of feeling for decoration, rather than of difficulties as to material, workshop receipts, and the like. The very praiseworthy studies of Mr Winston and his collaboration with Messrs Powell of Whitefriars in the manufacture of window-glass fit for the purpose made it possible for us many years ago to produce good stained-glass windows if our artistic powers did not fail us, or rather if they could be turned into the right direction; if the designers could understand that they should not attempt to design pictures but rather pieces of ornamental glazing which, while decorating the buildings of which they formed a part, should also tell stories in a simple straightforward manner.

This they have in a great measure learned to understand, and the public also are beginning to see that the picture-window of the semi-enamel style (as represented chiefly by the elaborate futilities produced by the Munich manufactories) cannot form, as a window should do, a part of the architecture of the building. On the other hand, there has been (unavoidably doubtless) too much mere copying of medieval designs; it has been forgotten that the naïvetés of drawing of an early stage of art which are

interesting when genuine and obviously belonging to their own period, become ridiculous when imitated in an epoch which demands at least plausibility of drawing from its artists. But that very demand for plausibility and the ease of its attainment form another snare for the stained-glass designer, whose designs, though made with a knowledge of the requirements of the art, and though not actually imitative of medieval work, are too often vacant and feelingless, mere characterless diagrams, rather than the expression of thought and emotion, as the work of the middle ages always was in spite of any rudeness of drawing or shortcoming in knowledge.

One drawback to the effectiveness of painted windows comes from the too common absence of any general plan for the glazing of the building. The donors of windows are allowed to insert whatever may please their individual tastes without regard to the rest of the glazing or the architectural requirements of the building; so that even where the window is good in itself, it fails in effect of decoration, and injures, or is injured, by its neighbours. The custodians of buildings before they allow any window to be put up should have some good plan of glazing schemed out embracing a system of subjects, an architectural arrangement, and a scheme of proportion of colour, and this plan should be carefully adhered to. Thus, one window would help the other, and even inferiority of design in one or two of the windows would be less noticed when the whole effect was pleasing. The gain of such a careful arrangement is sufficiently obvious in cases where the ancient glazing of a church is left intact; as, for instance, in the beautiful church of St Urbain at Troyes, a work of the end of the 13th century, and whose glazing is perhaps on the whole the most satisfactory example of the art of glass-painting. On the whole, it must be said of our modern stained glass that its worth must mainly depend on the genuineness and spontaneity of the architecture it is intended to decorate: it must stand or fall along with the feeling for art which

inspires this architecture, for its existence is impossible without architecture of some sort, and if that architecture is less than good and genuine, the stained-glass windows in it become a mere congeries of designs without unity of purpose, even though each one may be good in itself.

* Flashed-glass is mostly used for the beautiful 'ruby' glass deduced from copper, the making of which was revived by Messrs Powell of Whitefriars, in London, with the help of Mr Winston about the year 1853.

Notes

1 Frame enclosing a pane of glass.
2 James Wyatt (1747–1813), early Gothic Revival architect, responsible for so-called restorations at Salisbury, Durham and Hereford Cathedrals from 1782 and despised by Morris for his lack of understanding of the Gothic style.

TEXTILES

INTRODUCTION

Morris wrote more about textiles than about any other of the applied arts. They included a wide range of the Firm's most popular products: chintzes and woven cloths, carpets, tapestry, and embroidery. Intimate knowledge of these crafts had been hard-won and in the winning Morris had learnt much that he was eager to communicate.

When Morris first began seriously designing chintzes in the early 1870s, he hoped to contract out the printing, as he already did for wallpaper. However the quality of the work done by Thomas Clarkson of Preston, a leading calico-printer, did not satisfy him; he was particularly unhappy about the colour and quality of the chemical dyes used. He began to consider how to revive techniques of vegetable dyeing, by then a virtually lost art, and a small dyehouse was established on the Firm's premises in Queen Square. However, it was not until 1875 that the period of most intense experimentation began when Morris was able to collaborate with Thomas Wardle, the owner of a dye-works in Leek (and brother-in-law of his manager, George Wardle).

Many of their discussions were necessarily carried on by correspondence. These letters, of which only a few are printed here, demonstrate more vividly than any of Morris's other writings his consummate grasp of technique, his perfectionism, the eye for colour which is so evident in his actual designs, and his shrewd business sense. On the one hand Morris was constantly striving for the highest quality and the Firm's reputation rested on the quality of its goods. On the other hand he had to

bear in mind what the market would stand: 'I must also remind you how much we suffer from imitators: these will be all agog as soon as they hear of our printed goods being admired, and we must try not to give them the advantage of grossly underselling us' (p. 55).

By 1878 Wardle was printing fourteen designs for the Firm, some—such as 'Indian Diaper'—showing the influence of contemporary Indian textiles, and others—such as 'Honeysuckle' and 'Marigold'—based on flowing natural forms.

Fruitful though this relationship with Wardle was, Morris nevertheless grew increasingly frustrated, complaining that 'You must allow that it [is] putting us in an awkward position if we have to be the only persons responsible for the pieces, when we have no control over the processes' (p. 60). This situation was not fully resolved until the Firm moved to Merton Abbey in Surrey in 1881. Then Morris was able to set up a dyehouse and print shop, as well as a glass studio, a weaving factory, and carpet looms. The move stimulated a fresh burst of creativity: between 1881 and 1883 nineteen new designs were registered at the Patent Office, including 'Strawberry Thief', 'Brer Rabbit', and a series of designs named after tributaries of the Thames (many designed especially for indigo discharge technique). At the same time this absorption in textile design and dyeing was prompting Morris to give lectures such as 'Some Hints on Pattern Designing' (1881) and 'The Lesser Arts of Life' (1882). In these and in his essay, 'Dyeing as an Art', first-hand experience enables him to speak with confidence and authority. When Morris writes that 'the setting of the blue-vat is a ticklish job' (p. 70) and that 'matching a colour ... is an agreeable, but somewhat anxious game to play' (p. 71), one is reminded of his letter to Aglaia Coronio in which he tells her of his excitement in seeing 'the silk coming green out of the vat and gradually turning blue' (p. 57). His writings on textiles are the distillation of many, many hours of experimentation and study.

TO THOMAS WARDLE

23 November 1875

My dear Mr. Wardle

I proceed to answer both your letters before I begin work this morning. 1st woad[1] Couldn't anything be learned in France about this subject, where they seem to have used it later than we at all events? The indigo on my natal print[2] is certainly blocked in, as you would see if you had a bigger piece: I suspect Kay[3] don't know as much on the subject as the present writer, who now sendeth you a piece of cloth pencilled on (nothing will do but the chewed willow twig) by his own hands:[4] it is very easy to lay on, but I fancy we shall not easily get it brighter than the enclosed specimen: I have a block, now in the cutter's hands very elaborate as to print, but very simple as to blotch[5] on which we might at least try this blue: please however to refrain your natural grin of triumph when I mention that it is no use trying it on unbleached cloth.

Of course you would have children for the pencilling: our boys at 5/6 a week would be quite up to it. I should have thought (with deference) that we scarcely wanted more printers: which observation brings me to saying a word or two on the subject of price since you mentioned it in your last: after this I will hold my peace about it till the six months are ended.[6] I daresay you are right about the 6-colour prig[?] we sent you as to its being machine-printed: we know however that Clarkson's[7] prints (for us) are blocked in. he charges us 15/5l/2d for a 2 print cloth, and

for an elaborate 9-print cloth 3s/9d. this is a *very* big block: I give you these as being the two ends of his scale. Of course we both hope & think that, when all goes smoother, you will be able to do the cloths as cheap as other people: meanwhile we have shown the cloths long enough to find that people start at the present prices we are obliged to charge. I must also remind you how much we suffer from imitators: these will be all agog as soon as they hear of our printed cloths being admired, and we must try not to give them the advantage of grossly underselling us; and also (to get away from the subject of price) we must be able to say (in the long run) that the goods are fast.

I don't think you should look forward to our *ever* using a machine. As to the mercantile branch, that is quite out of *our* way: but I see no reason why *you* should not try it, if you think it would pay; and I should be happy to help if you wanted any help in the designing way. Of course we tried washing the /10 3/4 print before we sent it you.—what can you expect from Prussia?

Re tussore:[8] You are quite welcome to send the prints to the India house:[9] as to the colours of them I don't like the green or the blue: if you print those colours make the blue deep, rich, & greenish & the green full and deep but with plenty of yellow in it: but I think that yellows browns & reds would be best for them: I suppose you can't use madder for them because it comes on too strong on the unmordanted[10] parts: but I suppose Alizarine[11] could be used: As to our using them the only drawback seems to be that they are made awkward widths for our present blocks. could this be got over? I like the look of them very much. By the way I think the Carnation would look well on the Tussore. I should say that I consider my pencil-blue as a good colour to go with the madders, and I am sure very good greens could be got with it: I should mention that I have used it unthickened, and that it is the glucose receipt that seems the best I have tried yet: I have not tried the receipt with the tin[?].

I have found a Gerard[12] for you at last; it ought to get to you

tomorrow: it seemed a very good copy: but if it turns out imperfect please let me know.

I am Yours very truly
William Morris

Notes

1 Blue dye obtained from the leaves of a plant of the same name.

2 On 16 November Morris had sent Wardle 'a rag from the bed which heard my first squeak: my mother says it is about six years older than myself: I suppose it to be all indigo & madder except the yellow: the indigo is very nice and bright; whether it is blue-dip or china I don't know but it has certainly been blocked in some way ...' (*The Collected Letters of William Morris*, I, p. 278).

3 One of Wardle's dyers, of whom Morris had a very low opinion.

4 Kelvin notes that this piece of cloth is still with the original letter (*The Collected Letters of William Morris*, I, p. 281).

5 A fabric-printing method in which the ground colour is transferred from the cylinder and the motif retains the original colour of the cloth.

6 In earlier letters (*The Collected Letters of William Morris*, I, p. 295, 2 November 1875 and I, p. 298, 5 November 1875), Morris had expressed concern about the price of the cloth Wardle was printing, but had agreed to wait six months before renegotiating prices.

7 Thomas Clarkson of Bannister Hill Print Works, near Preston, Lancashire, who had produced the Firm's first chintz, 'Tulip and Willow', which Morris had regarded as being of too poor a quality to sell.

8 An Indian silk, usually brown.

9 Kelvin suggests that this is reference to the India Museum which 'contained dyeing materials, including many not as yet used in Europe' (*The Collected Letters of William Morris*, I, p. 281).

10 A mordant is a substance used to fix colour, especially a metallic compound such as an oxide or hydroxide, which combines with the organic dye and forms an insoluble coloured compound in the fibre.

11 A red chemical dye.

12 *Herbal or Generall Historie of Plantes* (1595) by John Gerard; a revised edition was published in 1633 by Thomas Johnson. Morris owned both (see *The Collected Letters of William Morris*, I, p. 265).

TO AGLAIA IONIDES CORONIO[1]

28 March 1876

My dear Aglaia

I am at last able to write to you, and thank you for your letter: I have a huge deal to do in a very limited time, for I am trying to learn all I can about dyeing, even the handiwork of it, which is simple enough, but, like many other simple things, contains matters in it that one would not think of unless one were told. Besides my business of seeing to the cotton-printing, I am working in Mr. Wardle's dye-house in sabots and blouse pretty much all day long: I am dyeing yellows and reds: the yellows are very easy to get, and so are a lot of shades of salmon and flesh-colour and buff and orange; my chief difficulty is in getting a deep blood red, but I hope to succeed before I come away: I have not got the proper indigo vat for wool, but I can dye blues in the cotton vat and get lovely greens with that and the bright yellow that weld[2] gives.

This morning I assisted at the dyeing of 20 lbs. of silk (for our damask[3]) in the blue vat; it was very exciting, as the thing is quite unused now, and we ran a good chance of spoiling the silk. There were four dyers and Mr. Wardle at work, and myself as dyers' mate: the men were encouraged with beer and to it they went, and pretty it was to see the silk coming green out of the vat and gradually turning blue: we succeeded very well as far as we can tell at present; the oldest of the workmen, an old fellow of seventy, remembers silk being dyed so, long ago. The vat, you

must know, is a formidable-looking thing, 9 ft. deep and about 6 ft. square: and is sunk into the earth right up to the top. To-morrow I am going to Nottingham to see wool dyed blue in the woad vat, as it is called; on Friday Mr. Wardle is going to dye 80 lbs. more silk for us, and I am going to dye about 20 lbs. of wool in madder for my deep red. With all this I shall be very glad indeed to be home again, as you may well imagine ...

Notes

1 Aglaia Ionides Coronio (1834–1906) was the daughter of Constantine Ionides, a wealthy Greek merchant, and, like him, was an enthusiastic patron of the arts. Her sympathetic friendship was a source of support to Morris through the difficulties of his marriage in the 1870s.

2 A kind of mignonette.

3 Parry explains that Morris's 'technical terminology ... is very confusing and that he meant by a damask simply a "smooth-surfaced lightweight fabric containing silk"' (*William Morris Textiles*, p. 58).

TO THOMAS WARDLE

17-30 November 1876

Dear Mr. Wardle

I am in receipt of both your letters, and am obliged to you for being quite open on the subject of our troubles, and beg you to believe my communication to be wholly a friendly one, though I may have to say 'no' where you say 'yes.' The difficulties of your carrying on a <private business> manufactory for us, a business which *must* in the nature of things be rather what is called today an art than a manufacture, I feel, as I always have felt, to be immense: I can only wonder how you ventured to face them with your own difficult business to attend to, and I don't think you need take any shame to yourself if you conclude to give it up; neither do I think that the nature of the business will change, though time and use may wear it smoother in some places: I mean that I can never be contented with getting anything short of the best, and that I should always go on trying to improve our goods in all ways, and should consider anything that was only tolerable as a ladder to mount up to the next stage—that is, in fact, my life. To come to more detail—we have never expected in the printing to get a close match, but if the pieces are to be of any use to us they must differ from the pattern on the right side if at all: I must say also that I have always strained my artistic conscience to the utmost in dealing with doubtful cases (to the very utmost) and have kept many pieces <with> which, if I were dealing merely in a business way, I should have refused, and

as a result we have a good deal of stock which is only half useful
to us: You must allow that it [is] putting us in an awkward
position if we have to be the only persons responsible for the
pieces, when we have no control over the process of them: still I
think we may venture so far as this: to accept the responsibility
for all pieces, after having first seen and approved the fents
[samples of cloth] printed from the stock of colour mixed [from]
for the order: and it would help, I think, at any rate in difficult
cases, if you would send us *all* the trial fents as you go on. I am
aware that this would not save us from misfortunes, but I wish
to meet you in the matter, as I can't help thinking you would not
like to give up the affair: on the other hand, if you do wish to
give it up, please understand I do not press you on the matter in
the least: in that case I would take the whole business off your
hands at such sum as you thought fair, only giving me some time
to make payment (due interest paid meantime): also, I should ask
you to keep the thing going at Leek for 3 or 6 months printing
easy things, in order to get us a little stock, while we were
looking about to start afresh during which time we would, if you
pleased, pay all expenses: It is quite true that you are not likely to
get your money back for some time for what you have spent on
the dyeing operations, and what I have just said about the
printing applies to this just as much or more: for me giving up
the dyeing schemes means giving up my business altogether, and
to give up the printing would be a serious blow to it, especially
as last midsummer our balance showed a loss on that account of
£1023.

To sum up the whole matter—the hitch over the printing
seems to be the lack of constant artistic supervision on the spot;
but since we can't have it, we must do the best we can by sending
the fents about: as to the change in the business arrangement, <I
am> (about taking the printed things) I am not much afraid of it
for my part; for I have not sent much back, and I know you will
do your best in the matter ...

TO THOMAS WARDLE

13 April 1877

My dear Wardle,

I have both your notes, and have to thank you first, for getting me news of the brocader:[1] I will clear off what I have to say about that first: We are willing to agree to his terms of 3000 fr: for the year, and think it would be prudent not to guarantee for longer, but if he suits us, no doubt the situation will be a permanent one for him: we agree to the travelling expenses of course: but I think before we strike a bargain we should see his specimens of work: meantime we send a parcel of examples of cloth such as we are likely to want as far as the weaving is concerned: they are all valuable, and some are not our own; so they must be taken care of & returned whole & in good condition: as a fixed wage is stipulated, we suppose he will work by the day, about how much per diem can he turn out: will he give us any idea of this? We suppose we shall have to find him standing-room for the loom: what space & height is wanted for this? As to the loom we should *by all means* want it big enough to weave the widest cloth that can be done *well* without steam-power: and it ought to be such as could weave a design 27 inches wide (Nicholson can only do us a 9 inch design) this width is what we have hithertoo had from Lyons. We should certainly want to weave damask. Your correspondent shall be welcome to the douceur,[2] which we shall be willing to add to if the matter turns out well: I hope he understands that we want a really intelligent man: if he turns out such,

his position with us will be good; as we should surely be wanting more looms, and he would be foreman over the others.

As soon as we are agreed he must let us know when he can come, & send us some proper paper for pointing, in order that we get a design ready for him without delay—Which latter word makes me express a hope that you will be able to dye us some silk against his coming: do you know for certain where we can best get our cards cut by the way.

So much for the brocader, when I have thanked you again very much for getting me on so far, and confessed that I am prodigiously excited about him. Thanks about the swivel[3] silk indigo: I really don't think the unevenness will matter much unless it is beyond measure: I have seen old silks, blue & green, which were evidently stripy from the vat, & they didn't look the worse for it.

The tapestry is a bright dream indeed; but it must wait till I get my carpets going: though I have had it my head lately, because there is a great sale now on in Paris of some of the finest ever turned out: much too splendid for anybody save the biggest pots to buy: I will send you the illustrated catalogue to look at in a day or two. Meantime much may be done in carpets: I saw yesterday a piece of *ancient* Persian time of Shah Abbas (our Elizabeth's time) that fairly threw on my back: I had no idea that such wonders could be done in carpets ...

Notes

1 Brocade is a woven fabric with a raised pattern. As a result of these negotiations, a French weaver, Louis Bazin, and his Jacquard loom came over from Lyon in June.

2 A tip or gratuity.

3 A swivel loom was used for weaving tape or ribbon.

TO THOMAS WARDLE

14 November 1877

My dear Wardle

Like you I shall probably find one letter's space not enough for going into the whole matter of the tapestry, but I will begin: Let's clear off off what you say about the possibility of establishing a non-artistic manufactory: you could do it of course; 'tis only a matter of money and trouble: but, cui bono?[1] it would not amuse you more than the Judson (unless I wholly misunderstand you) and would I am sure *not* pay commercially a *cheap* new article at once showy & ugly if advertised with humbug enough will sell of course: but an expensive article even with ugliness to recommend it:—I don't think anything under a Duke could sell it: however, as to the commercial element of this part of the scheme, 'tis not my affair, but on the art-side you must remember that, as nothing is so <ugly> beautiful as fine tapestry, nothing is so ugly & base as bad; eg. the Gobelins or the present Aubusson[2] work: also tapestry is not fit for anything but figure-work (except now & then, I shall mention wherein presently) the shuttle & loom beat it on one side, the needle on the other, in pattern work: but for figure-work 'tis the only way of making a web into a picture: now there is only one man at present living, (as far as I know) who can give you pictures at once good enough & suitable for tapestry—to wit Burne-Jones— the exception I mentioned above would be the making of leaf & flower-pieces (greeneries, des Verdures) which would generally

be used to eke out a set of figure-pieces: these would be within the compass of people, workfolk, who could not touch the figure-work: it would only be by doing these that you could cheapen the work at all.

The qualifications for a person who would do successful figure-work would be these:

1 General feeling for art, especially for its decorative side.
2 He must be a good colourist.
3 He must be able to draw well; ie he must be able to draw the human figure, especially hands & feet.
4 Of course he must know how to use the stich of the work.

Unless a man has these qualities, the first two of which are rare to meet with & cannot be taught, he will turn out nothing but bungles disgraceful to everyone concerned in the matter: I have no idea where to lay my hands on such a man, and therefore I feel that whatever I do I must do chiefly with my own hands. It seems to me that your weak point is that tapestry cannot be made a matter of what people now-a days call manufacturing, and that even so far as it can be made so, the only possible manufacturer must be an artist for the higher kind of work: otherwise all he has to do is to find house-room provide the frame & warp, and coloured worsteds exactly as the workman bids him. In speaking thus I am speaking of the picture-work: a cleverish woman could do the greeneries no doubt. When I was talking to you at Leek I did not fully understand what an entirely individual matter it must be: it is just like wood-engraving: it is a difficult art, but there is nothing to *teach* that a man cannot learn in half a day, though it would take a man long practice to do it well: There *are* manufacturers of wood-engraving e.g. the Dalziells,[3] as big humbugs as any within the narrow seas. I suspect you scarcely understand what a difficult matter it is to translate a painter's design into material: I have been at it 16 years now, & have never quite succeeded. In spite of all these difficulties if in anyway I can

help you I will: only you must fully understand that I intend setting up a frame and working at it myself, and I should bargain for my being taught by you what is teachable: also I see no difficulty in your doing greeneries & what patterns turned out desirable, & I would make myself responsible for the design of such matters. With all this, I have no doubt that we shall both lose money over the work: you don't know how precious little people care for such things.

The carpets like the Savonnerie[4] ones is another matter quite: because you can get girls to do the work and it is really quite a mechanical matter: that seems to me quite feasible for you at once, & I should be glad to go into the matter with you: premising once more that I should like to have a frame of my own up here in this matter also ...

Notes

1 To what good.

2 Gobelins and Aubusson were the leading French tapestry factories of the seventeenth and eighteenth centuries. For Morris's contempt for the work of these two factories, see 'On Weaving, from "The Lesser Arts of Life"' (p. 82). He particularly disapproved of the copying of oil paintings in tapestry, a common practice at both factories.

3 The Dalziel brothers, George (1815–1902), Edward (1817–1905), and Thomas (1823–1906), were extremely well-known wood-engravers.

4 Savonnerie, the most important European carpet factory, was founded by Louis XIII in 1627; it produced very expensive carpets with a fine, dense woollen pile. The name is often incorrectly applied to French pile carpets generally.

OF DYEING AS AN ART

1889

Dyeing is a very ancient art; from the earliest times of the ancient civilisations till within about forty years ago there had been no essential change in it, and not much change of any kind. Up to the time of the discovery of the process of Prussian-blue dyeing in about 1810 (it was known as a pigment thirty or forty years earlier), the only changes in the art were the result of the introduction of the American insect dye (cochineal), which gradually superseded the European one (kermes), and the American wood-dyes now known as logwood and Brazil-wood: the latter differs little from the Asiatic and African Red Saunders, and other red dye-woods; the former has cheapened and worsened black-dyeing, in so far as it has taken the place of the indigo-vat as a basis. The American quercitron[1] bark gives us also a useful additional yellow dye.

These changes, and one or two others, however, did little towards revolutionising the art; that revolution was left for our own days, and resulted from the discovery of what are known as the Aniline dyes, deduced by a long process from the plants of the coal-measures. Of these dyes it must be enough to say that their discovery, while conferring the greatest honour on the abstract science of chemistry, and while doing great service to capitalists in their hunt after profits, has terribly injured the art of dyeing, and for the general public has nearly destroyed it as an art. Henceforward there is an absolute divorce between the

commercial process and the *art* of dyeing. Any one wanting to produce dyed textile with any artistic quality in them must entirely forgo the modern and commercial methods in favour of those which are at least as old as Pliny, who speaks of them as being old in his time.[2]

Now, in order to dye textiles in patterns or otherwise, we need four colours to start with—to wit, blue, red, yellow, and brown; green, purple, black, and all intermediate shades can be made from a mixture of these colours.

Blue is given us by indigo and woad, which do not differ in colour in the least, their chemical product being the same. Woad may be called northern indigo; and indigo tropical or sub-tropical woad.

Note that until the introduction of Prussian blue about 1810 there was *no* other blue dye except this indigotine that could be called a dye; the other blue dyes were mere stains which would not bear the sun for more than a few days.

Red is yielded by the insect dyes kermes, lac-dye, and cochineal, and by the vegetable dye madder. Of these, kermes is the king; brighter than madder and at once more permanent and more beautiful than cochineal: the latter on an aluminous basis gives a rather cold crimson, and on a tin basis a rather hot scarlet (*e.g.* the dress-coat of a line officer). Madder yields on wool a deep-toned blood-red, somewhat bricky and tending to scarlet. On cotton and linen, all imaginable shades of red according to the process. It is not of much use in dyeing silk, which it is apt to 'blind'; *i.e.* it takes off the gloss. Lac-dye gives a hot and not pleasant scarlet, as may be noted in a private militiaman's coat. The French liners' trousers, by the way, are, or were, dyed with madder, so that their country-men sometimes call them the 'Madder-wearers'; but their cloth is somewhat too cheaply dyed to do credit to the drysaltery.[3]

Besides these permanent red dyes there are others produced from woods, called in the Middle Ages by the general name of

'Brazil'; whence the name of the American country, because the conquerors found so much dyeing-wood growing here. Some of these wood-dyes are very beautiful in colour; but unluckily they are none of them permanent, as you may see by examining the beautiful stuffs of the thirteenth and fourteenth centuries at the South Kensington Museum, in which you will scarcely find any red, but plenty of fawn-colour, which is in fact the wood-red of 500 years ago thus faded. If you turn from them to the Gothic tapestries, and note the reds in them, you will have the measure of the relative permanence of kermes and 'Brazil,' the tapestry reds being all dyed with kermes, and still retaining the greater part of their colour. The mediaeval dyers must be partly excused, however, because 'Brazil' is especially a silk dye, kermes sharing somewhat in the ill qualities of madder for silk; though I have dyed silk in kermes and got very beautiful and powerful colours by means of it.

Yellow dyes are chiefly given us by weld (sometimes called wild mignonette), quercitron bark (above mentioned), and old fustic, an American dye-wood. Of these weld is much the prettiest, and is the yellow silk dye *par excellence*, though it dyes wool well enough. But yellow dyes are the commonest to be met with in nature, and our fields and hedgerows bear plenty of greening-weeds, as our forefathers called them, since they used them chiefly for greening blue woollen cloth; for, as you may well believe, they, being good colourists, had no great taste for yellow woollen stuff. Dyers'-broom, saw-wort, the twigs of the poplar, the osier, and the birch, heather, broom, flowers and twigs, will all of them give yellows of more or less permanence. Of these I have tried poplar and osier twigs, which both gave a strong yellow, but the former not a very permanent one.

Speaking generally, yellow dyes are the least permanent of all, as once more you may see by looking at an old tapestry, in which the greens have always faded more than the reds or blues; the best yellow dyes, however, lose only their brighter shade, the

'lemon' colour, and leave a residuum of brownish yellow, which still makes a kind of a green over the blue.

Brown is best got from the roots of the walnut tree, or in their default from the green husks of the nuts. This material is especially best for 'saddening,' as the old dyers used to call it. The best and most enduring blacks also were done with this simple dye-stuff, the goods being first dyed in the indigo or woad-vat till they were a very dark blue and then browned into black by means of the walnut-root. Catechu, the inspissated[4] juice of a plant or plants, which comes to us from Indian, also gives rich and useful permanent browns of various shades.

Green is obtained by dyeing a blue of the required shade in the indigo-vat, and then greening it with a good yellow dye, adding what else may be necessary (as, *e.g.*, madder) to modify the colour according to taste.

Purple is got by blueing in the indigo-vat, and afterwards by a bath of cochineal or kermes, or madder; all intermediate shades of claret and murrey [a dark purplish-red] and russet can be got by these drugs helped out by 'saddening.'

Black, as aforesaid, is best made by dyeing dark blue wool with brown; and walnut is better than iron for the brown part, because the iron-brown is apt to rot the fibre; as once more you will see in some pieces of old tapestry or old Persian carpets, where the black is quite perished, or at least in the case of the carpet gone down to the knots. All intermediate shades can, as aforesaid, be got by the blending of these prime colours, or by using weak baths of them. For instance, all shades of flesh colour can be got by means of weak baths of madder and walnut 'saddening'; madder or cochineal mixed with weld gives us orange, and with saddening all imaginable shades between yellow and red, including the ambers, maize-colour, etc. The crimsons in Gothic tapestries must have been got by dyeing kermes over pale shades of blue, since the crimson red-dye, cochineal, had not yet come to Europe.

A word or two (entirely unscientific) about the processes of this old-fashioned or artistic dyeing.

In the first place, all *dyes* must be soluble colours, differing in this respect from *pigments*; most of which are insoluble, and are only very finely divided, as, *e.g.*, ultramarine, umber, terre-verte.

Next, dyes may be divided into those which need a mordant[5] and those which do not; or, as the old chemist Bancroft very conveniently expresses it, into *adjective* and *substantive* dyes.

Indigo is the great substantive dye: the indigo has to be de-oxidised and thereby made soluble, in which state it loses its blue colour in proportion as the solution is complete; the goods are plunged into this solution and worked in it 'between two waters,' as the phrase goes, and when exposed to the air the indigo they have got on them is swiftly oxidised, and once more becomes insoluble. This process is repeated till the required shade is got. All shades of blue can be got by this means, from the pale 'watchet,' as our forefathers called it, up to the blue which the eighteenth-century French dyers called 'Bleu d'enfer' [the blue of hell]. Navy Blue is the politer name for it to-day in England. I must add that, though this seems an easy process, the setting of the blue-vat is a ticklish job, and requires, I should say, more experience than any other dyeing process.

The brown dyes, walnut and catechu, need no mordant, and are substantive dyes; some of the yellows also can be dyed without mordant, but are much improved by it. The red dyes, kermes and madder, and the yellow dye weld, are especially mordant or adjective dyes: they are all dyed on an aluminous basis. To put the matter plainly, the goods are worked in a solution of alum (usually with a little acid added), and after an interval of a day or two (ageing) are dyed in a bath of the dissolved dye-stuff.

A lake is thus formed on the fibre which is in most cases very durable. The effect of this 'mordanting' of the fibre is clearest seen in the maddering of printed cotton goods, which are first

printed with aluminous mordants of various degrees of strength (or with iron if black is needed, or a mixture of iron with alumina for purple), and then dyed wholesale in the madder-beck: the result being that the parts which have been mordanted come out various shades of red, etc., according to the strength or composition of the mordant, while the unmordanted parts remain a dirty pink, which has to be 'cleared' into white by soaping and exposure to the sun and air; which process both brightens and fixes the dyed parts.

Pliny saw this going on in Egypt, and it puzzled him very much, that a cloth dyed in one colour should come out coloured diversely.

That reminds me to say a word on the fish-dye of the ancients: it was a substantive dye and behaved somewhat as indigo. It was very permanent. The colour was a real purple in the modern sense of the word, *i.e.* a colour or shades of a colour between red and blue. The real Byzantine books which are written on purple vellum give you some, at least, of its shades. The ancients, you must remember, used words for colours in a way that seems vague to us, because they were generally thinking of the tone rather than the *tint*. When they wanted to *specify* a red dye they would not use the word purpureus, but coccineus, *i.e.* scarlet of kermes.

The art of dyeing, I am bound to say, is a difficult one, needing for its practice a good craftsman, with plenty of experience. Matching a colour by means of it is an agreeable but somewhat anxious game to play.

As to the artistic value of these dye-stuffs, most of which, together with the necessary mordant alumina, the world discovered in early times (I mean early *historical* times), I must tell you that they all make in their simplest forms beautiful colours; they need no muddling into artistic usefulness, when you need your colours bright (as I hope you usually do), and they can be modified and toned without dirtying, as the foul blotches of the

capitalist dyer cannot be. Like all dyes, they are not eternal; the sun in lighting them and beautifying them consumes them; yet gradually, and for the most part kindly, as (to use my example for the last time in this paper) you will see if you look at the Gothic tapestries in the drawing-room at Hampton Court. These colours in fading still remain beautiful, and never, even after long wear, pass into nothingness, through that stage of livid ugliness which distinguishes the commercial dyes as nuisances, even more than their short and by no means merry life.

I may also note that no textiles dyed blue or green, otherwise than by indigo, keep an agreeable colour by candle-light: many quite bright greens turning into sheer drab [a dull grey]. A fashionable blue which simulates indigo turns into a slaty purple by candle-light; and Prussian blues are also much damaged by it. I except from this condemnation a commercial green known as gas-green, which is as abominable as its name, both by daylight and gaslight, and indeed one would almost expect it to make unlighted midnight hideous.

Notes

1 A kind of oak found in eastern North America.

2 Pliny the Elder (AD 23–79), Roman naturalist, encyclopedist, and writer, whose *Historia Naturalis* Morris had consulted in his quest for information about lost dyeing techniques

3 Business of dealing in chemicals and chemical products used in dyes, drugs, etc.

4 Thickened, as by evaporation.

5 A substance used to fix colour, especially a metallic compound such as an oxide or hydroxide, which combines with the organic dye and forms an insoluble coloured compound in the fibre.

ON DESIGNING FOR WOVEN TEXTILES

From 'Some Hints on Pattern-designing', 1881

... Now as to the pattern-designing for figured woven stuffs, which is one of the most important branches of the art. Here, as you will find yourself more limited by special material than in the branches above named, so you will not be so much beset by the dangers of commonplace. You cannot choose but make your flowers weavers' flowers. On the other hand, as the craft is a nobler one than paper-staining or cotton-printing, it claims from us a higher and more dignified style of design. Your forms must be clearer and sharper, your drawing more exquisite, your pattern must have more of meaning and history in it: in a word, your design must be more concentrated than in what we have hitherto been considering; yet again, if you have to risk more, you have some compensation in the fact that you will not be hampered by any necessity for masking the construction of your pattern, both because your stuff is pretty sure to be used falling into folds, and will be wrought in some material that is beautiful in itself, more or less; so that there will be a play of light and shade on it, which will give subordinate incident, and minimize the risk of hardness. Moreover, these last facts about woven stuffs call on you to design in a bolder fashion and on a larger scale than for stiffer and duller-surfaced goods; so we will say that the special qualities needful for a good design for woven stuff are breadth and

boldness, ingenuity and closeness of invention, clear definite detail joined to intricacy of parts, and, finally, a distinct appeal to the imagination by skilful suggestion of delightful pieces of nature.

In saying this about woven stuffs I have been thinking of goods woven by the shuttle in the common looms, which produce recurring patterns; there are, however, two forms of the weaver's craft which are outside these, and on which I will say a few words: first, the art of tapestry-weaving, in which the subjects are so elaborate that, of necessity, it has thrown aside all mechanical aid, and is wrought by the most primitive process of weaving, its loom being a tool rather than a machine. Under these circumstances it would be somewhat of a waste of labour to weave recurring patterns in it, though in less mechanical times it has been done. I have said that you could scarcely bring a whole bush into a room for your wall decoration, but since in this case the mechanical imitations are so few, and the colour obtainable in its materials is so deep, rich, and varied, as to be unattainable by anything else than the hand of a good painter in a finished picture, you really may almost turn your wall into a rose-hedge or a deep forest, for its material and general capabilities almost compel us to fashion plane above plane of rich, crisp, and varying foliage with bright blossoms, or strange birds showing through the intervals. However, such designs as this must be looked upon as a sort of halting-place on the way to historical art,[1] and may be so infinitely varied that we have not time to dwell upon it.

The second of these offshoots of the weaver's craft is the craft of carpet-making: by which I mean the real art, and not the makeshift goods woven purely mechanically. Now this craft, despite its near kinship as to technical matters with tapestry, is very specially a pattern-designer's affair. As to designing for it, I must say it is mighty difficult, because from the nature of it we are bound to make our carpet not only a passable piece of colour,

but even an exquisite one, and, at the same time, we must get enough of form and meaning into it to justify our making it at all in these Western parts of the world; since as to the mere colour we are not likely to beat, and may be well pleased if we equal, an ordinary genuine Eastern specimen.

Once more, the necessary limitations of the art will make us, not mar us, if we have courage and skill to face and overcome them. As for a carpet-design, it seems quite clear that it should be quite flat, that it should give no more at least than the merest hint of one plane behind another; and this, I take it, not so much for the obvious reason that we don't feel comfortable in walking over what simulates high relief, but rather because in a carpet we specially desire quality in material and colour: that is, every little bit of surface must have its own individual beauty of material and colour. Nothing must thrust this necessity out of view in a carpet. Now, if in our coarse, worsted mosaic we make awkward attempts at shading and softening tint into tint, we shall dirty our colour and so degrade our material; our mosaic will look coarse, as it ought never to look; we shall expose our lack of invention, and shall be parties to the making of an expensive piece of goods for no good reason.

Now, the way to get the design flat, and at the same time to make it both refined and effective in colour, in a carpet-design, is to follow the second kind of relief I told you of, and to surround all or most of your figure by a line of another tint, and to remember while you are doing it that it is done for this end, and not to make your design look neat and trim. If this is well done, your pieces of colour will look gemlike and beautiful in themselves, your flowers will be due carpet-flowers, and the effect of the whole will be soft and pleasing. But I admit that you will probably have to go to the school of the Eastern designers to attain excellence in the art, as this in its perfection is a speciality of theirs. Now, after all, I am bound to say that when these difficulties are conquered, I, as a Western man and a picture-lover,

must still insist on plenty of meaning in your patterns; I must have unmistakable suggestions of gardens and fields, and strange trees, boughs, and tendrils, or I can't do with your pattern, but must take the first piece of nonsense-work a Kurdish shepherd has woven from tradition and memory; all the more, as even in that there will be some hint of past history.

Since carpets are always bordered cloths, this will be a good place for saying a little on the subject of borders, which will apply somewhat to other kinds of wares. You may take it that there are two kinds of border: one that is merely a finish to a cloth, to keep it from looking frayed out, as it were, and which doesn't attract much notice. Such a border will not vary much from the colour of the cloth it bounds, and will have in its construction many of the elements of the construction of the filling-pattern; though it must be strongly marked enough to fix that filling in its place, so to say.

The other kind of border is meant to draw the eye to it more or less, and is sometimes of more importance than the filling: so that it will be markedly different in colour, and as to pattern will rather help out that of the filling by opposing its lines than by running with them. Of these borders, the first, I think, is the fitter when you are using a broad border; the second does best for a narrow one.

All borders should be made up of several members, even where they are narrow, or they will look bald and poor, and ruin the whole cloth. This is very important to remember.

The turning the corner of a border is a difficult business, and will try your designing skill rudely; but I advise you to face it, and not to stop your border at the corner by a rosette or what not. As a rule, you should make it run on, whereby you will at least earn the praise of trying to do your best.

As to the relative proportion of filling and border: if your filling be important in subject, and your cloth large, especially if it be long, your border is best to be narrow, but bright and

sparkling, harder and sharper than the filling, but smaller in its members; if, on the contrary, the filling be broken in colour and small in subject, then have a wide border, important in subject, clear and well defined in drawing, but by no means hard in relief.

Remember on this head, once more, that the bigger your cloth is the narrower in comparison should be your border; a wide border has a most curious tendency towards making the whole cloth look small.

So much very briefly about carpet-designing and weaving in general; and, once more, those of you who don't yet know what a pretty pattern is, and who don't care about a pattern, don't be dragooned by custom into having a pattern because it is a pattern, either on your carpets or your curtains, or even your waistcoats. That's the way that you, at present, can help the art of pattern-designing ...

Note

1 By this Morris means art with a narrative content.

ON WEAVING

From 'The Lesser Arts of Life', 1882

... The next craft I have to speak of is that of Weaving: not so much of an art as pottery and glass-making, because so much of it must be mechanical, engaged in the making of mere plain cloth; of which side of it all one need say is that we should have as little plain cloth made as we conveniently can, and for that reason should insist on having it made well and solidly, and of good materials; the other side of it, that which deals with figure-weaving, must be subdivided into figure-weaving which is carried out mechanically, and figure-weaving which is altogether a handicraft.

As to the first of these, its interest is limited by the fact that it is mechanical; since the manner of doing it has with some few exceptions varied little for many hundred years: such trivial alterations as the lifting the warp-threads by means of the Jacquard machine, or throwing the shuttle by steam-power, ought not to make much difference in the art of it, though I cannot say that they have not done so. On the other hand, though mechanical, it produces beautiful things, which an artist cannot disregard, and man's ingenuity and love of beauty may be made obvious enough in it; neither do I call the figure-weaver's craft a dull one, if he be set to do things which are worth doing: to watch the web growing day by day almost magically, in anticipation of the time when it is to be taken out and one can see it on the right side in all its well-schemed beauty; to make something beautiful that

will last, out of a few threads of silken wool, seems to me a not unpleasant way of earning one's livelihood so long only as one lives and works in a pleasant place, with the workday not too long, and a book or two to be got at.

However, since this is admittedly a mechanical craft, I have not much to say of it, for it is not my business this evening to speak of the designs for its fashioning; this much one may say, that as the designing of woven stuffs fell into degradation in the latter days, the designers got fidgeting after trivial novelties, change for the sake of change; they must needs strive to make their woven flowers look as if they were painted with a brush, or even sometimes as if they were drawn by the engraver's burin. This gave them plenty of trouble, and exercised their ingenuity in the tormenting of their web with spots and stripes and ribs and the rest of it, but quite destroyed the seriousness of the work, and even its *raison d'être*. As of pottery-painting, so of figure-weaving: do nothing in it but that which only weaving can do, and to this end make your design as elaborate as you please in silhouette, but carry it out simply; you are not drawing lines freely with your shuttle, you are building up a pattern with a fine rectilinear mosaic. If this is kept well in mind by the designer, and he does not try to force his material into no-thoroughfares, he may have abundant pleasure in the making of woven stuffs, and he is perhaps less likely to go wrong (if he has a feeling for colour) in this art than in any other. I will say further that he should be careful to get due proportion between his warp and weft: not to starve the first, which is the body of the web so to say, for the sake of the second, which is its clothes; this is done nowadays overmuch by ingenious designers who are trying to make their web look like non-mechanical stuffs, or who want to get a delusive show of solidity in a poor cloth, which is much to be avoided. A similar fault we are too likely to fall into is of a piece with what is done in all the lesser arts to-day, and which doubtless is much fostered by the ease given to our managers of

works by the over-development of machinery: I am thinking of the weaving up of rubbish into apparently delicate and dainty wares. No man with the true instinct of a workman should have anything to do with this: it may not mean commercial dishonesty, though I suspect it sometimes does, but it must mean artistic dishonesty: poor materials in this craft, as in all others, should only be used in coarse work, where they are used without pretence for what they are: this we must agree to at once, or sink all art in commerce (so called) in these crafts.

So much for mechanical figure-weaving. Its *raison d'être* is that it gives scope to the application of imagination and beauty to any cloth, thick or thin, close or open, costly or cheap. In some way or other you may weave any of these into figures; but when we may limit ourselves to certain heavy, close, and very costly cloths, we no longer need the help of anything that can fairly be called a machine: little more is needed than a frame which will support heavy beams on which we may strain our warp; our work is purely handwork, we may do what we will according to the fineness of our warp. These are the conditions of carpet and tapestry weaving, meaning by carpets the real thing, such as the East has furnished us with from time immemorial, and not the makeshift imitation woven by means of the Jacquard loom, or otherwise mechanically.

As to the art of carpet-weaving, then, one must say that historically it belongs to the East. I do not think it has been proved that any piled carpets were made in Europe during the Middle Ages proper, though some writers have thought that a fabric, called in edicts of the fourteenth century *tapisserie sarra-cenoise*, was in fact piled carpet-work: however, in the seventeenth century they certainly were being made to a certain extent even in these islands: amongst other examples I have seen some pieces of carpet-work in a Jacobean house in Oxfordshire, which an inventory of about 1620 calls, oddly enough, Irish stitch. But wherever the history of the art may begin among ourselves, I fear

it may almost be said to end with the seventeenth century; there are still a few places where hand-wrought carpets are made, but scarcely anything original is done; coarsely copied imitations of the Levantine carpets, and a sort of deduction from the degraded follies of the time of Louis the Fifteenth,[1] traditionally thought to be suitable for the dreary waste of an aristocratic country-house, are nearly all that is turned out at present. Still I do not agree with an opinion which I have heard expressed, that carpets can only be made in the East: such carpets as have been made there for the last hundred years or so, which are chiefly pieces of nearly formless colour, could not be made satisfactorily and spontaneously by Western art; but these carpets, delightful as they are, are themselves the products of a failing art: their prototypes are partly those simple but scientifically designed cloths whose patterns are founded on the elaborate pavement mosaics of Byzantine art; and partly they are degradations, traceable by close study, from the elaborate floral art of Persia. The originals of the first kind may be seen accurately figured in many of the pictures of the palmy days of Italian and Flemish art, and, as I have said, they are designed on scientific principles which any good designer can apply to works of our own day without burdening his conscience with the charge of plagiarism. As to the other kind of the Persian floral designs, there are still a few of these in existence, though, as I have never seen any of them figured in old pictures, I doubt if they found their way to Europe much in the Middle Ages. These, beautiful as they are in colour, are as far as possible from lacking form in design; they are fertile of imagination, and lovely in drawing; and though imitation of them would carry with it its usual disastrous consequences, they show us the way to set about designing such-like things, and that a carpet can be made which by no means depends for its success on the mere instinct for colour, which is the last gift of art to leave certain races. Withal, one thing seems certain, that if we don't set to work making our own carpets it will not be long

before we shall find the East fail us: for that last gift, the gift of the sense of harmonious colour, is speedily dying out in the East before the conquests of European rifles and money-bags.

As to the other manufacture of unmechanically woven cloth, the art of tapestry-weaving, it was, while it flourished, not only an art of Europe, but even of Northern Europe. Still more than carpet-weaving, it must be spoken of in the past tense. If you are curious on the subject of its technique you may see that going on as in its earlier, or let us say real, life at the Gobelins at Paris; but it is a melancholy sight: the workmen are as handy at it as only Frenchmen can be at such work, and their skill is traditional too, I have heard; for they are the sons, grandsons, and great-grandsons of tapestry-weavers. Well, their ingenuity is put to the greatest pains for the least results: it would be a mild word to say that what they make is worthless; it is more than that; it has a corrupting and deadening influence upon all the Lesser Arts of France, since it is always put forward as the very standard and crown of all that those arts can do at the best: a more idiotic waste of human labour and skill it is impossible to conceive. There is another branch of the same stupidity, differing slightly in technique, at Beauvais; and the little town of Aubusson in mid-France has a decaying commercial industry of the like rubbish. I am sorry to have to say that an attempt to set the art going which has been made, doubtless with the best intentions, under Royal patronage at Windsor, within the last few years, has most unluckily gone on the lines of the work at the Gobelins, and, if it does not change its system utterly, is doomed to artistic failure, whatever its commercial success may be.[2]

Well, this is all I have to say about the poor remains of the art of tapestry-weaving: and yet what a noble art it was once! To turn our chamber walls into the green woods of the leafy month of June, populous of bird and beast; or a summer garden with man and maid playing round a fountain, or a solemn procession of the mythical warriors and heroes of old; that surely was worth the

trouble of doing, and the money that had to be paid for it: that was no languid acquiescence in an upholsterer's fashion. How well I remember as a boy my first acquaintance with a room hung with faded greenery at Queen Elizabeth's Lodge, by Chingford Hatch, in Epping Forest (I wonder what has become of it now), and the impression of romance that it made upon me; a feeling that always comes back on me when I read, as I often do, Sir Walter Scott's Antiquary,[3] and come to the description of the green room at Monkbarns, amongst which the novelist has with such exquisite cunning of art imbedded the fresh and glittering verses of the summer poet Chaucer; yes, that was more than upholstery, believe me.

Nor must you forget that when the art was at its best, while on the one side it was almost a domestic art, and all sorts of naïve fancies were embodied in it, it took the place in Northern Europe of the fresco painting of Italy; among the existing easel pictures of the Flemish school of the fifteenth century there are no designs which are equal in conception and breadth of treatment to those which were worked out in tapestry, and I believe that some of the very best Northern artists spent the greater part of their time in designing for this art. Roger van der Weyden[4] of the Cologne school is named as having done much in this way: under the gallery of the great hall at Hampton Court hangs a piece which I suppose is by him, and which at any rate is, taking it altogether, the finest piece I have seen. There is quite a school of tapestry in the place, by the way; the withdrawing-room or solar at the end of the hall is hung with tapestries but little inferior to the first mentioned, and perhaps a little later, but unluckily, unlike it, much obscured by the dirt of centuries (they are not faded, only dirty), while the main walls of the great hall itself are hung with work of a later date, say about 1580. You may test your taste by comparing these later works (very fine of their kind) with the earlier, and seeing which you like best. I will not try to influence you on this matter, but will only say that

the borders of this later tapestry are admirably skilful pieces of execution.

Perhaps you will think I have said too much about an art that has practically perished; but as there is nothing whatever to prevent us from reviving it if we please, since the technique of it is easy to the last degree, so also it seems to me that in the better days of art the exaltation of certain parts of a craft into the region of the higher arts was both a necessary consequence of the excellence of the craft as a whole, and in return kept up that excellence to its due pitch by example. The magnificent woven pictures of the fifteenth and sixteenth centuries were the natural result of the pleasure and skill that were exercised in the art of weaving in every village and homestead, at the same time that they were an encouragement to the humbler brother of the craft to persevere in doing his best ...

Notes

1 Louis XV (1710–74). Morris despised the frivolities of the Rococo style of this period.

2 It was doomed to failure on both counts. The Royal Windsor Tapestry Manufactory was established in 1876 and closed, largely due to lack of demand for its products, in 1890. For further details, see Beryl Platt, 'A Brave Victorian Venture: The Royal Windsor Tapestry Manufactory', *Country Life*, 4299 (1970), pp. 2003-6.

3 *The Antiquary* (1816); the novels of Scott (1771–1832) were Morris's boyhood reading and remained favourites throughout his life.

4 Weyden, Roger van der, or Rogier de la Pasture (1399/1400–64), the major artist of mid-fifteenth-century Flanders.

ON COTTON PRINTING

From 'Some Hints on Pattern-designing', 1881

... As to the spirit of the designs for this craft, for some reason or other, I imagine because it is so decidedly an Eastern manufacture, it seems to call for specially fantastic forms. A pattern which would make a very good paper-hanging would often look dull and uninteresting as a chintz pattern. The naïvest of flowers with which you may do anything that is not ugly; birds and animals, no less naïve all made up of spots and stripes and flecks of broken colour, these seem the sort of thing we ask for. You cannot well go wrong so long as you avoid commonplace, and keep somewhat on the daylight side of nightmare. Only you must remember that, considering the price of the material it is done on, this craft is a specially troublesome one; so that in designing for it you must take special care that every fresh process you lay upon a poor filmy piece of cotton, worth fourpence or fivepence per yard, should really add beauty to it, and not be done for whim's sake. I really think you would be shocked if you knew how much trouble and anxiety can be thrown away on such trifles: what a stupendous weight of energy and the highest science have been brought to bear upon producing a pattern consisting of three black dots and a pink line, done in some special manner on a piece of cotton cloth ...

ON COTTON PRINTING

From 'The Lesser Arts of Life', 1882

... The art of dyeing leads me naturally to the humble but useful art of printing on cloth: really a very ancient art, since it is not essential to it that the pattern should be printed; it may be painted by hand. Now, the painting of cloth with real dyes was practised from the very earliest days in India; and, since the Egyptians of Pliny's time knew the art well, it is most probable that in that little-changing land it was very old also. Indeed many of the minute and elaborate patterns on the dresses of Egyptian imagery impress me strongly as representing what would naturally be the work of dye-painted linen. As to the craft among ourselves, it has, as a matter of course, suffered grievously from the degradation of dyeing, and this not only from the worsening of the tints both in beauty and durability, but from a more intricate cause. I have said that the older dyes were much more difficult to use than the modern ones. The processes for getting a many-coloured pattern on to a piece of cotton, even so short a while back as when I was a boy, were many and difficult. As a rule, this is done in fewer hours now than it was in days then. You may think this a desirable change, but, except on the score of cheapness, I can't agree with you. The natural and healthy diffi-culties of the old processes, all connected as they were with the endeavour to make the colour stable, drove any designer who had anything in him to making his pattern peculiarly suitable to the whole art, and gave a character to it, that character which you

so easily recognize in Indian palampores,[1] or in the faded curtains of our grandmothers' time, which still, in spite of many a summer's sun and many and many a strenuous washing, retain at least their reds and blues. In spite of the rudeness or the extravagance of these things, we are always attracted towards them, and the chief reason is, that we feel at once that there is something about the designs natural to the craft, that they can be done only by the practice of it, a quality which, I must once more repeat, is a necessity for all the designs of the lesser arts. But in the comparatively easy way in which these cloths are printed to-day, there are no special difficulties to stimulate the designer to invention; he can get any design done on his cloth; the printer will make no objections, so long as the pattern is the right size for his roller, and has only the due number of colours. The result of all this is ornament on the cotton, which might just as well have been printed or drawn on paper, and in spite of any grace or cleverness in the design, it is found to look poor and tame and wiry. That you will see clearly enough when some one has had a fancy to imitate some of the generous and fertile patterns that were once specially designed for the older cloths. It all comes to nothing; it is dull, hard, unsympathetic. No; there is nothing for it but the trouble and the simplicity of the earlier craft, if you are to have any beauty in cloth printing at all. And if not, why should we trouble to have a pattern of any sort on our cotton cloths? I for one am dead against it, unless the pattern is really beautiful; it is so very worthless if it is not ...

Note

1 Cotton print.

ON EMBROIDERY

From 'Some Hints on Pattern-designing', 1881

... As to embroidery-designing, it stands midway between that for tapestry and that for carpets; but as its technical limits are much less narrow than those of the latter craft, it is very apt to lead people into cheap and commonplace naturalism: now, indeed, it is a delightful idea to cover a piece of linen cloth with roses and jonquils and tulips, done quite natural with the needle, and we can't go too far in that direction if we only remember the needs of our material and the nature of our craft in general: these demand that our roses and the like, however unmistakably roses, shall be quaint and naïve to the last degree, and also, since we are using specially beautiful materials, that we shall make the most of them, and not forget that we are gardening with silk and gold-thread; and lastly, that in an art which may be accused by ill-natured persons of being a superfluity of life, we must be specially careful that it shall be beautiful, and not spare labour to make it sedulously elegant of form, and every part of it refined in line and colour ...

ON DRESS

From 'The Lesser Arts of Life', 1882

... The last of the Lesser Arts I have to speak of I come to with some trepidation; but it is so important to one half of the race of civilized mankind, the male half, that I will venture. Indeed I speak of the art of dress with the more terror because civilization has settled for us males that art shall have no place in our clothes, and that we must in this matter occupy the unamiable position of critics of our betters. Rebel as I am, I bow to that decision, though I find it difficult to admit that a chimney-pot hat or a tail-coat is the embodiment of wisdom in clothes-philosophy; and sometimes in my more sceptical moments I puzzle myself in thinking why, when I am indoors, I should wear two coats, one with a back and no front, and the other with a front and no back. However, I have not near enough courage even to suggest a rebellion against these stern sartorial laws; and after all one can slip into and out of the queer things with great ease, and that being the case, it is far more important to me what other people wear than what I wear: so that I ask leave to be an irresponsible critic for a few moments ...

... woman's dress is or may be on the whole graceful and sensible (please note that I say it maybe); for the most hopeful sign of the present period is its freedom: in the two previous periods there was no freedom ... but nowadays, and for years past, a lady may dress quite simply and beautifully, and yet not be noticed as

having anything peculiar or theatrical in her costume. Extravagances of fashion have not been lacking to us, but no one has been compelled to adopt them; every one might dress herself in the way which her own good sense told her suited her best. Now this, ladies, is the first and greatest necessity of rational and beautiful costume, that you should keep your liberty of choice; so I beg you to battle stoutly for it, or we shall all tumble into exploded follies again. Then next, your only chance of keeping that liberty is, to resist the imposition on costume of unnatural monstrosities. Garments should veil the human form, and neither caricature it, nor obliterate its lines: the body should be draped, and neither sewn up in a sack, nor stuck in the middle of a box: drapery, properly managed, is not a dead thing, but a living one, expressive of the endless beauty of motion; and if this be lost, half the pleasure of the eyes in common life is lost. You must specially bear this in mind, because the fashionable milliner has chiefly one end in view, how to hide and degrade the human body in the most expensive manner. She or he would see no beauty in the Venus of Milo; she or he looks upon you as scaffolds on which to hang a bundle of cheap rags, which can be sold dear under the name of a dress. Now, ladies, if you do not resist this to the bitter end, costume is ruined again, and all we males are rendered inexpressibly unhappy. So I beg of you fervently, do not allow yourselves to be upholstered like armchairs, but drape yourselves like women. Lastly, and this is really part of the same counsel, resist change for the sake of change; this is the very bane of all the arts. I say resist this stupidity, and the care of dress, duly subordinated to other duties, is a serious duty to you; but if you do not resist it, the care of dress becomes a frivolous waste of time. It follows, from the admission of this advice, that you should insist on having materials for your dresses that are excellent of their kind, and beautiful of their kind, and that when you have a dress of even moderately costly materials you won't be in a hurry to see the end of it ...

FURNISHING AND DECORATING A HOUSE

INTRODUCTION

My father's own rooms, sleeping room and study, were almost frugally bare; in the study no carpet and no curtains; his writing-table in earlier times a plain deal board and trestles, the wall nearly lined with books; just a fine inlaid Italian cabinet in one corner of the study ...

Above Father's rooms was the long drawing-room, which he turned into a haven of peace and sweet colour, breathing harmony and simplicity ... The walls of the room were furnished with the Bird hanging—a perfect blue with pale gleams of colour in the birds and foliage. A simple blue carpet was overlaid here and there with some flower-like Eastern rugs ... At the fire-side end of the room stood the Red House painted cabinet, a splendid central note and gathering-in of all colour in the room; on the open hearth was the massive pillared grate Mr. Webb had designed for Queen Square; and at right angles to the hearth the Red House settle caught the gleams of the fire on its tawny panels in the winter evenings, and in summer the dancing reflections of the river, while the lustre plates above the chimney-piece suggested flushed sunsets and dim moonlight nights beyond the elms. At the other end of the room one saw the discreet glimmer of old glass in closed cupboards sunk in the walls, and on a long narrow table lay a few pots and plates from the Far East. No picture of course —the simple scheme of the room did not allow of such broken wall-surface—no occasional tables, no chairs like feather-beds, no litter of any sort. Plenty of 'quarter-deck' to march up and down when discussons got animated and ideas needed exercise ...[1]

May Morris's vivid account of the furnishings of Kelmscott House to which the family moved in 1878 describes very much the kind of interior that Morris recommends in his lecture of 1880, 'Making the Best of It'. Simplicity is the key word for Morris:

> ... no room of the richest man should look grand enough to make a
> simple man shrink in it, or luxurious enough to make a thoughtful
> man feel ashamed in it; it will not do so if Art be at home there, for
> she has no foes so deadly as insolence and waste (p. 120).

In 'The Beauty of Life' Morris repeated his claim that 'the
greatest foe to art is luxury, art cannot live in its atmosphere'
(p. 122). There may seem to be a contradiction between theory
and practice here, for many of the products of the Firm, particu-
larly the later ones such as the tapestries and large hand-knotted
carpets, were extremely expensive and very rich in colour and
design. But for Morris there was a vital distinction between
beauty and luxury.

> This simplicity you may make as costly as you please ... you may hang
> your walls with tapestry instead of whitewash or paper; or you may
> cover them with mosaic, or have them frescoed by a great painter: all
> this is not luxury, if it be done for beauty's sake, and not for show ...

What Morris most disliked was the ostentation, the sham, and
the clutter of the average middle-class drawing room: 'I have
never been in any rich man's house which would not look the
better for having a bonfire made outside it of nine-tenths of all
that it held' (p. 181).

Equally, Morris was painfully aware that for many people
even the humblest art was far beyond their reach: 'the dreadful
contrast between waste and want ... is the great horror of civilized
countries' (p. 181). In his letter to Thomas Horsfall, he declares
that 'it is not possible at present for a man at 30/– a week (a father
of a family at any rate) to have any share in art' (p. 125) and goes
on to discuss what advice on furnishing a house can be given to
such a man. The problem of how popular art may be created in
an industrial society came increasingly to preoccupy him and
forms the subject of the final section of this book.

Notes

1 *The Introductions to the Collected Works of William Morris*, I, pp. 362-6.

MAKING THE BEST OF IT

1880

... Before we go inside our house, nay, before we look at its outside, we may consider its garden, chiefly with reference to town gardening; which, indeed, I, in common, I suppose, with most others who have tried it, have found uphill work enough— all the more as in our part of the world few indeed have any mercy upon the one thing necessary for decent life in a town, its trees; till we have come to this, that one trembles at the very sound of an axe as one sits at one's work at home. However, uphill work or not, the town garden must not be neglected if we are to be in earnest in making the best of it.

Now I am bound to say town gardeners generally do rather the reverse of that: our suburban gardeners in London, for instance, oftenest wind about their little bit of gravel walk and grass plot in ridiculous imitation of an ugly big garden of the landscape-gardening style, and then with a strange perversity fill up the spaces with the most formal plants they can get; whereas the merest common sense should have taught them to lay out their morsel of ground in the simplest way, to fence it as orderly as might be, one part from the other (if it be big enough for that) and the whole from the road, and then to fill up the flower-growing space with things that are free and interesting in their growth, leaving Nature to do the desired complexity, which she will certainly not fail to do if we do not desert her for the florist, who, I must say, has made it harder work than it should be to get the best of flowers.

It is scarcely a digression to note his way of dealing with flowers, which, moreover, gives us an apt illustration of that change without thought of beauty, change for the sake of change, which has played such a great part in the degradation of art in all times. So I ask you to note the way he has treated the rose, for instance: the rose has been grown double from I don't know when; the double rose was a gain to the world, a new beauty was given us by it, and nothing taken away since the wild rose grows in every hedge. Yet even then one might be excused for thinking that the wild rose was scarce improved on, for nothing can be more beautiful in general growth or in detail than a wayside bush of it, nor can any scent be as sweet and pure as its scent. Nevertheless the garden-rose had a new beauty of abundant form, while its leaves had not lost the wonderfully delicate texture of the wild one. The full colour it had gained, from the blush-rose to the damask, was pure and true amidst all its added force and though its scent had certainly lost some of the sweetness of the eglantine, it was fresh still, as well as so abundantly rich. Well, all that lasted till quite our own day, when the florists fell upon the rose—men who could never have enough—they strove for size and got it, a fine specimen of a florist's rose being about as big as a moderate Savoy cabbage. They tried for strong scent and got it—till a florist's rose has not unseldom a suspicion of the scent of the aforesaid cabbage—not at its best. They tried for strong colour and got it, strong and bad—like a conqueror. But all this while they missed the very essence of the rose's being; they thought there was nothing in it but redundance and luxury; they exaggerated these into coarseness, while they threw away the exquisite subtilty of form, delicacy of texture, and sweetness of colour, which, blent with the richness which the true garden-rose shares with many other flowers, yet makes it the queen of them all—the flower of flowers. Indeed, the worst of this is that these sham roses are driving the real ones out of existence. If we do not look to it our descendants will know nothing of the cabbage-rose, the loveliest

in form of all, or the blush-rose with its dark green stems and unequalled colour, or the yellow-centred rose of the East, which carries the richness of scent to the very furthest point it can go without losing freshness: they will know nothing of all these, and I fear they will reproach the poets of past time for having done according to their wont, and exaggerated grossly the beauties of the rose.

Well, as a Londoner perhaps I have said too much of roses, since we can scarcely grow them among suburban smoke, but what I have said of them applies to other flowers, of which I will say this much more. Be very shy of double flowers; choose the old columbine where the clustering doves are unmistakable and distinct, not the double one, where they run into mere tatters. Choose (if you can get it) the old china-aster with the yellow centre, that goes so well with the purple-brown stems and curiously coloured florets, instead of the lumps that look like cut paper, of which we are now so proud. Don't be swindled out of that wonder of beauty, a single snowdrop; there is no gain and plenty of loss in the double one. More loss still in the double sunflower, which is a coarse-coloured and dull plant, whereas the single one, though a late comer to our gardens, is by no means to be despised, since it will grow anywhere, and is both interesting and beautiful, with its sharply chiselled yellow florets relieved by the quaintly patterned sad-coloured centre clogged with honey and beset with bees and butterflies.

So much for over-artificiality in flowers. A word or two about the misplacing of them. Don't have ferns in your garden. The hart's tongue in the clefts of the rock, the queer things that grow within reach of the spray of the waterfall, these are right in their places. Still more the brake on the woodside, whether in late autumn, when its withered haulm helps out the well-remembered woodland scent, or in spring, when it is thrusting its volutes through last year's waste. But all this is nothing to a garden, and is not to be got out of it; and if you try it you will take away from it all possible romance, the romance of a garden.

The same thing may be said about many plants which are curiosities only, which Nature meant to be grotesque, not beautiful, and which are generally the growth of hot countries where things sprout over-quick and rank. Take note that the strangest of these come from the jungle and the tropical waste, from places where man is not at home, but is an intruder, an enemy. Go to a botanical garden and look at them, and think of those strange places to your heart's content. But don't set them to starve in your smoke-drenched scrap of ground amongst the bricks, for they will be no ornament to it.

As to colour in gardens. Flowers in masses are mighty strong colour, and if not used with a great deal of caution are very destructive to pleasure in gardening. On the whole, I think the best and safest plan is to mix up your flowers, and rather eschew great masses of colour—in combination I mean. But there are some flowers (inventions of men, *i.e.* florists) which are bad colour altogether, and not to be used at all. Scarlet geraniums, for instance, or the yellow calceolaria, which indeed are not uncommonly grown together profusely, in order, I suppose, to show that even flowers can be thoroughly ugly.

Another thing also much too commonly seen is an aberration of the human mind, which otherwise I should have been ashamed to warn you of. It is technically called carpet-gardening. Need I explain it further? I had rather not, for when I think of it even when I am quite alone I blush with shame at the thought.

I am afraid it is specially necessary in these days when making the best of it is a hard job, and when the ordinary iron hurdles are so common and so destructive of any kind of beauty in a garden, to say when you fence anything in a garden use a live hedge, or stones set flatwise (as they do in some parts of the Cotswold country), or timber, or wattle, or, in short, anything but iron.*

And now to sum up as to a garden. Large or small, it should look both orderly and rich. It should be well fenced from the outside world. It should by no means imitate either the

wilfulness or the wildness of Nature, but should look like a thing
never to be seen except near a house. It should, in fact, look like
a part of the house. It follows from this that no private pleasure-
garden should be very big, and a public garden should be divided
and made to look like so many flower-closes in a meadow, or a
wood, or amidst the pavement.

It will be a key to right thinking about gardens if you consider
in what kind of places a garden is most desired. In a very
beautiful country, especially if it be mountainous, we can do
without it well enough; whereas in a flat and dull country we
crave after it, and there it is often the very making of the
homestead. While in great towns, gardens, both private and
public, are positive necessities if the citizens are to live reasonable
and healthy lives in body and mind.

So much for the garden, of which, since I have said that it
ought to be part of the house, I hope I have not spoken too
much.

Now, as to the outside of our makeshift house, I fear it is too
ugly to keep us long. Let what painting you have to do about it
be as simple as possible, and be chiefly white or whitish; for
when a building is ugly in form it will bear no decoration, and to
mark its parts by varying colour will be the way to bring out its
ugliness. So I don't advise you to paint your houses blood-red
and chocolate with white facings, as seems to be getting the
fashion in some parts of London. You should, however, always
paint your sash-bars and window-frames white to break up the
dreary space of window somewhat. The only other thing I have
to say, is to warn you against using at all a hot brownish red,
which some decorators are very fond of. Till some one invents a
better name for it, let us call it cockroach colour, and have
nought to do with it.

So we have got to the inside of our house, and are in the
room we are to live in, call it by what name you will. As to its
proportions, it will be great luck indeed in an ordinary modern
house if they are tolerable; but let us hope for the best. If it is to

be well proportioned, one of its parts, either its height, length, or breadth, ought to exceed the others, or be marked somehow. If it be square or so nearly as to seem so, it should not be high; if it be long and narrow, it might be high without any harm, but yet would be more interesting low; whereas if it be an obvious but moderate oblong on plan, great height will be decidedly good.

As to the parts of a room that we have to think of, they are wall, ceiling, floor, windows and doors, fireplace, and movables. Of these the wall is of so much the most importance to a decorator and will lead us so far a-field, that I will mostly clear off the other parts first, as to the mere arrangement of them, asking you meanwhile to understand that the greater part of what I shall be saying as to the design of the patterns for the wall, I consider more or less applicable to patterns everywhere.

As to the windows then; I fear we must grumble again. In most decent houses, or what are so called, the windows are much too big, and let in a flood of light in a haphazard and ill-considered way, which the indwellers are forced to obscure again by shutters, blinds, curtains, screens, heavy upholsteries, and such other nuisances. The windows, also, are almost always brought too low down, and often so low down as to have their sills on a level with our ankles, sending thereby a raking light across the room that destroys all pleasantness of tone. The windows, moreover, are either big rectangular holes in the wall, or, which is worse, have ill-proportioned round or segmental heads, while the common custom in 'good' houses is either to fill these openings with one huge sheet of plate-glass, or to divide them across the middle with a thin bar. If we insist on glazing them thus, we may make up our minds that we have done the worst we can for our windows, nor can a room look tolerable where it is so treated. You may see how people feel this by their admiration of the tracery of a Gothic window, or the lattice-work of a Cairo house. Our makeshift substitute for those beauties must be the filling of the window with moderate-sized panes of glass (plate-glass if you will) set in solid sash-bars; we shall then

at all events feel as if we were indoors on a cold day—as if we had a roof over our heads.

As to the floor: a little time ago it was the universal custom for those who could afford it to cover it all up into its dustiest and crookedest corners with a carpet, good, bad, or indifferent. Now I daresay you have heard from others, whose subject is the health of houses rather than their art (if indeed the two subjects can be considered apart, as they cannot really be), you have heard from teachers like Dr. Richardson[1] what a nasty and unwholesome custom this is, so I will only say that it looks nasty and unwholesome. Happily, however, it is now a custom so much broken into that we may consider it doomed; for in all houses that pretend to any taste of arrangement, the carpet is now a rug, large it may be, but at any rate not looking immovable, and not being a trap for dust in the corners. Still I would go further than this even and get rich people no longer to look upon a carpet as a necessity for a room at all, at least in the summer. This would have two advantages: 1st, It would compel us to have better floors (and less drafty), our present ones being one of the chief disgraces to modern building; and 2ndly, since we should have less carpet to provide, what we did have we could afford to have better. We could have a few real works of art at the same price for which we now have hundreds of yards of makeshift machine-woven goods. In any case it is a great comfort to see the actual floor; and the said floor may be, as you know, made very ornamental by either wood mosaic, or tile and marble mosaic; the latter especially is such an easy art as far as mere technicality goes, and so full of resources, that I think it is a great pity it is not used more. The contrast between its grey tones and the rich positive colour of Eastern carpet-work is so beautiful, that the two together make satisfactory decoration for a room with little addition.

When wood mosaic or parquet-work is used, owing to the necessary simplicity of the forms, I think it best not to vary the colour of the wood. The variation caused by the diverse lie of the

grain and so forth, is enough. Most decorators will be willing, I believe, to accept it as an axiom, that when a pattern is made of very simple geometrical forms, strong contrast of colour is to be avoided.

So much for the floor. As for its fellow, the ceiling, that is, I must confess, a sore point with me in my attempts at making the best of it. The simplest and most natural way of decorating a ceiling is to show the underside of the joists and beams duly moulded, and if you will, painted in patterns. How far this is from being possible in our modern makeshift houses, I suppose I need not say. Then there is a natural and beautiful way of ornamenting a ceiling by working the plaster into delicate patterns, such as you see in our Elizabethan and Jacobean houses; which often enough, richly designed and skilfully wrought as they are, are by no means pedantically smooth in finish—nay, may sometimes be called rough as to workmanship. But, unhappily there are few of the lesser arts that have fallen so low as the plasterer's. The cast work one sees perpetually in pretentious rooms is a mere ghastly caricature of ornament, which no one is expected to look at if he can help it. It is simply meant to say, 'This house is built for a rich man.' The very material of it is all wrong, as, indeed, mostly happens with an art that has fallen sick. That richly designed, freely wrought plastering of our old houses was done with a slowly-drying tough plaster, that encouraged the hand like modeller's clay, and could not have been done at all with the brittle plaster used in ceilings nowadays, whose excellence is supposed to consist in its smoothness only. To be good, according to our present false standard, it must shine like a sheet of hot-pressed paper, so that, for the present, and without the expenditure of abundant time and trouble, this kind of ceiling decoration is not to be hoped for.

It may be suggested that we should paper our ceilings like our walls, but I can't think that it will do. Theoretically, a paper-hanging is so much distemper colour applied to a surface by being printed on paper instead of being painted on plaster by the

hand; but practically, we never forget that it is paper, and a room papered all over would be like a box to live in. Besides, the covering a room all over with cheap recurring patterns in an uninteresting material, is but a poor way out of our difficulty, and one which we should soon tire of.

There remains, then, nothing but to paint our ceilings cautiously and with as much refinement as we can, when we can afford it: though even that simple matter is complicated by the hideousness of the aforesaid plaster ornaments and cornices, which are so very bad that you must ignore them by leaving them unpainted, though even this neglect, while you paint the flat of the ceiling, makes them in a way part of the decoration, and so is apt to beat you out of every scheme of colour conceivable. Still, I see nothing for it but cautious painting, or leaving the blank white space alone, to be forgotten if possible. This painting, of course, assumes that you know better than to use gas in your rooms, which will indeed soon reduce all your decorations to a pretty general average.

So now we come to the walls of our room, the part which chiefly concerns us, since no one will admit the possibility of leaving them quite alone. And the first question is, how shall we space them out horizontally?

If the room be small and not high, or the wall be much broken by pictures and tall pieces of furniture, I would not divide it horizontally. One pattern of paper, or whatever it may be, or one tint may serve us, unless we have in hand an elaborate and architectural scheme of decoration, as in a makeshift house is not like to be the case; but if it be a goodsized room, and the wall be not much broken up, some horizontal division is good, even if the room be not very high.

How are we to divide it then? I need scarcely say not into two equal parts; no one out of the island of Laputa[2] could do that. For the rest, unless again we have a very elaborate scheme of decoration, I think dividing it once, making it into two spaces, is enough. Now there are practically two ways of doing that: you

may either have a narrow frieze below the cornice, and hang the wall thence to the floor, or you may have a moderate dado, say 4 feet 6 inches high, and hang the wall from the cornice to the top of the dado. Either way is good according to circumstances; the first with the tall hanging and the narrow frieze is fittest if your wall is to be covered with stuffs, tapestry, or panelling, in which case making the frieze a piece of delicate painting is desirable in default of such plaster-work as I have spoken of above; or even if the proportions of the room very much cry out for it, you may, in default of hand-painting, use a strip of printed paper, though this, I must say, is a makeshift of makeshifts. The division into dado and wall hung from thence to the cornice, is fittest for a wall which is to be covered with painted decoration, or its makeshift, paper-hangings.

As to these, I would earnestly dissuade you from using more than one pattern in one room, unless one of them be but a breaking of the surface with a pattern so insignificant as scarce to be noticeable. I have seen a good deal of the practice of putting pattern over pattern in paper-hangings, and it seems to me a very unsatisfactory one, and I am, in short, convinced, as I hinted just now, that cheap recurring patterns in a material which has no play of light in it, and no special beauty of its own, should be employed rather sparingly, or they destroy all refinement of decoration and blunt our enjoyment of whatever beauty may lie in the designs of such things.

Before I leave this subject of the spacing out of the wall for decoration, I should say that in dealing with a very high room it is best to put nothing that attracts the eye above a level of about eight feet from the floor—to let everything above that be mere air and space, as it were. I think you will find that this will tend to take off that look of dreariness that often besets tall rooms.

So much then for the spacing out of our wall. We have now to consider what the covering of it is to be, which subject, before we have done with it, will take us over a great deal of ground and

lead us into the consideration of designing for flat spaces in
general with work other than picture-work.

To clear the way, I have a word or two to say about the
treatment of the wood-work in our room. If I could I would have
no woodwork in it that needed flat painting, meaning by that
word a mere paying it over with four coats of tinted lead-pigment
ground in oils or varnish, but unless one can have a noble wood,
such as oak, I don't see what else is to be done. I have never seen
deal stained transparently with success, and its natural colour is
poor, and will not enter into any scheme of decoration, while
polishing it makes it worse. In short, it is such a poor material
that it must be hidden unless it be used on a big scale as mere
timber. Even then, in a church roof or what not, colouring it
with distemper will not hurt it, and in a room I should certainly
do this to the woodwork of roof and ceiling, while I painted such
woodwork as came within touch of hand. As to the colour of
this, it should, as a rule, be of the same general tone as the walls,
but a shade or two darker in tint. Very dark woodwork makes a
room dreary and disagreeable, while unless the decoration be in
a very bright key of colour, it does not do to have the woodwork
lighter than the walls. For the rest, if you are lucky enough to be
able to use oak, and plenty of it, found your decoration on that,
leaving it just as it comes from the plane.

Now, as you are not bound to use anything for the decoration
of your walls but simple tints, I will here say a few words on the
main colours, before I go on to what is more properly decoration,
only in speaking of them one can scarce think only of such tints
as are fit to colour a wall with, of which, to say truth, there are
not many.

Though we may each have our special preferences among the
main colours, which we shall do quite right to indulge, it is a sign
of disease in an artist to have a prejudice against any particular
colour, though such prejudices are common and violent enough
among people imperfectly educated in art, or with naturally dull
perceptions of it. Still, colours have their ways in decoration, so

to say, both positively in themselves, and relatively to each man's way of using them. So I may be excused for setting down some things I seem to have noticed about these ways.

Yellow is not a colour that can be used in masses unless it be much broken or mingled with other colours, and even then it wants some material to help it out which has great play of light and shade in it. You know people are always calling yellow things golden, even when they are not at all the colour of gold, which, even unalloyed, is not a bright yellow. That shows that delightful yellows are not very positive, and that, as aforesaid, they need gleaming materials to help them. The light bright yellows, like jonquil and primrose, are scarcely usable in art, save in silk, whose gleam takes colour from and adds light to the local tint, just as sunlight does to the yellow blossoms which are so common in Nature. In dead materials, such as distemper colour, a positive yellow can only be used sparingly in combination with other tints.

Red is also a difficult colour to use, unless it be helped by some beauty of material, for, whether it tend toward yellow and be called scarlet, or towards blue and be crimson, there is but little pleasure in it, unless it be deep and full. If the scarlet pass a certain degree of impurity it falls into a hot brown-red, very disagreeable in large masses. If the crimson be much reduced it tends towards a cold colour called in these latter days magenta, impossible for an artist to use either by itself or in combination. The finest tint of red is a central one between crimson and scarlet, and is a very powerful colour indeed, but scarce to be got in a flat tint. A crimson broken by greyish-brown and tending towards russet is also a very useful colour, but, like all the finest reds, is rather a dyer's colour than a house-painter's; the world being very rich in soluble reds, which of course are not the most enduring of pigments, though very fast as soluble colours.

Pink, though one of the most beautiful colours in combination, is not easy to use as a flat tint even over moderate spaces;

the more orangy shades of it are the most useful, a cold pink being a colour much to be avoided.

As to purple, no one in his senses would think of using it bright in masses. In combination it may be used somewhat bright, if it be warm and tend towards red; but the best and most characteristic shade of purple is nowise bright, but tends towards russet. Egyptian porphyry, especially when contrasted with orange, as in the pavement of St. Mark's at Venice, will represent the colour for you. At the British Museum, and one or two other famous libraries, are still left specimens of this tint, as Byzantine art in its palmy days understood it. These are books written with gold and silver on vellum stained purple, probably with the now lost murex or fish-dye of the ancients, the tint of which dye-stuff Pliny describes minutely and accurately in his 'Natural History.' I need scarcely say that no ordinary flat tint could reproduce this most splendid of colours.

Though green (at all events in England) is the colour widest used by Nature, yet there is not so much bright green used by her as many people seem to think; the most of it being used for a week or two in spring, when the leafage is small, and blended with the greys and other negative colours of the twigs; when 'leaves grow large and long,' as the ballad has it, they also grow grey. I believe it has been noted by Mr. Ruskin, and it certainly seems true, that the pleasure we take in the young spring foliage comes largely from its tenderness of tone rather than its brightness of hue. Anyhow, you may be sure that if we try to outdo Nature's green tints on our walls we shall fail, and make ourselves uncomfortable to boot. We must, in short, be very careful of bright greens, and seldom, if ever, use them at once bright and strong.

On the other hand, do not fall into the trap of a dingy bilious-looking yellow-green, a colour to which I have a special and personal hatred, because (if you will excuse my mentioning personal matters) I have been supposed to have somewhat

brought it into vogue. I assure you I am not really responsible for it.

The truth is, that to get a green that is at once pure and neither cold nor rank, and not too bright to live with, is, of simple things, as difficult as anything a decorator has to do; but it can be done, and without the help of special material; and when done such a green is so useful, and so restful to the eyes, that in this matter also we are bound to follow Nature and make large use of that work-a-day colour green.

But if green be called a work-a-day colour, surely blue must be called the holiday one, and those who long most for bright colours may please themselves most with it; for if you duly guard against getting it cold if it tend towards red, or rank if it tend towards green, you need not be much afraid of its brightness. Now, as red is above all a dyer's colour, so blue is especially a pigment and an enamel colour; the world is rich in insoluble blues, many of which are practically indestructible.

I have said that there are not many tints fit to colour a wall with: this is my list of them as far as I know; a solid red, not very deep, but rather describable as a full pink, and toned both with yellow and blue, a very fine colour if you can hit it. A light orangy pink, to be used rather sparingly. A pale golden tint, *i.e.*, a yellowish-brown; a very difficult colour to hit. A colour between these two last; call it pale copper colour. All these three you must be careful over, for if you get them muddy or dirty you are lost.

Tints of green from pure and pale to deepish and grey: always remembering that the purer the paler, and the deeper the greyer.

Tints of pure pale blue from a greenish one, the colour of a starling's egg, to a grey ultramarine colour, hard to use because so full of colour, but incomparable when right. In these you must carefully avoid the point at which the green overcomes the blue and turns it rank, or that at which the red overcomes the blue and produces those woeful hues of pale lavender and starch blue which have not seldom been favourites with decorators of elegant drawing-rooms and respectable dining-rooms.

You will understand that I am here speaking of distemper tinting, and in that material these are all the tints I can think of; if you use bolder, deeper or stronger colours I think you will find yourself beaten out of monochrome in order to get your colour harmonious.

One last word as to distemper which is not monochrome, and its makeshift, paper-hanging. I think it is always best not to force the colour, but to be content with getting it either quite light or quite grey in these materials, and in no case very dark, trusting for richness to stuffs, or to painting which allows of gilding being introduced.

I must finish these crude notes about general colour by reminding you that you must be moderate with your colour on the walls of an ordinary dwelling-room; according to the material you are using, you may go along the scale from light and bright to deep and rich, but some soberness of tone is absolutely necessary if you would not weary people till they cry out against all decoration. But I suppose this is a caution which only very young decorators are likely to need. It is the right-hand defection; the left-hand falling away is to get your colour dingy and muddy, a worse fault than the other because less likely to be curable. All right-minded craftsmen who work in colour will strive to make their work as bright as possible, as full of colour as the nature of the work will allow it to be. The meaning they may be bound to express, the nature of its material, or the use it may be put to, may limit this fulness; but in whatever key of colour they are working, if they do not succeed in getting the colour pure and clear, they have not learned their craft, and if they do not see their fault when it is present in their work, they are not likely to learn it.

Now, hitherto we have not got further into the matter of decoration than to talk of its arrangement. Before I speak of some general matters connected with our subject, I must say a little on the design of the patterns which will form the chief part of your decoration. The subject is a wide and difficult one, and my time

much too short to do it any justice, but here and there, perhaps, a hint may crop up, and I may put it in a way somewhat new.

On the whole, in speaking of these patterns I shall be thinking of those that necessarily recur; designs which have to be carried out by more or less mechanical appliances, such as the printing-block or the loom.

Since we have been considering colour lately, we had better take that side first, though I know it will be difficult to separate the consideration of it from that of the other necessary qualifications of design.

The first step away from monochrome is breaking the ground by putting a pattern on it of the same colour, but of a lighter or darker shade, the first being the best and most natural way. I need say but little on this as a matter of colour though many very important designs are so treated. One thing I have noticed about these damasks, as I should call them: that of the three chief colours, red is the one where the two shades must be the nearest to one another, or you get the effect poor and weak; while in blue you may have a great deal of difference without losing colour, and green holds a middle place between the two.

Next, if you make these two shades different in tint as well as, or instead of, in depth, you have fairly got out of monochrome, and will find plenty of difficulties in getting your two tints to go well together. The putting, for instance, of a light greenish blue on a deep reddish one, turquoise on sapphire, will try all your skill. The Persians practise this feat, but not often without adding a third colour, and so getting into the next stage. In fact, this plan of relieving the pattern by shifting its tint as well as its depth, is chiefly of use in dealing with quite low-toned colours—golden browns or greys, for instance. In dealing with the more forcible ones, you will find it in general necessary to add a third colour at least, and so get into the next stage.

This is the relieving a pattern of more than one colour, but all the colours light, upon a dark ground. This is above all useful in cases where your palette is somewhat limited; say, for instance, in

a figured cloth which has to be woven mechanically, and where you have but three or four colours in a line, including the ground.

You will not find this a difficult way of relieving your pattern, if you only are not too ambitious of getting the diverse super-imposed colours too forcible on the one hand, so that they fly out from one another, or on the other hand too delicate, so that they run together into confusion. The excellence of this sort of work lies in a clear but soft relief of the form, in colours each beautiful in itself, and harmonious one with the other on ground whose colour is also beautiful, though unobtrusive. Hardness ruins the work, confusion of form caused by timidity of colour annoys the eye, and makes it restless, and lack of colour is felt as destroying the *raison d'être* of it. So you see it taxes the designer heavily enough after all. Nevertheless I still call it the easiest way of complete pattern-designing.

I have spoken of it as the placing of a light pattern on a dark ground. I should mention that in the fully developed form of the design I am thinking of there is often an impression given, of there being more than one plane in the pattern. Where the pattern is strictly on one plane, we have not reached the full development of this manner of designing, the full development of colour and form used together, but form predominant.

We are not left without examples of this kind of design at its best. The looms of Corinth, Palermo, and Lucca, in the twelfth, thirteenth, and fourteenth centuries, turned out figured silk cloths, which were so widely sought for, that you may see specimens of their work figured on fifteenth-century screens in East Anglian churches, or the background of pictures by the Van Eycks, while one of the most important collections of the actual goods is preserved in the treasury of the Mary Church at Dantzig; the South Kensington Museum has also a very fine collection of these, which I can't help thinking are not quite as visible to the public as they should be. They are, however, discoverable by the help of Dr. Rock's excellent catalogue

published by the department, and I hope will, as the Museum gains space, be more easy to see.

Now to sum up: This method of pattern-designing must be considered the Western and civilized method: that used by craftsmen who were always seeing pictures, and whose minds were full of definite ideas of form. Colour was essential to their work, and they loved it and understood it, but always subordinated it to form.

There is next the method of relief by placing a dark figure on a light ground. Sometimes this method is but the converse of the last, and is not so useful, because it is capable of less variety and play of colour and tone. Sometimes it must be looked on as a transition from the last-mentioned method to the next of colour laid by colour. Thus used there is something incomplete about it. One finds oneself longing for more colours than one's shuttles or blocks allow one. There is a need felt for the speciality of the next method, where the dividing line is used, and it gradually gets drawn into that method. Which, indeed, is the last I have to speak to you of, and in which colour is laid by colour.

In this method it is necessary that the diverse colours should be separated each by a line of another colour, and that not merely to mark the form, but to complete the colour itself; which outlining, while it serves the purpose of gradation, which in more naturalistic work is got by shading, makes the design quite flat, and takes from it any idea of there being more than one plane in it.

This way of treating pattern-design is so much more difficult than the others, as to be almost an art by itself, and to demand a study apart. As the method of relief by laying light upon dark may be called the Western way of treatment and the civilized, so this is the Eastern, and, to a certain extent, the uncivilized.

But it has a wide range, from works where the form is of little importance and only exists to make boundaries for colour, to those in which the form is so studied, so elaborate, and so lovely, that it is hardly true to say that the form is subordinate to the

colour; while, on the other hand, so much delight is taken in the colour, it is so inventive and so unerringly harmonious, that it is scarcely possible to think of the form without it—the two inter-penetrate.

Such things as these, which, as far as I know, are only found in Persian art at its best, do carry the art of mere pattern-designing to its utmost perfection, and it seems somewhat hard to call such an art uncivilized. But, you see, its whole soul was given up to producing matters of subsidiary art, as people call it; its carpets were of more importance than its pictures; nay, properly speaking, they were its pictures. And it may be that such an art never has a future of change before it, save the change of death, which has now certainly come over that Eastern art; while the more impatient, more aspiring, less sensuous art which belongs to Western civilization may bear many a change and not die utterly; nay, may feed on its intellect alone for a season, and enduring the martyrdom of a grim time of ugliness, may live on, rebuking at once the narrow-minded pedant of science, and the luxurious tyrant of plutocracy, till change bring back the spring again, and it blossoms once more into pleasure. May it be so!

Meanwhile, we may say for certain that colour for colour's sake only will never take real hold on the art of our civilization, not even in its subsidiary art. Imitation and affectation may deceive people into thinking that such an instinct is quickening amongst us, but the deception will not last. To have a meaning and to make others feel and understand it, must ever be the aim and end of our Western art.

Before I leave this subject of the colouring of patterns, I must warn you against the abuse of the dotting, hatching, and lining of backgrounds, and other mechanical contrivances for breaking them; such practices are too often the resource to which want of invention is driven, and unless used with great caution they vulgarize a pattern completely. Compare, for instance, those Sicilian and other silk cloths I have mentioned with the brocades (common everywhere) turned out from the looms of Lyons,

Venice, and Genoa, at the end of the seventeenth and beginning of the eighteenth centuries. The first perfectly simple in manufacture, trusting wholly to beauty of design, and the play of light on the naturally woven surface, while the latter eke out their gaudy feebleness with spots and ribs and long floats, and all kinds of meaningless tormenting of the web, till there is nothing to be learned from them save a warning.

So much for the colour of pattern-designing. Now, for a space, let us consider some other things that are necessary to it, and which I am driven to call its moral qualities, and which are finally reducible to two—order and meaning.

Without order your work cannot even exist; without meaning, it were better not to exist.

Now order imposes on us certain limitations, which partly spring from the nature of the art itself, and partly from the materials in which we have to work; and it is a sign of mere incompetence in either a school or an individual to refuse to accept such limitations, or even not to accept them joyfully and turn them to special account, much as if a poet should complain of having to write in measure and rhyme.

Now, in our craft the chief of the limitations that spring from the essence of the art is that the decorator's art cannot be imitative even to the limited extent that the picture-painter's art is.

This you have been told hundreds of times, and in theory it is accepted everywhere, so I need not say much about it—chiefly this, that it does not excuse want of observation of nature, or laziness of drawing, as some people seem to think. On the contrary, unless you know plenty about the natural form that you are conventionalizing, you will not only find it impossible to give people a satisfactory impression of what is in your own mind about it, but you will also be so hampered by your ignorance, that you will not be able to make your conventionalized form ornamental. It will not fill a space properly, or look crisp and sharp, or fulfil any purpose you may strive to put it to.

It follows from this that your convention must be your own, and not borrowed from other times and peoples; or, at the least, that you must make it your own by thoroughly understanding both the nature and the art you are dealing with. If you do not heed this, I do not know but what you may not as well turn to and draw laborious portraits of natural forms of flower and bird and beast, and stick them on your walls anyhow. It is true you will not get ornament so, but you may learn something for your trouble; whereas, using an obviously true principle as a stalking-horse for laziness of purpose and lack of invention, will but injure art all round, and blind people to the truth of that very principle.

Limitations also, both as to imitation and exuberance, are imposed on us by the office our pattern has to fulfil. A small and often-recurring pattern of a subordinate kind will bear much less naturalism than one in a freer space and more important position, and the more obvious the geometrical structure of a pattern is, the less its parts should tend toward naturalism. This has been well understood from the earliest days of art to the very latest times during which pattern-designing has clung to any wholesome tradition, but is pretty generally unheeded at present.

As to the limitations that arise from the material we may be working in, we must remember that all material offers certain difficulties to be overcome, and certain facilities to be made the most of. Up to a certain point you must be the master of your material, but you must never be so much the master as to turn it surly, so to say. You must not make it your slave, or presently you will be a slave also. You must master it so far as to make it express a meaning, and to serve your aim at beauty. You may go beyond that necessary point for your own pleasure and amusement, and still be in the right way; but if you go on after that merely to make people stare at your dexterity in dealing with a difficult thing, you have forgotten art along with the rights of your material, and you will make not a work of art, but a mere toy; you are no longer an artist, but a juggler. The history of the arts

gives us abundant examples and warnings in this matter. First clear steady principle, then playing with the danger, and lastly falling into the snare, mark with the utmost distinctness the times of the health, the decline, and the last sickness of art.

Allow me to give you one example in the noble art of mosaic. The difficulty in it necessary to be overcome was the making of a pure and true flexible line, not over thick, with little bits of glass or marble nearly rectangular. Its glory lay in its durability, the lovely colour to be got in it, the play of light on its facetted and gleaming surface, and the clearness mingled with softness, with which forms were relieved on the lustrous gold which was so freely used in its best days. Moreover, however bright were the colours used, they were toned delightfully by the greyness which the innumerable joints between the tesserae spread over the whole surface.

Now the difficulty of the art was overcome in its earliest and best days, and no care or pains were spared in making the most of its special qualities, while for long and long no force was put upon the material to make it imitate the qualities of brush-painting, either in power of colour, in delicacy of gradation, or intricacy of treating a subject; and, moreover, easy as it would have been to minimize the jointing of the tesserae, no attempt was made at it.

But as time went on, men began to tire of the solemn simplicity of the art, and began to aim at making it keep pace with the growing complexity of picture painting, and, though still beautiful, it lost colour without gaining form. From that point (say about 1460), it went on from bad to worse, till at last men were set to work in it merely because it was an intractable material in which to imitate oil-painting, and by this time it was fallen from being a master art, the crowning beauty of the most solemn buildings, to being a mere tax on the craftsmen's patience, and a toy for people who no longer cared for art. And just such a history may be told of every art that deals with special material.

Under this head of order should be included something about the structure of patterns, but time for dealing with such an intricate question obviously fails me; so I will but note that, whereas it has been said that a recurring pattern should be constructed on a geometrical basis, it is clear that it cannot be constructed otherwise; only the structure may be more or less masked, and some designers take a great deal of pains to do so.

I cannot say that I think this always necessary. It may be so when the pattern is on a very small scale, and meant to attract but little attention. But it is sometimes the reverse of desirable in large and important patterns, and, to my mind, all noble patterns should at least *look* large. Some of the finest and pleasantest of these show their geometrical structure clearly enough; and if the lines of them grow strongly and flow gracefully, I think they are decidedly helped by their structure not being elaborately concealed.

At the same time in all patterns which are meant to fill the eye and satisfy the mind, there should be a certain mystery. We should not be able to read the whole thing at once, nor desire to do so, nor be impelled by that desire to go on tracing line after line to find out how the pattern is made, and I think that the obvious presence of a geometrical order, if it be, as it should be, beautiful, tends towards this end, and prevents our feeling restless over a pattern.

That every line in a pattern should have its due growth, and be traceable to its beginning, this, which you have doubtless heard before, is undoubtedly essential to the finest pattern-work; equally so is it that no stem should be so far from its parent stock as to look weak or wavering. Mutual support and unceasing progress distinguish real and natural order from its mockery, pedantic tyranny.

Every one who has practised the designing of patterns knows the necessity for covering the ground equably and richly. This is really to a great extent the secret of obtaining the look of

satisfying mystery aforesaid, and it is the very test of capacity in a designer.

Finally, no amount of delicacy is too great in drawing the curves of a pattern, no amount of care in getting the leading lines right from the first can be thrown away, for beauty of detail cannot afterwards cure any shortcoming in this. Remember that a pattern is either right or wrong. It cannot be forgiven for blundering, as a picture may be which has otherwise great qualities in it. It is with a pattern as with a fortress, it is no stronger than its weakest point. A failure for ever recurring torments the eye too much to allow the mind to take any pleasure in suggestion and intention.

As to the second moral quality of design—meaning, I include in that the invention and imagination which forms the soul of this art, as of all others, and which, when submitted to the bonds of order, has a body and a visible existence.

Now you may well think that there is less to be said of this than the other quality; for form may be taught, but the spirit that breathes through it cannot be. So I will content myself with saying this on these qualities, that though a designer may put all manner of strangeness and surprise into his patterns, he must not do so at the expense of beauty. You will never find a case in this kind of work where ugliness and violence are not the result of barrenness, and not of fertility of invention. The fertile man, he of resource, has not to worry himself about invention. He need but think of beauty and simplicity of expression; his work will grow on and on, one thing leading to another, as it fares with a beautiful tree. Whereas the laborious paste-and-scissors man goes hunting up and down for oddities, sticks one in here and another there, and tries to connect them with commonplace; and when it is all done, the oddities are not more inventive than the commonplace, nor the commonplace more graceful than the oddities.

No pattern should be without some sort of meaning. True it is that that meaning may have come down to us traditionally, and

not be our own invention, yet we must at heart understand it, or we can neither receive it, nor hand it down to our successors. It is no longer tradition if it is servilely copied, without change, the token of life. You may be sure that the softest and loveliest of patterns will weary the steadiest admirers of their school as soon as they see that here is no hope of growth in them. For you know all art is compact of effort, of failure and of hope, and we cannot but think that somewhere perfection lies ahead, as we look anxiously for the better thing that is to come from the good.

Furthermore, you must not only mean something in your patterns, but must also be able to make others understand that meaning. They say that the difference between a genius and a madman is that the genius can get one or two people to believe in him, whereas the madman, poor fellow, has himself only for his audience. Now the only way in our craft of design for compelling people to understand you is to follow hard on Nature; for what else can you refer people to, or what else is there which everybody can understand?—everybody that it is worth addressing yourself to, which includes all people who can feel and think.

Now let us end the talk about those qualities of invention and imagination with a word of memory and of thanks to the designers of time past. Surely he who runs may read them abundantly set forth in those lesser arts they practised. Surely it had been pity indeed, if so much of this had been lost as would have been if it had been crushed out by the pride of intellect, that will not stoop to look at beauty unless its own kings and great men have had a hand in it. Belike the thoughts of the men who wrought this kind of art could not have been expressed in grander ways or more definitely, or, at least, would not have been; therefore I believe I am not thinking only of my own pleasure, but of the pleasure of many people, when I praise the usefulness of the lives of these men, whose names are long forgotten, but whose works we still wonder at. In their own way they meant to tell us how the flowers grew in the gardens of

Damascus, or how the hunt was up on the plains of Kirman, or how the tulips shone among the grass in the mid-Persian valley, and how their souls delighted in it all, and what joy they had in life; nor did they fail to make their meaning clear to some of us.

But, indeed, they and other matters have led us afar from our makeshift house, and the room we have to decorate therein. And there is still left the fireplace to consider.

Now I think there is nothing about a house in which a contrast is greater between old and new than this piece of architecture. The old, either delightful in its comfortable simplicity, or decorated with the noblest and most meaning art in the place; the modern, mean, miserable, uncomfortable, and showy, plastered about with wretched sham ornament, trumpery of cast-iron, and brass and polished steel, and what not—offensive to look at, and a nuisance to clean—and the whole thing huddled up with rubbish of ash-pan, and fender, and rug, till surely the hearths which we have been bidden so often to defend (whether there was a chance of their being attacked or not) have now become a mere figure of speech the meaning of which in a short time it will be impossible for learned philologists to find out.

I do most seriously advise you to get rid of all this, or as much of it as you can without absolute ruin to your prospects in life; and even if you do not know how to decorate it, at least have a hole in the wall of a convenient shape, faced with such bricks or tiles as will at once bear fire and clean; then some sort of iron basket in it, and out from that a real hearth of cleanable brick or tile, which will not make you blush when you look at it, and as little in the way of guard and fender as you think will be safe; that will do to begin with. For the rest, if you have wooden work about the fireplace, which is often good to have, don't mix up the wood and the tiles together; let the wood-work look like part of the wall-covering, and the tiles like part of the chimney.

As for movable furniture, even if time did not fail us, 'tis a large subject—or a very small one—so I will but say, don't have too much of it; have none for mere finery's sake, or to satisfy the

claims of custom—these are flat truisms, are they not? But really it seems as if some people had never thought of them, for 'tis almost the universal custom to stuff up some rooms so that you can scarcely move in them, and to leave others deadly bare; whereas all rooms ought to look as if they were lived in, and to have, so to say, a friendly welcome ready for the incomer.

A dining-room ought not to look as if one went into it as one goes into a dentist's parlour—for an operation, and came out of it when the operation was over—the tooth out, or the dinner in. A drawing-room ought to look as if some kind of work could be done in it less toilsome than being bored. A library certainly ought to have books in it, not boots only, as in Thackeray's country snob's house,[3] but so ought each and every room in the house more or less; also, though all rooms should look tidy, and even very tidy, they ought not to look too tidy.

Furthermore, no room of the richest man should look grand enough to make a simple man shrink in it, or luxurious enough to make a thoughtful man feel ashamed in it; it will not do so if Art be at home there, for she has no foes so deadly as insolence and waste. Indeed, I fear that at present the decoration of rich men's houses is mostly wrought out at the bidding of grandeur and luxury, and that art has been mostly cowed or shamed out of them; nor when I come to think of it will I lament it overmuch. Art was not born in the palace; rather she fell sick there, and it will take more bracing air than that of rich men's houses to heal her again. If she is ever to be strong enough to help mankind once more, she must gather strength in simple places; the refuge from wind and weather to which the goodman comes home from field or hill-side; the well-tidied space into which the craftsman draws from the litter of loom, and smithy, and bench; the scholar's island in the sea of books; the artist's clearing in the canvas-grove: it is from these places that Art must come if she is ever again to be enthroned in that other kind of building, which I think, under some name or other, whether you call it Church or Hall of Reason, or what not, will always be needed; the

building in which people meet to forget their own transient personal and family troubles in aspirations for their fellows and the days to come, and which to a certain extent make up to town-dwellers for their loss of field, and river, and mountain ...

* I know that well-designed hammered iron trellises and gates have been used happily enough, though chiefly in rather grandiose gardens, and so they might be again—one of these days—but I fear not yet awhile.

Notes

1 Benjamin Ward Richardson (1828–96), an eminent sanitary reformer with a particular interest in domestic hygiene. He was the founder and editor of the *Sanitary Review and Journal of Public Health* and author of such works as *Diseases of Modern Life* (1876) and *Health and Life* (1878).

2 An imaginary flying island in Swift's *Gulliver's Travels*, the inhabitants of which engage in ridiculous projects and pseudo-scientific experiments.

3 William Makepeace Thackeray (1811–63) published *The Snobs of England* (later published as *The Book of Snobs*), satires on social pretentiousness, in *Punch* in 1847.

ON SIMPLICITY

From 'The Beauty of Life', 1880

... [H]ow are we to pay for decent houses?

It seems to me that by a great piece of good luck the way to pay for them, is by doing that which alone can produce popular art among us: living a simple life, I mean. Once more I say that the greatest foe to art is luxury, art cannot live in its atmosphere.

When you hear of the luxuries of the ancients, you must remember that they were not like our luxuries, they were rather indulgence in pieces of extravagant folly than what we to-day call luxury; which perhaps you would rather call comfort: well, I accept the word, and say that a Greek or Roman of the luxurious time would stare astonished could he be brought back again, and shown the comforts of a well-to-do middle-class house.

But some, I know, think that the attainment of these very comforts is what makes the difference between civilisation and uncivilisation. Is it so indeed? Farewell my hope then!—I had thought that civilisation meant the attainment of peace and order and freedom, of goodwill between man and man, of the love of truth, and the hatred of injustice, and by consequence the attainment of the good life which these things breed, a life free from craven fear, but full of incident: that was what I thought it meant, not more stuffed chairs and more cushions, and more carpets and gas, and more dainty meat and drink—and therewithal more and sharper differences between class and class.

If that be what it is, I for my part wish I were well out of it,

and living in a tent in the Persian desert, or a turf hut on the Iceland hill-side. But however it be, and I think my view is the true view, I tell you that art abhors that side of civilisation, she cannot breathe in the houses that lie under its stuffy slavery.

Believe me if we want art to begin at home, as it must, we must clear our houses of troublesome superfluities that are for ever in our way: conventional comforts that are no real comforts, and do but make work for servants and doctors: if you want a golden rule that will fit everybody, this is it:

'Have nothing in your houses that you do not know to be useful, or believe to be beautiful."

And if we apply that rule strictly, we shall in the first place show the builders and such-like servants of the public what we really want, we shall create a demand for real art, as the phrase goes; and in the second place, we shall surely have more money to pay for decent houses.

Perhaps it will not try your patience too much if I lay before you my idea of the fittings necessary to the sitting-room of a healthy person: a room, I mean, in which he would not have to cook in much, or sleep in generally, or in which he would not have to do any very litter-making manual work.

First a book-case with a great many books in it: next a table that will keep steady when you write or work at it: then several chairs that you can move, and a bench that you can sit or lie upon: next a cupboard with drawers: next, unless either the book-case or the cupboard be very beautiful with painting or carving, you will want pictures or engravings, such as you can afford, only not stopgaps, but real works of art on the wall; or else the wall itself must be ornamented with some beautiful and restful pattern: we shall also want a vase or two to put flowers in, which latter you must have sometimes, especially if you live in a town. Then there will be the fireplace of course, which in our climate is bound to be the chief object in the room.

That is all we shall want, especially if the floor be good; if it

be not, as, by the way, in a modern house it is pretty certain not to be, I admit that a small carpet which can be bundled out of the room in two minutes will be useful, and we must also take care that it is beautiful, or it will annoy us terribly.

Now unless we are musical, and need a piano (in which case, as far as beauty is concerned, we are in a bad way), that is quite all we want: and we can add very little to these necessaries without troubling ourselves, and hindering our work, our thought, and our rest.

If these things were done at the least cost for which they could be done well and solidly, they ought not to cost much; and they are so few, that those that could afford to have them at all, could afford to spend some trouble to get them fitting and beautiful: and all those who care about art ought to take great trouble to do so, and to take care that there be no sham art amongst them, nothing that it has degraded a man to make or sell. And I feel sure, that if all who care about art were to take this pains, it would make a great impression upon the public.

This simplicity you may make as costly as you please or can, on the other hand: you may hang your walls with tapestry instead of whitewash or paper; or you may cover them with mosaic, or have them frescoed by a great painter: all this is not luxury, if it be done for beauty's sake, and not for show: it does not break our golden rule: *Have nothing in your houses which you do not know to be useful or believe to be beautiful ...*

TO THOMAS COGLAN HORSFALL[1]

11-28 February 1881

... let us face the truth, which seems to me this: that a man of 30/– a week can only have any share of art if art is in such condition that it touches *everything* that man makes, but 'tis at present so far from being in that condition that, on the contrary, 'tis only here and there that art touches the matters of our daily life: *therefore* it is not possible at present for a man at 30/– a week (a father of a family at any rate) to have any share in art; a hard conclusion indeed, yet to that belief I will do my best to bring all men who care for living art, or for justice. For it is at least firm ground to stand on, albeit at the bottom of the pit. Standing on that ground, we shall at least make up our minds to one thing; not to try to make a poor man's art for the poor while we keep a rich man's art for ourselves: not to say, there, that suits your condition, I wouldn't have it myself but 'tis good enough for you. We should also soon find out not only that the man at 30/– can't have art, but also that he at £30 can scarcely have it, and will get less and less the longer things go on as they are, and should make up our minds to alter them: palliation is no use when the evils are great, and when people have not begun *to strike at the root.*

Educate your workmen into general discontent: that is the only remedy. Stuff into them what they *will* learn, chiefly natural science and politics, I fancy. Of course, if people come to ask you for advice about art you must do your best. A tough job you'll have of it, I fear.

Meanwhile, as for ourselves, the middle classes: if I understand rightly what Ruskin said to you, I do most heartily agree with it: I say, do with as little furniture, as little ornament, as you possibly can: my gloss on that is to have what you do have good: but look upon it as unmanly to have a luxurious home. I say with the utmost seriousness, that it seems as if luxury were going to stifle civilisation: and I protest against it from my soul.

The furniture for a workman's cottage? What can be done? If it be well made instead of ill made it will cost not twice as much, but twenty times as much: crede mihi experte.[2]

I have made rough furniture, often of the type of what would have been found in a yeoman's stead of old, and I have been aghast at the cost if it.

No, if you must give a £78 man advice about his house, it had better be to keep it as clean as a new pin, not to have much carpet, and stick up on his walls any engravings he really likes and to do a little window-gardening, what the smoke will allow him to.

For the rest, is it not enough, and even as much as can be done, to go on steadily with your Museum, founding your hopes on what *indirect influence* it may have on working people: it will perhaps attract some among them to genuine study of art: at any rate, it will be an instrument of education, I hope a most powerful one: and it will educate most by showing people not make-shifts but masterpieces ...

Notes

1 Thomas Coglan Horsfall (1841–1932), a Manchester philanthropist, who was engaged in setting up an art museum for the working classes. It was to include a model workman's room, containing examples of inexpensive but good design, hence the content of this letter. See *The Collected Letters of William Morris*, II, pp. 12-13.

2 Believe me to be an expert.

ON WALLPAPER

From 'Some Hints on Pattern-designing', 1881

... Now, again, as to paperhangings, one may accept as an axiom that, other things being equal, the more mechanical the process, the less direct should be the imitation of natural forms; on the other hand, in these wares which are stretched out flat on the wall, and have no special beauty of execution about them, we may find ourselves driven to do more than we otherwise should in masking the construction of our patterns. It gives us a chance of showing that we are pattern-designers born by accepting this apparent dilemma cheerfully, and setting our wits to work to conquer it. Let me state the difficulty again. In this craft the absence of limitations as to number of colours, and the general ease of the manufacture, is apt to tempt us into a mere twisting of natural forms into lines that may pass for ornamental; to yield to this temptation will almost certainly result in our designing a mere platitude. On the other hand is the temptation to design a pattern as we might do for a piece of woven goods, where the structure is boldly shown, and the members strongly marked; but such a pattern done in a cheap material will be apt to look over-ambitious, and, being stretched out flat on the wall, will lead the eye overmuch to its geometrical lines, and all repose will be lost.

What we have to do to meet this difficulty is to create due paper-stainers' flowers and leaves, forms that are obviously fit for printing with a block; to mask the construction of our pattern

enough to prevent people from counting the repeats of our pattern, while we manage to lull their curiosity to trace it out; to be careful to cover our ground equably. If we are successful in these two last things, we shall attain a look of satisfying mystery, which is an essential in all patterned goods, and which in paper-hangings must be done by the designer, since, as aforesaid, they fall into no folds, and have no special beauty of material to attract the eye.

Furthermore, we must, if we possibly can, avoid making accidental lines, which are very apt to turn up when a pattern is repeated over a wall. As to such lines, vertical lines are the worst; diagonal ones are pretty bad, and horizontal ones do not so much matter.

As to the colouring of paperhangings, it is much on the same footing as the forms of the design. The material being common-place and the manufacture mechanical, the colour should above all things be modest; though there are plenty of pigments which might tempt us into making our colour very bright or even very rich, we shall do well to be specially cautious in their use, and not to attempt brightness unless we are working in a very light key of colour, and if our general tone is bound to be deep, to keep the colour grey. You understand, of course, that no colour should ever be muddy or dingy; to make goods of such sort shows inexperience, and to persist in making them, incapacity.

ON FURNITURE

From 'The Lesser Arts of Life', 1882

... Simplicity is the one thing needful in furnishing, of that I am certain; I mean first as to quantity, and secondly as to kind and manner of design. The arrangement of our houses ought surely to express the kind of life we lead, or desire to lead; and to my mind, if there is anything to be said in favour of that to-day somewhat well-abused English middle class, it is that, amidst all the narrowness that is more or less justly charged against it, it has a kind of orderly intelligence which is not without some value. Such as it is, such its houses ought to be if it takes any pains about them, as I think it should: they should look like part of the life of decent citizens prepared to give good commonplace reasons for what they do. For us to set to work to imitate the minor vices of the Borgias,[1] or the degraded and nightmare whims of the *blasé* and bankrupt French aristocracy of Louis the Fifteenth's time,[2] seems to me merely ridiculous. So I say our furniture should be good citizen's furniture, solid and well made in workmanship, and in design should have nothing about it that is not easily defensible, no monstrosities or extravagances, not even of beauty, lest we weary of it. As to matters of construction, it should not have to depend on the special skill of a very picked workman, or the super-excellence of his glue, but be made on the proper principles of the art of joinery: also I think that, except for very movable things like chairs, it should not be so very light as to be nearly imponderable; it should be made of timber rather

than walking-sticks. Moreover, I must needs think of furniture as of two kinds: one part of it being chairs, dining and working tables, and the like, the necessary work-a-day furniture in short, which should be of course both well made and well proportioned, but simple to the last degree; nay, if it were rough I should like it the better, not the worse; with work-a-day furniture like this we should among other blessings avoid the terror which now too often goes with the tolerably regularly recurring accidents of the week.

But besides this kind of furniture, there is the other kind of what I should call state-furniture, which I think is proper even for a citizen; I mean sideboards, cabinets, and the like, which we have quite as much for beauty's sake as for use; we need not spare ornament on these, but may make them as elegant and elaborate as we can with carving, inlaying, or painting; these are the blossoms of the art of furniture, as picture tapestry is of the art of weaving: but these also should not be scattered about the house at haphazard, but should be used architecturally to dignify important chambers and important places in them. And once more, whatever you have in your rooms think first of the walls, for they are that which makes your house and home; and if you don't make some sacrifice in their favour, you will find your chambers have a kind of makeshift, lodging-house look about them, however rich and handsome your movables may be ...

Notes

1 Renowned for ruthless ambition and criminality: Cesare Borgia (1476–1507) and Lucrezia Borgia (1480–1519) were the children of Pope Alexander VI.

2 Louis XV (1710–74). The Rococo furniture of this time was characterized by serpentine curves and a high degree of decoration, particularly in the form of non-functional ormolu mounts curving over the surface.

ON POTTERY AND GLASS

From 'The Lesser Arts of Life', 1882

So let us begin with pottery ... First. Your vessel must be of a convenient shape for its purpose. Second. Its shape must show to the greatest advantage the plastic and easily-worked nature of clay; the lines of its contour must flow easily; but you must be on the look-out to check the weakness and languidness that comes from striving after over-elegance. Third. All the surface must show the hand of the potter, and not be finished with a baser tool. Fourth. Smoothness and high finish of surface, though a quality not to be despised, is to be sought after as a means for gaining some special elegance of ornament, and not as an end for its own sake. Fifth. The commoner the material the rougher the ornament, but by no means the scantier; on the contrary, a pot of fine materials may be more slightly orna-mented, both because all the parts of the ornamentation will be minuter, and also because it will in general be considered more carefully. Sixth. As in the making of the pot, so in its surface ornament, the hand of the workman must be always visible in it; it must glorify the necessary tools and necessary pigment: swift and decided execution is necessary to it; whatever delicacy there may be in it must be won in the teeth of the difficulties that will result from this; and because of these difficulties the delicacy will be more exquisite and delightful than in easier arts where, so to say, the execution can wait for more laborious patience. These, I say, seem to me the principles that guided the potter's art in the

days when it was progressive: it began to cease to be so in
civilized countries somewhat late in that period of blight which
was introduced by the so-called Renaissance ...

... [In] our own times ... styleless anarchy prevails; a state of
things not so hopeless as in the last century, because it shows a
certain uneasiness as to whether we are right or wrong, which
may be a sign of life. Meanwhile, as to matters of art, the craft
which turns out such tons of commercial wares, every piece of
which ought to be a work of art, produces almost literally
nothing. On this dismal side of things I will not dwell, but will
ask you to consider with me what can be done to remedy it; a
question which I know exercises much many excellent and
public-spirited men who are at the head of pottery works. Well,
in the first place, it is clear that the initiative cannot be wholly
taken by these men; we, all of us I mean who care about the arts,
must help them by asking for the right thing, and making them
quite clear what it is we ask for. To my mind it should be
something like this, which is but another way of putting those
principles of the art which I spoke of before. First. No vessel
should be fashioned by being pressed into a mould that can be
made by throwing on the wheel, or otherwise by hand. Second.
All vessels should be finished on the wheel, not turned in a lathe,
as is now the custom. How can you expect to have good work-
men when they know that whatever surface their hands may put
on the work will be taken off by a machine? Third. It follows, as
a corollary to the last point, that we must not demand excessive
neatness in pottery, and this more especially in cheap wares.
Workmanlike finish is necessary, but finish to be workmanlike
must always be in proportion to the kind of work. What we get
in pottery at present is mechanical finish, not workmanlike, and
is as easy to do as the other is hard: one is a matter of a manager's
system, the other comes of constant thought and trouble on the
part of the men, who by that time are artists, as we call them.

Fourth. As to the surface decoration on pottery, it is clear it must never be printed; for the rest, it would take more than an hour to go even very briefly into the matter of painting on pottery; but one rule we have for a guide, and whatever we do if we abide by it, we are quite sure to go wrong if we reject it: and it is common to all the lesser arts. Think of your material. Don't paint anything on pottery save what can be painted only on pottery; if you do, it is clear that, however good a draughtsman you may be, you do not care about that special art. You can't suppose that the Greek wall-painting was anything like their painting on pottery; there is plenty of evidence to show that it was not. Or take another example from the Persian art; it is easy for those conversant with it to tell from an outline tracing of a design whether it was done for pottery-painting or for other work. Fifth. Finally, when you have asked for these qualities from the potters, and even in a very friendly way boycotted them a little till you get them, you will of course be prepared to pay a great deal more for your pottery than you do now, even for the rough work you may have to take. I'm sure that won't hurt you; we shall only have less and break less, and our incomes will still be the same.

Now as to the kindred art of making glass vessels. It is on much the same footing as the potter's craft. Never till our own day has an ugly or stupid glass vessel been made; and no wonder, considering the capabilities of the art. In the hands of a good workman the metal is positively alive, and is, you may say, coaxing him to make something pretty. Nothing but commercial enterprise capturing an unlucky man and setting him down in the glassmaker's chair with his pattern beside him (which I should think must generally have been originally designed by a landscape gardener): nothing but this kind of thing could turn out ugly glasses. This stupidity will never be set right till we give up demanding accurately-gauged glasses made by the gross. I am fully in earnest when I say that if I were setting about getting good glasses made, I would get some good workmen together,

tell them the height and capacity of the vessels I wanted, and perhaps some general idea as to kind of shape, and then let them do their best. Then I would sort them out as they came from the annealing arches[1] (what a pleasure that would be!) and I would put a good price on the best ones, for they would be worth it; and I don't believe that the worst would be bad.

In speaking of glass-work, it is a matter of course that I am only thinking of that which is blown and worked by hand; moulded and cut glass may have commercial, but cannot have artistic value. As to the material of the glass vessels, that is a very important point. Modern managers have worked very hard to get their glass colourless: it does not seem to me that they have quite succeeded. I should say that their glass was cold and bluish in colour; but whether or not, their aim was wrong. A slight tint is an advantage in the metal; so are slight specks and streaks, for these things make the form visible. The modern managers of glassworks have taken enormous pains to get rid of all colour in their glass; to get it so that when worked into a vessel it shall not show any slightest speck or streak; in fact, they have toiled to take all character out of the metal, and have succeeded; and this in spite of the universal admiration for the Venice glass of the seventeenth century, which is both specked and streaky, and has visible colour in it. This glass of Venice or Murano is most delicate in its form, and was certainly meant quite as much for ornament as use; so you may be sure that if the makers of it had seen any necessity for getting more mechanical perfection in their metal they would have tried for it and got it; but like all true artists they were contented when they had a material that served the purpose of their special craft, and would not weary themselves in seeking after what they did not want. And I feel sure that if they had been making glass for ordinary table use at a low price, and which ran more risks of breakage, as they would have had to fashion their vessels thicker and less daintily they would have been contented with a rougher metal than that which they

used. Such a manufacture yet remains to be set on foot, and I very much wish it could be done; only it must be a manufacture; must be done by hand, and not by machine, human or otherwise.

So much, and very briefly, of these two important Lesser Arts, which it must be admitted are useful, even to Diogenes,[2] since the introduction of tea: I have myself at a pinch tried a tin mug for tea, and found it altogether inconvenient, and a horn I found worse still; so, since we must have pottery and glass, and since it is only by an exertion of the cultivated intellect that they can be made ugly, I must needs wish that we might take a little less trouble in that direction: at the same time I quite understand that in this case both the goods would cost the consumers more, even much more, and that the capitalists who risk their money in keeping the manufactories of the goods going would make less money; both which things to my mind would be fruitful in benefits to the community.

Notes

1 Openings or chambers in a glass-making furnace.
2 Greek Cynic philosopher, born about 412 BC, famed for his austerity.

A DINING-ROOM

From NEWS FROM NOWHERE, *1890*

... [T]he pretty waitresses came to us smiling, and chattering sweetly like reed warblers by the river-side, and fell to giving us our dinner. As to this, as at our breakfast, everything was cooked and served with a daintiness which showed that those who had prepared it were interested in it; but there was no excess either of quantity or of gourmandise; everything was simple, though so excellent of its kind; and it was made clear to us that this was no feast, only an ordinary meal. The glass, crockery, and plate were very beautiful to my eyes, used to the study of mediaeval art; but a nineteenth-century club-haunter would, I daresay, have found them rough and lacking in finish; the crockery being lead-glazed pot-ware, though beautifully ornamented; the only porcelain being here and there a piece of old oriental ware. The glass, again, though elegant and quaint, and very varied in form, was somewhat bubbled and hornier in texture than the commercial articles of the nineteenth century. The furniture and general fittings of the hall were much of a piece with the table-gear, beautiful in form and highly ornamented, but without the commercial 'finish' of the joiners and cabinet-makers of our time. Withal, there was a total absence of what the nineteenth century calls 'comfort'—that is, stuffy inconvenience; so that, even apart from the delightful excitement of the day, I had never eaten my dinner so pleasantly before ...

A COUNTRY HOUSE

From NEWS FROM NOWHERE, *1890*

[Ellen] led me up close to the house, and laid her shapely sun browned hand and arm on the lichened wall as if to embrace it, and cried out, 'O me! O me! How I love the earth, and the seasons, and weather, and all things that deal with it, and all that grows out of it,—as this has done!'

... We drew back a little, and looked up at the house: the door and the windows were open to the fragrant sun-cured air: from the upper window-sills hung festoons of flowers in honour of the festival, as if the others shared in the love for the old house ...

... We went in, and found no soul in any room as we wandered from room to room,—from the rose-covered porch to the strange and quaint garrets amongst the great timbers of the roof, where of old time the tillers and herdsmen of the manor slept, but which a-nights seemed now, by the small size of the beds, and the litter of useless and disregarded matters—bunches of dying flowers, feathers of birds, shells of starlings' eggs, caddis worms in mugs, and the like—seemed to be inhabited for the time by children.

Everywhere there was but little furniture, and that only the most necessary, and of the simplest forms. The extravagant love of ornament which I had noted in this people elsewhere seemed here to have given place to the feeling that the house itself and its associations was the ornament of the country life amidst which it

had been left stranded from old times, and that to re-ornament it would but take away its use as a piece of natural beauty.

We sat down at last in a room over the wall which Ellen had caressed, and which was still hung with old tapestry, originally of no artistic value, but now faded into pleasant grey tones which harmonised thoroughly well with the quiet of the place, and which would have been ill supplanted by brighter and more striking decoration ...

PRINTING

INTRODUCTION

If I were asked to say what is at once the most important production of Art and the thing most to be longed for, I should answer, A beautiful House; and if I were further asked to name the production next in importance and the thing next to be longed for, I should answer, A beautiful Book ...' (p. 142).

Morris's feeling for books amounted to a passion: 'let us say, concerning the Book, that to cosset and hug it up as a material piece of goods, is surely natural to a man who cares about the ideas that lie betwixt its boards' (p. 142). According to Mackail, 'The mere handling of a beautiful thing seemed to give him intense physical pleasure'.[1] '"If you have got one of his books on your hands for a minute," Burne-Jones said of him, "he'll take it away from you as if you were hurting it, and show it you himself."'[2] For Morris, the 'dearly beloved book-friend' (p. 142) was almost a living thing.

His love of books as objects of art went back to his undergraduate days when he and Burne-Jones used to go to the Bodleian Library to look at the illuminated manuscripts. Morris taught himself calligraphy in the early 1870s, but it was not until the late 1880s that he thought seriously of designing his own books. From there it was a short step to setting up the Kelmscott Press. As with dyeing, he was driven on by his dissatisfaction with the poor quality of much contemporary printing and book design. Again, it was only through achieving complete mastery of technique and control over materials that he could produce work to the standard he required. As with every other area of design,

Morris had a clear idea of what those standards should be and set them out in his lecture 'The Ideal Book'. He himself supervised or specified every aspect of the work of the Kelmscott Press: the paper (especially made from a fifteenth-century Venetian model); the ink (imported from Germany); and, above all, the type. He designed the Golden type, modelled on a Roman type designed by the fifteenth-century Venetian printer, Nicholas Jenson, and another type which was cut in two sizes: an 18 point, the Troy, and a 12 point, the Chaucer.

Morris's own prose romance, *The Story of the Glittering Plain*, was the first book printed by the Press in May 1891. He could afford the luxury of publishing exactly what he pleased. The fifty-three titles produced by the Press included Morris's own works, Ruskin's 'On the Nature of Gothic', *The Poems of John Keats*, and, most ambitiously of all, the Kelmscott *Chaucer*, which Morris only just lived to see completed. The Press itself did not long outlive him, but its influence was considerable. It stimulated the private press revival in Britain and the States and encouraged higher standards of book design from commercial publishers, such as J.M. Dent, whose Everyman series it inspired.

Notes

1 *The Life of William Morris*, II, p. 343.
2 *The Life of William Morris*, II, p. 343.

FROM 'SOME THOUGHTS ON THE ORNAMENTED MANUSCRIPTS OF THE MIDDLE AGES'

Around 1892

If I were asked to say what is at once the most important production of Art and the thing most to be longed for, I should answer, A beautiful House; and if I were further asked to name the production next in importance and the thing next to be longed for, I should answer, A beautiful Book. To enjoy good houses and good books in self-respect and decent comfort, seems to me to be the pleasurable end towards which all societies of human beings ought now to struggle.

Leaving the House alone for the present, let us say concerning the Book, that to cosset and hug it up as a material piece of goods, is surely natural to a man who cares about the ideas that lie betwixt its boards. Only the present age of superabundance of books makes some enthusiastic lovers of the spiritual part of books show their love for them by treating them as some men do their closest cronies and friends, speaking with familiar roughness to them, checking them affectionately though rudely in all their little vanities and the like, because they feel that they understand each other too well, that the bond between them is too close to be broken by such outside maltreatment. Just so I have seen a man take hold of his dearly beloved book-friend, the mislaying of which would destroy his night's rest, and bend back

the boards till the back cracked again; I have seen him thump its familiar pages with his fist, dogs-ear its leaves, turn it face downwards on a dirty table, blot it with ink and smear the blot off with his thumb; in short so maul it that he deserved to have his books read aloud to him henceforward, instead of being allowed to read them to himself. Such behaviour may be forgiven, but only on the grounds that the utilitarian production of makeshifts, which is the especial curse of modern times, has swept away the book-producer in its current, and that few books nowadays can at the best claim anything more than negative qualities as to their appearance; if they are revoltingly ugly and vulgar in aspect that [is] about as much as we can expect of them.

In the Middle Ages it was very different; the book-lover, the student had before him, as he took in the thoughts of his author, a piece of beauty obvious to the eyesight. The Clerk of Oxenford if he took up one of his 'Twentie bookes clad in black and red';[1] the fellow of the college, when with careful ceremony he took the volume from the chest of books which held the common stock of literature; the Scholar of the early Renaissance when he sold his best coat to buy the beworshipped classic new-printed by Vindelin[2] or Jenson, each of these was dealing with a palpable work of art, a comely body fit for the habitation of the dead man who was speaking to them: the craftsman, scribe, limner, printer, who had produced it had worked on it directly as an artist, not turned it out as the machine of a tradesman; and moreover amidst the traditions that swayed him he could no more help doing so than the present book-maker can help working as a machine ...

Notes

1 Geoffrey Chaucer, *The Canterbury Tales* (c. 1387–1400), General Prologue, l. 294.
2 Vindelinus de Spira (*fl.* 1469–77), Venetian printer.

THE IDEAL BOOK

1893

By the ideal book, I suppose we are to understand a book not limited by commercial exigencies of price: we can do what we like with it, according to what its nature, as a book, demands of Art. But we may conclude, I think, that its maker will limit us somewhat; a work on differential calculus, a medical work, a dictionary, a collection of a statesman's speeches, of a treatise on manures, such books, though they might be handsomely and well printed, would scarcely receive ornament with the same exuberance as a volume of lyrical poems, or a standard classic, or such like. A work on Art, I think, bears less of ornament than any other kind of book (NON BIS IN IDEM[1] is a good motto); again, a book that must have illustrations, more or less utilitarian, should, I think, have no actual ornament at all, because the ornament and the illustration must almost certainly fight. Still, whatever the subject-matter of the book may be, and however bare it may be of decoration, it can still be a work of art, if the type be good and attention be paid to its general arrangement. All here present, I should suppose, will agree in thinking an opening of Schoeffer's[2] 1462 Bible beautiful, even when it has neither been illuminated nor rubricated; the same may be said of Schüssler,[3] or Jenson, or, in short, of any of the *good* old printers; their works, without any further ornament than they derived from the design and arrangement of the letters were definite works of art. In fact a book, printed or written, has

a tendency to be a beautiful object, and that we of this age should generally produce ugly books, shows, I fear, something like malice prepense—a determination to put our eyes in our pockets wherever we can.

Well, I lay it down, first, that a book quite un-ornamented can look actually and positively beautiful, and not merely un-ugly, if it be, so to say, architecturally good, which by the by, need not add much to its price, since it costs no more to pick up pretty stamps than ugly ones, and the taste and forethought that goes to the proper setting, position, and so on, will soon grow into a habit, if cultivated, and will not take up much of the master-printer's time when taken with his other necessary business.

Now, then, let us see what this architectural arrangement claims of us.

First, the pages must be clear and easy to read; which they can hardly be unless,

Secondly, the type is well designed; and

Thirdly, whether the margins be small or big, they must be in due proportion to the page of letter.

For clearness of reading, the things necessary to be heeded are, first, that the letters should be properly put on their bodies, and, I think, especially that there should be small whites between them. It is curious, but to me certain, that the irregularity of some early type, notably the roman letter of the early printers of Rome, which is, of all roman type, the rudest, does not tend towards illegibility: what does do so, is the lateral compression of the letter, which necessarily involves the over-thinning out of its shape. Of course I do not mean to say that the above-mentioned irregularity is other than a fault to be corrected. One thing should never be done in ideal printing, the spacing out of letters, that is, putting an extra white between them; except in such hurried and unimportant work as newspaper printing, it is inexcusable.

This leads us to the second matter on this head, the lateral

spacing of words (the whites between them). To make a beautiful page great attention should be paid to this, which, I fear, is not often done. No more white should be used between the words than just clearly cuts them of from one another; if the whites are bigger than this it both tends to illegibility and makes the page ugly. I remember once buying a handsome fifteenth-century Venetian book, and I could not tell at first why some of its pages were so worrying to read, and so commonplace and vulgar to look at, for there was no fault to find with the type. But presently it was accounted for by the spacing; for the said pages were spaced like a modern book, i.e., the black and white nearly equal. Next, if you want a legible book, the white should be white and the black black. When that excellent journal the Westminster Gazette, first came out, there was a discussion on the advantages of its green paper, in which a good deal of nonsense was talked. My friend, Mr. Jacobi,[4] being a practical printer, set these wise men right, if they noticed his letter, which I fear they did not, by pointing out that what they had done was to lower the tone (not the moral tone) of the paper, and that, therefore, in order to make it as legible as ordinary black and white, they should make their black blacker – which of course they do not do. You may depend upon it that a grey page is very trying to the eyes.

As above said, legibility depends also much on the design of the letter; and again I take up the cudgels against compressed type, and that especially in Roman letter: the full-sized lower-case letters a, b, d, & c, should be designed on something like a square to get good results: otherwise one may fairly say that there is no room for the design. Furthermore, each letter should have its due characteristic drawing; e.g., the thickening out for a b, should not be of the same kind as that for a d; a u should not merely be an n turned upside down; the dot of the i should not be a circle drawn with compasses, but a delicately drawn diamond, and so on. To be short, the letters should be designed by an artist, and not an engineer. As to the forms of letters in

England (I mean Great Britain), there has been much progress within the last forty years. The sweltering hideousness of the Bodoni[5] letter, the most illegible type that was ever cut, with its preposterous thicks and thins, has been mostly relegated to works that do not profess anything but the baldest utilitarianism (though why even utilitarianism should use illegible types, I fail to see), and Caslon's[6] letter, and the somewhat wiry, but in its way, elegant old-faced type cut in our own days, has largely taken its place. It is rather unlucky, however, that a somewhat low standard of excellence has been accepted for the design of modern roman type at its best, the comparatively poor and wiry letter of Plantin,[7] and the Elzeviers,[8] having served for the model, rather than the generous and logical designs of the fifteenth-century Venetian printers, at the head of whom stands Nicholas Jenson. When it is so obvious that this is the best and clearest roman type yet struck, it seems a pity that we should make our starting point for a possible new departure at any period worse than the best. If any of you doubt the superiority of this type over that of the seventeenth century, the study of a specimen enlarged about five times will convince him, I should think. I must admit, however, that a commercial consideration comes in here, to wit, that the Jenson letters take up more room than the imitations of the seventeenth century; and that touches on another commercial difficulty; to wit, that you cannot have a book either handsome or clear to read which is printed in small characters. For my part, except where books smaller than an ordinary octavo are wanted, I would fight against anything smaller than pica; but at any rate small pica seems to me the smallest type that should be used in the body of any book.[9] I might suggest to printers that if they want to get more in they can reduce the size of the leads, or leave them out altogether. Of course this is more desirable in some types than others; e.g., Caslon's letter, which has long ascenders and descenders, never needs leading, except for special purposes.

I have hitherto had a fine and generous roman type in my
mind, but after all, a certain amount of variety is desirable, and
when you have once got your roman letter as good as the best
that has been, I do not think you will find much scope for devel-
opment of it. I would, therefore, put in a word for some form of
gothic letter for use in our improved printed book. This may
startle some of you, but you must remember that except for a
very remarkable type used very seldom by Berthelette[10] (I have
only seen two books in this type, Bartholomew the Englishman,
and the Gower of 1532), English black-letter, since the days of
Wynkyn de Worde,[11] has been always the letter which was intro-
duced from Holland about that time (I except again, of course,
the modern imitations of Caxton). Now this, though a hand-
some and stately letter, is not very easy reading, it is too much
compressed, too spiky, and, so to say, too prepensely Gothic. But
there are many types which are of a transitional character and of
all degrees of transition; from those which do little more than
take in just a little of the crisp floweriness of the gothic, like some
of the Mentelin or quasiMentelin ones (which, indeed, are
models of beautiful simplicity), or, say, like the letter of the Ulm
Ptolemy, of which it is difficult to say whether it is gothic or
roman, to the splendid Mainz type, of which, I suppose, the
finest example is the Schoeffer Bible of 1462, and which is
almost wholly gothic. This gives us a wide field for variety, I
think, so I make the suggestion to you, and leave this part of the
subject with two remarks: first, that a good deal of the difficulty
of reading gothic books is caused by the numerous contractions
in them, which were a survival of the practice of the scribes; and
in a lesser degree by the over abundance of tied letters, both of
which drawbacks I take it for granted would be absent in modern
types founded on these semi-gothic letters. And, secondly, that in
my opinion the capitals are the strong side of roman, and the
lower-case of gothic letter, which is but natural, since the roman

was originally an alphabet of capitals, and the lower-case a deduction from them.

We now come to the position of the page of print on the paper, which is a most important point, and one that till quite lately has been wholly misunderstood by modern, and seldom done wrong by ancient printers, or indeed by producers of books of any kind. On this head, I must begin by reminding you that we only occasionally see one page of a book at a time; the two pages making an opening are really the unit of the book, and this was thoroughly understood by the old book producers. I think you will very seldom find a book, produced before the eighteenth century, and which has not been cut down by that enemy of books (and of the human race), the binder, in which this rule is not adhered to: that the hinder edge (that which is bound in) must be the smallest member of the margins, the head margin must be larger than this, the fore larger still, and the tail largest of all. I assert that, to the eye of any man who knows what proportion is, this looks satisfactory, and that no other does so look. But the modern printer, as a rule, dumps down his page in what he calls the middle of the paper, which is often not even really the middle, as he measures his page from the headline, if he has one, though it is not really part of the page, but a spray of type only faintly staining the head of the paper. Now I go so far as to say that any book in which the page is properly put on the paper, is tolerable to look at, however poor the type may be— always so long as there is no 'ornament' which may spoil the whole thing. Whereas any book in which the page is wrongly set on the paper is intolerable to look at, however good the type and ornaments may be. I have got on my shelves now a Jenson's Latin Pliny, which, in spite of its beautiful type and handsome painted ornaments, I dare scarcely look at, because the binder (adjectives fail me here) has chopped off two-thirds of the tail margin. Such stupidities are like a man with his coat buttoned up behind, or a lady with her bonnet put on hindside foremost.

Before I finish this section I should like to say a word concerning large paper copies. I am clean against them, though I have sinned a good deal in that way myself, but that was in the days of ignorance, and I petition for pardon on that ground only. If you want to publish a handsome edition of a book as well as a cheap one, do so; but let them be two books, and if you (or the public) cannot afford this, spend your ingenuity and your money in making the cheap book as sightly as you can. Your making a large paper copy out of the small one lands you in a dilemma even if you reimpose the pages for the larger paper, which is not often done I think. If the margins are right for the smaller book, they must be wrong for the larger, and you have to offer the public the worse book at the bigger price. If they are right for the large paper they are wrong for the small, and thus spoil it, as we have seen above that they must do; and that seems scarcely fair to the general public—from the point of view of artistic morality— who might have had a book that was sightly, though not high priced.

As to the paper of our ideal book we are at a great disadvantage compared with past times. Up to the end of the fifteenth or, indeed, the first quarter of the sixteenth centuries, no bad paper was made, and the greater part was very good indeed. At present there is very little good paper made, and most of it is very bad. Our ideal book must, I think, be printed on hand-made paper as good as it can be made; penury here will make a poor book of it. Yet if machine-made paper must be used, it should not profess fineness or luxury; but should show itself for what it is. For my part I decidedly prefer the cheaper papers that are used for the journals, so far as appearance is concerned, to the thick, smooth, sham-fine papers on which respectable books are printed, and the worst of these are those which imitate the structure of hand-made papers.

But granted your hand-made paper, there is something to be said about its substance. A small book should not be printed on

thick paper, however good it may be. You want a book to turn
over easily, and to lie quiet while you are reading it, which is
impossible, unless you keep heavy paper for big books.

And, by the way, I wish to make a protest against the
superstition that only small books are comfortable to read. Some
small books are tolerably comfortable, but the best of them are
not so comfortable as a fairly big folio, the size, say, of an uncut
Polyphilus, or somewhat bigger. The fact is, a small book seldom
does lie quiet, and you have either to cramp your hand by
holding it, or else to put it on the table with a paraphernalia of
matters to keep it down, a table-spoon on one side, a knife on
another, and so on, which things always tumble off at a critical
moment, and fidget you out of the repose which is absolutely
necessary to reading. Whereas, a big folio lies quiet and majestic
on the table, waiting kindly till you please to come to it, with its
leaves flat and peaceful, giving you no trouble of body, so that
your mind is free to enjoy the literature which its beauty
enshrines.

So far, then, I have been speaking of books whose only orna-
ment is the necessary and essential beauty which arises out of the
fitness of a piece of craftsmanship for the use which it is made.
But if we get as far as that, no doubt from such craftsmanship
definite ornament will arise, and will be used, sometimes with
wise forbearance, sometimes with prodigality equally wise.
Meantime, if we really feel impelled to ornament our books, no
doubt we ought to try what we can do; but in this attempt we
must remember one thing, that if we think the ornament is
ornamentally a part of the book merely because it is printed with
it, and bound up with it, we shall be much mistaken. The
ornament must form as much a part of the page as the type itself,
or it will miss its mark, and in order to succeed, and to be
ornament, it must submit to certain limitations, and become
architectural; a mere black and white picture, however inter-
esting it may be as a picture, may be far from an ornament in a

book; while on the other hand, a book ornamented with pictures that are suitable for that, and that only, may become a work of art second to none, save a fine building duly decorated, or a fine piece of literature.

These two latter things are, indeed, the one absolutely necessary gift that we should claim of art. The picture-book is not, perhaps, absolutely necessary to man's life, but it gives us such endless pleasure, and is so intimately connected with the other absolutely necessary art of imaginative literature that it must remain one of the very worthiest things towards the production of which reasonable men should strive.

Notes

1 Not twice for the same purpose.
2 Peter Schoeffer (*fl.* 1449–1502), German printer.
3 Johann Schüssler (*fl.* 1470–73), German printer.
4 Charles T. Jacobi (1853–1933), manager of the Chiswick Press and one of Morris's advisors on setting up the Kelmscott Press.
5 Giambattista Bodoni (1740–1813), Italian type-designer and printer.
6 William Caslon (1692–1766), English maker of type.
7 Christophe Plantin (c.1520–89), Antwerp printer.
8 Elezevier family, Dutch printers and publishers of the sixteenth to eighteenth centuries.
9 Pica is 12-point type, small pica, 11-point.
10 Thomas Berthelet (d.1555), London printer.
11 Wynkyn de Worde (d.1535), London printer.

ART AND SOCIETY

INTRODUCTION

... [I]n spite of all the success I have had, I have not failed to be conscious that the art I have been helping to produce would fall with the death of a few of us who really care about it ... Both my historical studies and my practical conflict with the philistinism of modern society have forced on me the conviction that art cannot have a real life and growth under the present system of commercialism and profit-mongering. I have tried to develope this view, which is in fact Socialism seen through the eyes of an artist, in various lectures ...[1]

Morris wrote in a letter of 1856, 'I can't enter into politico-social subjects with any interest, for on the whole I see that things are in a muddle, and I have no power or vocation to set them right in ever so little a degree. My work is the embodiment of dreams in one form or another'.[2] By the late 1870s, he was beginning to feel that this was not enough. Two particular causes, one architectural, the other political, stirred him into action. In 1877 he was instrumental in founding the Society for the Protection of Ancient Buildings, intended, in particular, to protect medieval buildings from the depredations of insensitive restorers. The other cause was Morris's involvement with the so-called Eastern Question. He was fiercely opposed to war with Russia, which he believed the Tory government, led by Disraeli, was willing to enter into for considerations of trade and political expediency. Morris allied himself with the Liberal opposition and became treasurer of the Eastern Question Association. He subsequently became disillusioned with liberalism, but

through it he came to know and respect working-class radicals in London.

Morris's political and aesthetic convictions began to converge. In his first public lecture, 'The Lesser Arts' (1877), he declared, 'I do not want art for a few, any more than education for a few, or freedom for a few' (p. 176). He was well aware that many of those who most needed the solace that art could bring were unable to afford his chairs and textiles. His sense of frustration was most memorably expressed in an incident which took place during the decoration of Rounton Grange for the ironmaster, Sir Lowthian Bell, in the late 1870s. One day Sir Lowthian heard Morris talking and walking about in an agitated way and asked him if anything was wrong. 'He turned on me like a mad animal—"It is only that I spend my life in ministering to the swinish luxury of the rich."'[3] Although Morris could reach a wider audience through lectures, he grew increasingly convinced that art could not be available to all in a capitalist society. It was this belief and his sense of shame at the gulf between rich and poor that underlay his conversion to socialism in 1883. Having declared his political allegiance, he was able henceforth to express openly his conviction that a revolution in art could not come without a revolution in society. He did not read *Das Kapital* until after he had become a socialist, but when he did so what he found in Marx's theory of the alienation of the worker in a capitalist society was not so far removed from Ruskin's views on the human cost of the division of labour. The influence of both writers is evident in Morris's essay, 'The Revival of Handicraft'.

Notes

1 *The Collected Letters of William Morris*, II, p. 230.

2 *The Life of William Morris*, I, p. 107.

3 W.R. Lethaby, *Philip Webb and his Work* (London: Oxford University Press, 1935), pp. 94-95.

FROM 'THE LESSER ARTS'

1877

Hereafter I hope in another lecture to have the pleasure of laying before you an historical survey of the lesser, or as they are called the Decorative Arts, and I must confess it would have been pleasanter for me to have begun my talk with you by entering at once upon the subject of the history of this great industry; but, as I have something to say in a third lecture about various matters connected with the practice of Decoration among ourselves in these days, I feel that I should be in a false position before you, and one that might lead to confusion, or overmuch explanation, if I did not let you know what I think on the nature and scope of these arts, on their condition at the present time, and their outlook in times to come. In doing this it is like enough that I shall say things with which you will very much disagree; I must ask you therefore from the outset to believe that whatever I may blame or whatever I may praise, I neither, when I think of what history has been, am inclined to lament the past, to despise the present, or despair of the future; that I believe all the change and stir about us is a sign of the world's life, and that it will lead—by ways, indeed, of which we have no guess—to the bettering of all mankind.

Now as to the scope and nature of these Arts I have to say, that though when I come more into the details of my subject I shall not meddle much with the great art of Architecture, and less still with the great arts commonly called Sculpture and

Painting, yet I cannot in my own mind quite sever them from those lesser so-called Decorative Arts, which I have to speak about: it is only in latter times, and under the most intricate conditions of life, that they have fallen apart from one another; and I hold that, when they are so parted, it is ill for the Arts altogether: the lesser ones become trivial, mechanical, unintelligent, incapable of resisting the changes pressed upon them by fashion or dishonesty; while the greater, however they may be practised for a while by men of great minds and wonder-making hands, unhelped by the lesser, unhelped by each other, are sure to lose their dignity of popular arts, and become nothing but dull adjuncts to unmeaning pomp, or ingenious toys for a few rich and idle men.

However, I have not undertaken to talk to you of Architecture, Sculpture, and Painting, in the narrower sense of those words, since, most unhappily as I think, these master-arts, these arts more especially of the intellect, are at the present day divorced from decoration in its narrower sense. Our subject is that great body of art, by means of which men have at all times more or less striven to beautify the familiar matters of everyday life: a wide subject, a great industry; both a great part of the history of the world, and a most helpful instrument to the study of that history.

A very great industry indeed, comprising the crafts of house-building, painting, joinery and carpentry, smiths' work, pottery and glass-making, weaving, and many others: a body of art most important to the public in general, but still more so to us handicraftsmen; since there is scarce anything that they use, and that we fashion, but it has always been thought to be unfinished till it has had some touch or other of decoration about it. True it is that in many or most cases we have got so used to this ornament, that we look upon it as if it had grown of itself, and note it no more than the mosses on the dry sticks with which we light our fires. So much the worse! for there *is* the decoration, or the pretence

of it, and it has, or ought to have, a use and a meaning. For, and this is at the root of the whole matter, everything made by man's hands has a form, which must be either beautiful or ugly; beautiful if it is in accord with Nature, and helps her; ugly if it is discordant with Nature, and thwarts her; it cannot be indifferent: we, for our parts, are busy or sluggish, eager or unhappy, and our eyes are apt to get dulled to this eventfulness of form in those things which we are always looking at. Now it is one of the chief uses of decoration, the chief part of its alliance with nature, that it has to sharpen our dulled senses in this matter: for this end are those wonders of intricate patterns interwoven, those strange forms invented, which men have so long delighted in: forms and intricacies that do not necessarily imitate nature, but in which the hand of the craftsman is guided to work in the way that she does; till the web, the cup, or the knife, look as natural, nay as lovely, as the green field, the river bank, or the mountain flint.

To give people pleasure in the things they must perforce *use*, that it one great office of decoration; to give people pleasure in the things they must perforce *make*, that is the other use of it.

Does not our subject look important enough now? I say that without these arts, our rest would be vacant and uninteresting, our labour mere endurance, mere wearing away of body and mind.

As for that last use of the arts, the giving us pleasure in our work, I scarcely know how to speak strongly enough of it; and yet if I did not know the value of repeating a truth again and again, I should have to excuse myself to you for saying more about this, when I remember how a great man now living has spoken of it: I mean my friend Professor John Ruskin: if you read the chapter in the 2nd vol. of his *Stones of Venice* entitled, 'On the Nature of Gothic, and the Office of the Workman therein,' you will read at once the truest and most eloquent words that can possibly be said on the subject. What I have to say upon it can scarcely be more than an echo of his words, yet I repeat there is

some use in reiterating a truth, lest it be forgotten; so I will say this much further: we all know what people have said about the curse of labour, and what heavy and grievous nonsense are the more part of their words thereupon; whereas indeed the real curses of craftsmen have been the curse of stupidity, and the curse of injustice from within and from without: no, I cannot suppose there is anybody here who would think it either a good life, or an amusing one, to sit with one's hands before one doing nothing—to live like a gentleman, as fools call it.

Nevertheless there *is* dull work to be done, and a weary business it is setting men about such work, and seeing them through it, and I would rather do the work twice over with my own hands than have such a job: but now only let the arts which we are talking of beautify our labour, and be widely spread, intelligent, well understood both by the maker and the user, let them grow in one word *popular*, and there will be pretty much an end of dull work and its wearing slavery; and no man will any longer have any excuse for talking about the curse of labour, no man will any longer have an excuse for evading the blessing of labour. I believe there is nothing that will aid the world's progress so much as this; I protest there is nothing in the world that I desire so much as the attainment of this, wrapped up, as I am sure it is, with changes political and social, that in one way or another we all desire.

Now if the objection be made, that these arts have been the handmaids of luxury, of tyranny and of superstition, I must needs say that it is true in a sense; they have been so used, as many other excellent things have been. But it is also true that, among some nations, their most vigorous and freest times have been the very blossoming times of art: while at the same time, I must allow that these decorative arts have flourished among oppressed peoples, who have seemed to have no hope of freedom: yet I do not think that we shall be wrong in thinking that at such times, among such peoples, art, at least, was free; when it has not been,

when it has really been gripped by superstition, or by luxury, it has straightway begun to sicken under that grip. Nor must you forget that when men say popes, kings, and emperors built such and such buildings it is a mere way of speaking. You look in your history-books to see who built Westminster Abbey, who built St. Sophia at Constantinople, and they tell you Henry III.,[1] Justinian the Emperor.[2] Did they? or, rather, men like you and me, handicraftsmen, who have left no names behind them, nothing but their work?

Now as these arts call people's attention and interest to the matters of every-day life in the present, so also, and that I think is no little matter, they call our attention at every step to that history, of which, I said before, they are so great a part; for no nation, no state of society, however rude, has been wholly without them: nay, there are peoples not a few, of whom we know scarce anything, save that they thought such and such forms beautiful. So strong is the bond between history and decoration, that in the practice of the latter we cannot, if we would, wholly shake off the influence of past times over what we do at present. I do not think that it is too much to say that no man, however original he may be, can sit down to-day and draw the ornament of a cloth, or the form of an ordinary vessel or piece of furniture, that will be other than a development or a degradation of forms used hundreds of years ago; and these, too, very often, forms that once had a serious meaning, though they are now become little more than a habit of the hand; forms that were once perhaps the mysterious symbols of worships and beliefs now little remembered or wholly forgotten. Those who have diligently followed the delightful study of these arts are able as if through windows to look upon the art of the past:—the very beginnings of thought among nations whom we cannot even name; the terrible empires of the ancient East; the free vigour and glory of Greece; the heavy weight, the firm grasp of Rome; the fall of her temporal empire which spread so wide about the

world all that good and evil which men can never forget, and never cease to feel; the clashing of East and West, South and North, about her rich and fruitful daughter Byzantium; the rise, the dissensions, and the waning of Islam; the wanderings of Scandinavia; the Crusades; the foundation of the States of modern Europe; the struggles of free thought with ancient dying system—with all these events and their meaning is the history of popular art interwoven; with all this, I say, the careful student of decoration as an historical industry must be familiar. When I think of this, and the usefulness of all this knowledge, at a time when history has become so earnest a study amongst us as to have given us, as it were, a new sense: at a time when we so long to know the reality of all that has happened, and are to be put off no longer with the dull records of the battles and intrigues of kings and scoundrels,—I say when I think of all this, I hardly know how to say that this interweaving of the Decorative Arts with the history of the past is of less importance than their dealings with the life of the present: for should not these memories also be a part of our daily life?

And now let me recapitulate a little before I go further, before we begin to look into the condition of the arts at the present day. These arts, I have said, are part of a great system invented for the expression of a man's delight in beauty: all peoples and times have used them; they have been the joy of free nations, and the solace of oppressed nations; religion has used and elevated them, has abused and degraded them; they are connected with all history, and are clear teachers of it; and, best of all, they are the sweeteners of human labour, both to the handicraftsman, whose life is spent in working in them, and to people in general who are influenced by the sight of them at every turn of the day's work: they make our toil happy, our rest fruitful.

And now if all I have said seems to you but mere open-mouthed praise of these arts, I must say that it is not for nothing that what I have hitherto put before you has taken that form.

It is because I must now ask you this question: All these good things—will you have them? will you cast them from you?

Are you surprised at my question—you, most of whom, like myself, are engaged in the actual practice of the arts that are, or ought to be, popular?

In explanation, I must somewhat repeat what I have already said. Time was when the mystery and wonder of handicrafts were well acknowledged by the world, when imagination and fancy mingled with all things made by man; and in those days all handicraftsmen were *artists*, as we should now call them. But the thought of man became more intricate, more difficult to express; art grew a heavier thing to deal with, and its labour was more divided among great men, lesser men, and little men; till that art, which was once scarce more than a rest of body and soul, as the hand cast the shuttle or swung the hammer, became to some men so serious a labour, that their working lives have been one long tragedy of hope and fear, joy and trouble. This was the growth of art: like all growth, it was good and fruitful for a awhile; like all fruitful growth, it grew into decay: like all decay of what was once fruitful, it will grow into something new.

Into decay; for as the arts sundered into the greater and the lesser, contempt on one side, carelessness on the other arose, both begotten of ignorance of that *philosophy* of the Decorative Arts, a hint of which I have tried just now to put before you. The artist came out from the handicraftsmen, and left them without hope of elevation, while he himself was left without the help of intelligent, industrious sympathy. Both have suffered; the artist no less than the workman. It is with art as it fares with a company of soldiers before a redoubt, when the captain runs forward full of hope and energy, but looks not behind him to see if his men are following, and they hang back, not knowing why they are brought there to die. The captain's life is spent for nothing, and his men are sullen prisoners in the redoubt of Unhappiness and Brutality.

I must in plain words say of the Decorative Arts, of all the arts, that it is not so much that we are inferior in them to all who have gone before us, but rather that they are in a state of anarchy and disorganisation, which makes a sweeping change necessary and certain.

So that again I ask my question, All that good fruit which the arts should bear, will you have it? will you cast it from you? Shall that sweeping change that must come, be the change of loss or of gain?

We who believe in the continuous life of the world, surely we are bound to hope that the change will bring us gain and not loss, and to strive to bring that gain about.

Yet how the world may answer my question who can say? A man in his short life can see but a little way ahead, and even in mine wonderful and unexpected things have come to pass. I must needs say that therein lies my hope rather than in all I see going on round about us. Without disputing that if the imaginative arts perish, some new thing, at present unguessed of, *may* be put forward to supply their loss in men's lives, I cannot feel happy in that prospect, nor can I believe that mankind will endure such a loss forever: but in the meantime the present state of the arts and their dealings with modern life and progress seem to me to point in appearance at least to this immediate future; that the world, which has for a long time busied itself about other matters than the arts, and has carelessly let them sink lower and lower, till many not uncultivated men, ignorant of what they once were, and hopeless of what they might yet be, look upon them with mere contempt; that the world, I say, thus busied and hurried, will one day wipe the slate, and be clean rid in her impatience of the whole matter with all its tangle and trouble ...

... Meantime it is the plain duty of all who look seriously on the arts to do their best to save the world from what at the best will be a loss, the result of ignorance and unwisdom; to prevent, in

fact, that most discouraging of all changes, the supplying the place of an extinct brutality by a new one; nay, even if those who really care for the arts are so weak and few that they can do nothing else, it may be their business to keep alive some tradition, some memory of the past, so that the new life when it comes may not waste itself more that enough in fashioning wholly new forms for its new spirit.

To what side then shall those turn for help, who really understand the gain of a great art in the world, and the loss of peace and good life that must follow from the lack of it? I think that they must begin by acknowledging that the ancient art, the art of unconscious intelligence, as one should call it, which began without a date, at least so long ago as those strange and masterly scratchings on mammoth-bones and the like found but the other day in the drift—that this art of unconscious intelligence is all but dead; that what little of it is left lingers among half-civilised nations, and is growing coarser, feebler, less intelligent year by year; nay, it is mostly at the mercy of some commercial accident, such as the arrival of a few shiploads of European dye-stuffs or a few dozen orders from European merchants: this they must recognize, and must hope to see in time its place filled by a new art of conscious intelligence, the birth of wiser, simpler, freer ways of life than the world leads now, than the world has ever led.

I said, *to see* this in time; I do not mean to say that our own eyes will look upon it: it may be so far off, as indeed it seems to some, that many would scarcely think it worth while thinking of: but there are some of us who cannot turn our faces to the wall, or sit deedless because our hope seems somewhat dim; and, indeed, I think that while the signs of the last decay of the old art with all the evils that must follow in its train are only too obvious about us, so on the other hand there are not wanting signs of the new dawn beyond that possible night of the arts, of which I have before spoken: this sign chiefly, that there are some few at least

who are heartily discontented with things as they are, and crave for something better, or at least some promise of it—this best of signs: for I suppose that if some half-dozen men at any time earnestly set their hearts on something coming about which is not discordant with nature, it will come to pass one day or other; because it is not by accident that an idea comes into the heads of a few; rather they are pushed on, and forced to speak or act by something stirring in the heart of the world which would otherwise be left without expression.

By what means then shall those work who long for reform in the arts, and whom shall they seek to kindle into eager desire for possession of beauty, and better still, for the development of the faculty that creates beauty?

People say to me often enough: If you want to make your art succeed and flourish, you must make it the fashion: a phrase which I confess annoys me: for they mean by it that I should spend one day over my work to two days in trying to convince rich, and supposed influential people, that they care very much for what they really do not care in the least, so that it may happen according to the proverb: *Bell-wether took the leap and we all went over:*[3] well, such advisers are right if they are content with the thing lasting but a little while; say till you can make a little money—if you don't get pinched by the door shutting too quickly: otherwise they are wrong: the people they are thinking of have too many strings to their bow and can turn their backs too easily on a thing that fails, for it to be safe work trusting to their whims: it is not their fault, they cannot help it, but they have no chance of spending time enough over the arts to know anything practical of them, and they must of necessity be in the hands of those who spend their time pushing fashion this way and that for their own advantage.

Sirs, there is no help to be got out of these latter, or those who let themselves be led by them: the only real help for the

decorative arts must come from those who work in them; nor
must they be led, they must lead.

You whose hands make those things that should be works of
art, you must be all artists, and good artists too, before the public
at large can take real interest in such things; and when you have
become so, I promise that you shall lead the fashion; fashion
shall follow your hands obediently enough.

That is the only way in which we can get a supply of intelli-
gent popular art: a few artists of the kind so-called now, what can
they do working in the teeth of difficulties thrown in their way
by what is called Commerce, but which should be called greed of
money? working helplessly among the crowd of those who are
ridiculously called manufacturers, *i.e.* handicraftsmen, though
the more part of them never did a stroke of hand-work in their
lives, and are nothing better than capitalists and salesmen. What
can these grains of sand do, I say, amidst the enormous mass of
work turned out every year which professes in some way to be
decorative art, but the decoration of which no one heeds except
the salesmen who have to do with it, and are hard put to it to
supply the cravings of the public for something new, not for
something pretty.

The remedy I repeat is plain if it can be applied; the handi-
craftsman, left behind by the artist when the arts sundered, must
come up with him, must work side by side with him: apart from
the difference between a great master and a scholar, apart from
the differences of the natural bent of men's minds, which would
make one man an imitative, and another an architectural or
decorative artist, there should be no difference between those
employed on strictly ornamental work: and the body of artists
dealing with this should quicken with their art all makers of
things into artists also, in proportion to the necessities and uses
of the things they would make.

I know what stupendous difficulties social and economical,
there are in the way of this; yet I think that they seem to be

greater than they are: and of one thing I am sure, that no real living decorative art is possible if this is impossible.

It is not impossible, on the contrary it is certain to come about, if you are at heart desirous to quicken the arts; if the world will, for the sake of beauty and decency, sacrifice some of the things it is so busy over (many of which I think are not very worthy of its trouble) art will begin to grow again; as for those difficulties above mentioned, some of them I know will in any case melt away before the steady change of the relative conditions of men; the rest, reason and resolute attention to the laws of nature, which are also the laws of art, will dispose of little by little: once more, the way will not be far to seek, if the will be with us.

Yet, granted the will, and though the way lies ready to us, we must be discouraged if the journey seem barren enough at first, nay, not even if things seem to grow worse for a while: for it is natural enough that the very evil which has forced on the beginning of reform should look uglier while, on the one hand, life and wisdom are building up the new, and on the other, folly and deadness are hugging the old to them.

In this, as in all other matters, lapse of time will be needed before things seem to straighten, and the courage and patience that does not despise small things lying ready to be done; and care and watchfulness, lest we begin to build the wall ere the footings are well in, and always through all things much humility that is not easily cast down by failure, that seeks to be taught, and is ready to learn.

For your teachers, they must be Nature and History: as for the first, that you must learn of it is so obvious that I need not dwell upon that now: hereafter, when I have to speak more of matters of detail, I may have to speak of the manner in which you must learn of Nature. As to the second, I do not think that any man but one of the highest genius, could do anything in these days without much study of ancient art, and even he would be

much hindered if he lacked it. If you think that this contradicts what I said about the death of that ancient art, and the necessity I implied for an art that should be characteristic of the present day, I can only say that, in these times of plenteous knowledge and meagre performance, if we do not study the ancient work directly and learn to understand it, we shall find ourselves influenced by the feeble work all round us, and shall be copying the better work through the copyists and *without* understanding it, which will by no means bring about intelligent art. Let us therefore study it wisely, be taught by it, kindled by it; all the while determining not to imitate or repeat it; to have either no art at all, or an art which we have made our own.

Yet I am almost brought to a stand-still when bidding you to study nature and the history of art, by remembering that this is London, and what it is like: how can I ask working-men passing up and down these hideous streets day by day to care about beauty? If it were politics, we must care about that; or science, you could wrap yourselves up in the study of facts, no doubt, without much caring what goes on about you—but beauty! do you not see what terrible difficulties beset art, owing to a long neglect of art—and neglect of reason, too, in this matter? It is such a heavy question by what effort, by what dead-lift, you can thrust this difficulty from you, that I must perforce set it aside for the present, and must at least hope that the study of history and its monuments will help you somewhat herein. If you can really fill your minds with memories of great works of art, and great times of art, you will, I think, be able to a certain extent to look through the aforesaid ugly surroundings, and will be moved to discontent of what is careless and brutal now, and will, I hope, at last be so much discontented with what is bad, that you will determine to bear no longer that short-sighted, reckless brutality of squalor that so disgraces our intricate civilisation.

Well, at any rate, London is good for this, that it is well off for museums,—which I heartily wish were to be got at seven days in

the week instead of six, or at least on the only day on which an ordinarily busy man, one of the taxpayers who support them, can as a rule see them quietly,—and certainly any of us who may have any natural turn for art must get more help from frequenting them than one can well say. It is true, however, that people need some preliminary instruction before they can get all the good possible to be got from the prodigious treasures of art possessed by the country in that form: there also one sees things in a piecemeal way: nor can I deny that there is something melancholy about a museum, such a tale of violence, destruction, and carelessness, as its treasured scraps tell us.

But moreover you may sometimes have an opportunity of studying ancient art in a narrower but a more intimate, a more kindly form, the monuments of our own land. Sometimes only, since we live in the middle of this world of brick and mortar, and there is little else left us amidst it, except the ghost of the great church at Westminster, ruined as its exterior is by the stupidity of the restoring architect, and insulted as its glorious interior is by the pompous undertakers' lies, by the vainglory, and ignorance of the last two centuries and a half—little besides that and the matchless Hall near it: but when we can get beyond that smoky world, there, out in the country we may still see the works of our fathers yet alive amidst the very nature they were wrought into, and of which they are so completely a part: for there indeed if anywhere, in the English country, in the days when people cared about such things, was there a full sympathy between the works of man and the land they were made for:—the land is a little land; too much shut up within the narrow seas, as it seems, to have much space for swelling into hugeness: there are no great wastes overwhelming in their dreariness, no great solitudes of forests, no terrible untrodden mountain-walls: all is measured, mingled, varied, gliding easily one thing into another: little rivers, little plains, swelling, speedily-changing uplands, all beset with handsome orderly trees; little hills, little mountains, netted

over with the walls of sheep-walks: all is little; yet not foolish
and blank, but serious rather, and abundant of meaning for such
as choose to seek it: it is neither prison nor palace, but a decent
home.

All which I neither praise nor blame, but say that so it is:
some people praise this homeliness overmuch, as if the land were
the very axle-tree of the world; so do not I, nor any unblinded by
pride in themselves and all that belongs to them: others there are
who scorn it and the tameness of it: not I any the more: though
it would indeed be hard if there were nothing else in the world,
no wonders, no terrors, no unspeakable beauties: yet when we
think what a small part of the world's history, past, present, and
to come, is this land we live in, and how much smaller still in the
history of the arts, and yet how our forefathers clung to it, and
with what care and pains they adorned it, this unromantic,
uneventful-looking land of England, surely by this too our hearts
may be touched, and our hope quickened.

For as was the land, such was the art of it while folk yet
troubled themselves about such things; it strove little to impress
people either by pomp or ingenuity: not unseldom it fell into
commonplace, rarely it rose into majesty; yet was it never
oppressive, never a slave's nightmare nor an insolent boast: and
at its best it had an inventiveness, an individuality, that grander
styles have never overpassed: its best too, and that was in its very
heart, was given as freely to the yeoman's house, and the humble
village church, as to the lord's palace or the mighty cathedral:
never coarse, though often rude enough, sweet, natural and
unaffected, an art of peasants rather than of merchant-princes or
courtiers, it must be a hard heart, I think, that does not love it:
whether a man has been born among it like ourselves, or has
come wonderingly on its simplicity from all the grandeur over-
seas. A peasant art, I say, and it clung fast to the life of the people,
and still lived among the cottagers and yeomen in many parts of
the country while the big houses were being built 'French and

fine': Still lived also in many a quaint pattern of loom and
printing-block, and embroiderer's needle, while over-seas stupid
pomp had extinguished all nature and freedom, and art was
become, in France especially, the mere expression of that
successful and exultant rascality, which in the flesh no long time
afterwards went down into the pit for ever.[4]

Such was the English art, whose history is in a sense at your
doors, grown scarce indeed, and growing scarcer year by year, not
only through greedy destruction, of which there is certainly less
than there used to be, but also through the attacks of another foe,
called now-a-days 'restoration.'

... You will see by all that I have said on this study of ancient art
that I mean by education herein something much wider than the
teaching of a definite art in schools of design, and that it must be
something that we must do more or less for ourselves: I mean by
it a systematic concentration of our thoughts on the matter, a
studying of it in all ways, careful and laborious practice of it, and
a determination to do nothing but what is known to be good in
workmanship and design.

Of course, however, both as an instrument of that study we
have been speaking of, as well as of the practice of the arts, all
handicraftsmen should be taught to draw very carefully; as
indeed all people should be taught drawing who are not physi-
cally incapable of learning it: but the art of drawing so taught
would not be the art of designing, but only a means towards *this*
end, *general capability in dealing with the arts.*

For I wish specially to impress this upon you, that *designing*
cannot be taught at all in a school: continued practice will help a
man who is naturally a designer, continual notice of nature and
of art: no doubt those who have some faculty for designing are
still numerous, and they want from a school certain technical
teaching, just as they want tools: in these days also, when the best
school, the school of successful practice going on around you, is

at such a low ebb, they do undoubtedly want instruction in the history of the arts: these two things schools of design can give: but the royal road of a set of rules deduced from a sham science of design, that is itself not a science but another set of rules, will lead nowhere;—or, let us rather say, to beginning again.

As to the kind of drawing that should be taught to men engaged in ornamental work, there is only *one best* way of teaching drawing, and that is teaching the scholar to draw the human figure: both because the lines of a man's body are much more subtle than anything else, and because you can more surely be found out and set right if you go wrong. I do think that such teaching as this, given to all people who care for it, would help the revival of the arts very much: the habit of discriminating between right and wrong, the sense of pleasure in drawing a good line, would really, I think, be education in the due sense of the word for all such people as had the germs of invention in them; yet as aforesaid, in this age of the world it would be mere affectation to pretend to shut one's eyes to the art of past ages: that also we must study. If other circumstances, social and economical, do not stand in our way, that is to say, if the world is not too busy to allow us to have Decorative Arts at all, these two are the *direct* means by which we shall get them; that is, general cultivation of the powers of the mind, general cultivation of the powers of the eye and hand ...

There is a great deal of sham work in the world, hurtful to the buyer, more hurtful to the seller, if he only knew it, most hurtful to the maker: how good a foundation it would be toward getting good Decorative Art, that is ornamental workmanship, if we craftsmen were to resolve to turn out nothing but excellent workmanship in all things, instead of having, as we too often have now, a very low average standard of work, which we often fall below.

I do not blame either one class or another in this matter, I

blame all: to set aside our own class of handicraftsmen, of whose shortcomings you and I know so much that we need talk no more about it, I know that public in general are set on having things cheap, being so ignorant that they do not know when they get them nasty also; so ignorant that they neither know nor care whether they give a man his due: I know that the manufacturers (so called) are so set on carrying out competition to its utmost, competition of cheapness, not of excellence, that they meet the bargain-hunters half way, and cheerfully furnish them with nasty wares at the cheap rate they are asked for, by means of what can be called by no prettier name than fraud. England has of late been too much busied with the counting-house and not enough with the workshop: with the result that the counting-house at the present moment is rather barren of orders.

I say all classes are to blame in this matter, but also I say that the remedy lies with the handicraftsmen, who are not ignorant of these things like the public, and who have no call to be greedy and isolated like the manufacturers or middlemen; the duty and honour of educating the public lies with them, and they have in them the seeds of order and organisation which make that duty the easier.

When will they see to this and help to make men of us by insisting on this most weighty piece of manners; so that we may adorn life with the pleasure of cheerfully *buying* goods at their due price; with the pleasure of *selling* goods that we could be proud of both for fair price and fair workmanship: with the pleasure of working soundly and without haste at *making* goods that we could be proud of?—much the greatest pleasure of the three is that last, such a pleasure as, I think, the world has none like it.

You must not say that this piece of manners lies out of my subject: it is essentially a part of it and most important: for I am bidding you learn to be artists, if art is not to come to an end amongst us: and what is an artist but a workman who is

determined that, whatever else happens, his work shall be excellent? or, to put it another way: the decoration of workmanship, what is it but the expression of man's pleasure in successful labour? But what pleasure can there be in *bad* work, in *un*successful labour; why should we decorate *that*? and how can we bear to be always unsuccessful in our labour?

As greed of unfair gain, wanting to be paid for what we have not earned, cumbers our path with this tangle of bad work, of sham work, so the heaped-up money which this greed has brought us (for greed will have its way, like all other strong passions), this money, I say, gathered into heaps little and big, with all the false distinction which so unhappily it yet commands amongst us, has raised up against the arts a barrier of the love of luxury and show, which is of all obvious hindrances the worst to overpass: the highest and most cultivated classes are not free from the vulgarity of it, and the lower are not free from its pretence. I beg you to remember both as a remedy against this, and as explaining exactly what I mean, that nothing can be a work of art which is not useful; that is to say, which does not minister to the body when well under command of the mind, or which does not amuse, soothe, or elevate the mind in a healthy state. What tons upon tons of unutterable rubbish pretending to be works of art in some degree would this maxim clear out of our London houses, if it were understood and acted upon! To my mind it is only here and there (out of the kitchen) that you can find in a well-to-do house things that are of any use at all: as a rule all the decoration (so called) that has got there is there, for the sake of show, not because anybody likes it. I repeat, this stupidity goes through all classes of society: the silk curtains in my Lord's drawing-room are no more a matter of art to him than the powder in his footman's hair; the kitchen in a country farmhouse is most commonly a pleasant and homelike place, the parlour dreary and useless.

Simplicity of life, begetting simplicity of taste, that is, a love

for sweet and lofty things, is of all matters most necessary for the birth of the new and better art we crave for; simplicity everywhere, in the palace as well as in the cottage.

Still more is this necessary, cleanliness and decency everywhere, in the cottage as well as in the palace: the lack of that is a serious piece of *manners* for us to correct: that lack and all the inequalities of life, and the heaped-up thoughtlessness and disorder of so many centuries that cause it: and as yet it is only a very few men who have begun to think about a remedy for it in its widest range: even in its narrower aspect, in the defacements of our big towns by all that commerce brings with it, who heeds it? who tries to control their squalor and hideousness? there is nothing but thoughtlessness and recklessness in the matter: the helplessness of people who don't live long enough to do a thing themselves, and have not manliness and foresight enough to begin the work, and pass it on to those that shall come after them.

Is money to be gathered? cut down the pleasant trees among the houses, pull down ancient and venerable buildings for the money that a few square yards of London dirt will fetch; blacken rivers, hide the sun and poison the air with smoke and worse, and it's nobody's business to see to it or mend it: that is all that modern commerce, the counting-house forgetful of the workshop, will do for us herein.

And Science—we have loved her well, and followed her diligently, what will she do? I fear she is so much in the pay of the counting-house, the counting-house and the drill-sergeant, that she is too busy, and will for the present do nothing. Yet there are matters which I should have thought easy for her; say for example teaching Manchester how to consume its own smoke, or Leeds how to get rid of its superfluous black dye without turning it into the river, which would be as much worth her attention as the production of the heaviest of heavy black silks, or the biggest of useless guns. Anyhow, however it be done, unless

people care about carrying on their business without making the world hideous, how can they care about Art? I know it will cost much both of time and money to better these things even a little; but I do not see how these can be better spent than in making life cheerful and honourable for others and for ourselves; and the gain of good life to the country at large that would result from men seriously setting about the bettering of the decency of our big towns would be priceless, even if nothing specially good befell the arts in consequence: I do not know that it would; but I should begin to think matters hopeful if men turned their attention to such things, and I repeat that, unless they do so, we can scarcely even begin with any hope our endeavours for the bettering of the Arts.

Unless something or other is done to give all men some pleasure for the eyes and rest for the mind in the aspect of their own and their neighbours' houses, until the contrast is less disgraceful between the fields where beasts live and the streets where men live, I suppose that the practice of the arts must be mainly kept in the hands of a few highly cultivated men, who can go often to beautiful places, whose education enables them, in the contemplation of the past glories of the world, to shut out from their view the everyday squalors that the most of men move in. Sirs, I believe that art has such sympathy with cheerful freedom, open-heartedness and reality, so much she sickens under selfishness and luxury, that she will not live thus isolated and exclusive. I will go further than this, and say that on such terms I do not wish her to live. I protest that it would be a shame to an honest artist to enjoy what he had huddled up to himself of such art, as it would be for a rich man to sit and eat dainty food amongst starving soldiers in a beleaguered fort.

I do not want art for a few, any more than education for a few, or freedom for a few.

No, rather than art should live this poor thin life among a few exceptional men, despising those beneath them for an ignorance

for which they themselves are responsible, for a brutality that they will not struggle with,—rather than this, I would that the world should indeed sweep away all art for awhile, as I said before I thought it possible she might do: rather than the wheat should rot in the miser's granary, I would that the earth had it, that it might yet have a chance to quicken in the dark.

I have a sort of faith, though, that this clearing away of all art will not happen, that men will get wiser, as well as more learned; that many of the intricacies of life, on which we now pride ourselves more than enough, partly because they are new, partly because they have come with the gain of better things, will be cast aside as having played their part, and being useful no longer. I hope that we shall have leisure from war,—war commercial, as well as war of the bullet and the bayonet; leisure from the knowledge that darkens counsel; leisure above all from the greed of money, and the craving for that overwhelming distinction that money now brings: I believe that as we have even now partly achieved LIBERTY, so we shall one day achieve EQUALITY, which, and which only, means FRATERNITY, and so have leisure from poverty and all its griping, sordid cares.

Then, having leisure from all these things, amidst renewed simplicity of life we shall have leisure to think about our work, that faithful daily companion, which no man any longer will venture to call the Curse of labour: for surely then we shall be happy in it, each in his place, no man grudging at another; no one bidden to be any man's *servant*, everyone scorning to be any man's *master*: men will then assuredly be happy in their work, and that happiness will assuredly bring forth decorative, noble, *popular* art.

That art will make our streets as beautiful as the woods, as elevating as the mountain-sides: it will be a pleasure and a rest, and not a weight upon the spirits to come from the open country into a town; every man's house will be fair and decent, soothing to his mind and helpful to his work: all the works of man that we

live amongst and handle will be in harmony with nature, will be reasonable and beautiful: yet all will be simple and inspiriting, not childish nor enervating; for as nothing of beauty and splendour that man's mind and hand may compass shall be wanting from our public buildings, so in no private dwelling will there be any signs of waste, pomp, or insolence, and every man will have his share of the *best*.

It is a dream, you may say, of what has never been and never will be: true, it has never been, and therefore, since the world is alive and moving yet, my hope is the greater that it one day will be: true, it is a dream; but dreams have before now come about of things so good and necessary to us, that we scarcely think of them more than of the daylight, though once people had to live without them, without even the hope of them.

Anyhow, dream as it is, I pray you to pardon my setting it before you, for it lies at the bottom of all my work in the Decorative Arts, nor will it ever be out of my thoughts: and I am here with you to-night to ask you to help me in realising this dream, this *hope*.

Notes

1 1207–72.

2 Justinian I (483–565), Byzantine emperor.

3 A bell-wether is a male sheep which leads the flock.

4 A reference to French Baroque and Rococo art, and to the French Revolution of 1789.

FROM 'THE ART OF THE PEOPLE'

1879

... That thing which I understand by real art is the expression by man of his pleasure in labour. I do not believe he can be happy in his labour without expressing that happiness; and especially is this so when he is at work at anything in which he specially excels. A most kind gift is this of nature, since all men, nay, it seems all things too, must labour; so that not only does the dog take pleasure in hunting, and the horse in running, and the bird in flying, but so natural does the idea seem to us, that we imagine to ourselves that the earth and the very elements rejoice in doing their appointed work; and the poets have told us of the spring meadows smiling, of the exultation of the fire, of the countless laughter of the sea.

Nor until these latter days has man ever rejected this universal gift, but always, when he has not been too much perplexed, too much bound by disease or beaten down by trouble, has striven to make his work at least, happy. Pain he has too often found in his pleasure, and weariness in his rest, to trust to these. What matter if his happiness lie with what must be always with him—his work?

And, once more, shall we, who have gained so much, forego this gain, the earliest, most natural gain of mankind? If we have to a great extent done so, as I verily fear we have, what strange foglights must have misled us; or rather let me say, how hard pressed we must have been in the battle with the evils we have

overcome, to have forgotten the greatest of all evils. I cannot call
it less than that. If a man has work to do which he despises,
which does not satisfy his natural and rightful desire for pleasure,
the greater part of his life must pass unhappily and without self-
respect. Consider, I beg of you, what that means, and what ruin
must come of it in the end ...

... I cannot forget that, in my mind, it is not possible to disso-
ciate art from morality, politics, and religion. Truth in these great
matters of principle is of one, and it is only in formal treatises
that it can be split up diversely. I must also ask you to remember
how I have already said, that though my mouth alone speaks, it
speaks, however feebly and disjointedly, the thoughts of many
men better than myself. And further, though when things are
tending to the best, we shall still, as aforesaid, need our best men
to lead us quite right; yet even now surely, when it is far from
that, the least of us can do some yeoman's service to the cause,
and live and die not without honour.

So I will say that I believe there are two virtues much needed
in modern life, if it is ever to become sweet; and I am quite sure
that they are absolutely necessary in the sowing the seed of an *art
which is to be made by the people and for the people, as a happiness to the
maker and the user.* These virtues are honesty, and simplicity of life.
To make my meaning clearer I will name the opposing vice of the
second of these—luxury to wit. Also I mean by honesty, the
careful and eager giving his due to every man, the determination
not to gain by any man's loss, which in my experience is not a
common virtue.

But note how the practice of either of these virtues will make
the other easier to us. For if our wants are few, we shall have
but little chance of being driven by our wants into injustice; and
if we are fixed in the principle of giving every man his due,
how can our self-respect bear that we should give too much to
ourselves?

And in art, and in that preparation for it without which no art

that is stable or worthy can be, the raising, namely, of those classes which have heretofore been degraded, the practice of these virtues would make a new world of it. For if you are rich, your simplicity of life will both go towards smoothing over the dreadful contrast between waste and want, which is the great horror of civilised countries, and will also give an example and standard of dignified life to those classes which you desire to raise, who, as it is indeed, being like enough to rich people, are given both to envy and to imitate the idleness and waste that the possession of much money produces.

Nay, and apart from the morality of the matter, which I am forced to speak to you of, let me tell you that though simplicity in art may be costly as well as uncostly, at least it is not wasteful, and nothing is more destructive to art than the want of it. I have never been in any rich man's house which would not have looked the better for having a bonfire made outside of it of nine-tenths of all that it held. Indeed, our sacrifice on the side of luxury will, it seems to me, be little or nothing: for, as far as I can make out, what people usually mean by it, is either a gathering of possessions which are sheer vexations to the owner, or a chain of pompous circumstance, which checks and annoys the rich man at every step. Yes, luxury cannot exist without slavery of some kind or other, and its abolition will be blessed, like the abolition of other slaveries, by the freeing both of the slaves and of their masters.

Lastly, if, besides attaining to simplicity of life, we attain also to the love of justice, then will all things be ready for the new springtime of the arts. For those of us that are employers of labour, how can we bear to give any man less money than he can decently live on, less leisure than his education and self-respect demand? or those of us who are workmen, how can we bear to fail in the contract we have undertaken, or to make it necessary for a foreman to go up and down spying out our mean tricks and evasions? or we the shopkeepers—can we endure to lie about our

wares, that we may shuffle off our losses on to some one else's shoulders? or we the public—how can we bear to pay a price for a piece of goods which will help to trouble one man, to ruin another, and starve a third? Or, still more, I think, how can we bear to use, how can we enjoy something which has been a pain and a grief for the maker to make?

... if to any of you I have seemed to speak hopelessly, my words have been lacking in art; and you must remember that hopelessness would have locked my mouth, not opened it. I am, indeed, hopeful, but can I give a date to the accomplishment of my hope, and say that it will happen in my life or yours?

But I will say at least, Courage! for things wonderful, unhoped-for, glorious, have happened even in this short while I have been alive.

Yes, surely these times are wonderful and fruitful of change, which, as it wears and gathers new life even in its wearing, will one day bring better things for the toiling days of men, who with freer hearts and clearer eyes, will once more gain the sense of outward beauty, and rejoice in it.

Meanwhile, if these hours be dark, as, indeed, in many ways they are, at least do not let us sit deedless, like fools and fine gentlemen, thinking the common toil not good enough for us, and beaten by the muddle; but rather let us work like good fellows trying by some dim candle-light to set our workshop ready against to-morrow's daylight—that to-morrow, when the civilised world, no longer greedy, strifeful, and destructive, shall have a new art, a glorious art, made by the people and for the people, as a happiness to the maker and the user.

FROM 'THE AIMS OF ART'

1886

... I do not think that anything will take the place of art; not that I doubt the ingenuity of man, which seems to be boundless in the direction of making himself unhappy, but because I believe the springs of art in the human mind to be deathless, and also because it seems to me easy to see the causes of the present obliteration of the arts.

For we civilized people have not given them up consciously, or of our free will; we have been *forced* to give them up. Perhaps I can illustrate that by the detail of the application of machinery to the production of things in which artistic form of some sort is possible. Why does a reasonable man use a machine? Surely to save his labour. There are some things which a machine can do as well as man's hand, *plus* a tool can do them. He need not, for instance, grind his corn in hand-quern; a little trickle of water, a wheel, and a few simple contrivances will do it all perfectly well, and leave him free to smoke his pipe and think, or carve the handle of his knife. That, so far, is unmixed gain in the use of a machine—always, mind you, supposing equality of condition among men; no art is lost, leisure or time for more pleasurable work is gained. Perhaps a perfectly reasonable and free man would stop there in his dealings with machinery; but such reason and freedom are too much to expect, so let us follow our machine-inventor a step further. He has to weave plain cloth, and finds doing so dullish on the one hand, and on the other that a

power-loom will weave the cloth nearly as well as a hand-loom: so, in order to gain more leisure or time for more pleasurable work, he uses a power-loom, and foregoes the small advantage of the little extra art in the cloth. But so doing, as far as the art is concerned, he has not got a pure gain; he has made a bargain between art and labour, and has got a makeshift as a consequence. I do not say that he may not be right in doing so, but he has lost as well as gained. Now, this is as far as a man who values art and is reasonable would go in the matter of machinery *as long as he was free*—that is, was not *forced* to work for another man's profit; so long as he was living in a society *that accepted equality of condition*. Carry the machine used for art a step further, and he becomes an unreasonable man if he values art, and is free. To avoid misunderstanding, I must say that I am thinking of the modern machine, which is as it were alive, and to which the man is auxiliary, and not of the old machine, the improved tool, which is auxiliary to the man, and only works as long as his hand is thinking; though I will remark, that even this elementary form of machine has to be dropped when we come to the higher and more intricate forms of art. Well, as to the machine proper used for art, when it gets to the stage above dealing with a necessary production that has accidentally some beauty about it, a reasonable man with a feeling for art will only use it when he is *forced* to. If he thinks he would like ornament, for instance, and knows that the machine cannot do it properly, and does not care to spend the time doing it properly, why should he do it at all? He will not diminish his leisure for the sake of making something he does not want unless some man or band of men force him to it; so he will either go without the ornament, or sacrifice some of his leisure to have it genuine. That will be a sign that he wants it very much, and that it will be worth his trouble: in which case, again, his labour on it will not be mere trouble, but will interest and please him by satisfying the needs of his mood of energy.

This, I say is how a reasonable man would act if he were free

from man's compulsion; not being free, he acts very differently. He has long passed the stage at which machines are only used for doing work repulsive to an average man, or for doing what could be done as well by a machine as a man, and he instinctively expects a machine to be invented whenever any product of industry becomes sort after. He is the slave to the machinery; the new machine *must* be invented, and when invented he *must*—I will not say use it, but be used by it, whether he likes it or not.

But why is he the slave to the machinery? Because he is the slave to the system for whose existence the invention of machinery was necessary.

And now I must drop, or rather have dropped, the assumption of the equality of condition, and remind you that, though in a sense we are all the slaves of machinery, yet that some men are so directly without any metaphor at all, and that these are just those on whom the great body of the arts depends—the workmen. It is necessary for the system which keeps them in their position as an inferior class that they should either be themselves machines or be the servants to machines, in no case having any interest in the work which they turn out. To their employers they are, as far as they are workmen, a part of the machinery of the workshop or the factory; to themselves they are proletarians, human beings working to live that they may live to work: their part of craftsmen, of makers of things by their own free will, is played out ...

THE REVIVAL OF HANDICRAFT

1888

For some time past there has been a good deal of interest shown in what is called in our modern slang Art Workmanship, and quite recently there has been a growing feeling that this art workmanship to be of any value must have some of the workman's individuality imparted to it beside whatever of art it may have got from the design of the artist who has planned, but not executed the work. This feeling has gone so far that there is growing up a fashion for demanding handmade goods even when they are not ornamented in any way, as, for instance, woollen and linen cloth spun by hand and woven without power, hand-knitted hosiery, and the like. Nay, it is not uncommon to hear regrets for the hand-labour in the fields, now fast disappearing from even backward districts of civilized countries. The scythe, the sickle, and even the flail are lamented over, and many are looking forward with drooping spirits to the time when the hand-plough will be as completely extinct as the quern, and the rattle of the steam-engine will take the place of the whistle of the curly-headed ploughboy through all the length and breadth of the land. People interested, or who suppose that they are interested, in the details of the arts of life feel a desire to revert to methods of handicraft for production in general; and it may therefore be worth considering how far this is a mere reactionary sentiment incapable of realization, and how far it may foreshadow a real coming change in our habits of life as

irresistible as the former change which has produced the system of machine-production, the system against which revolt is now attempted.

In this paper I propose to confine the aforesaid consideration as much as I can to the effect of machinery *versus* handicraft upon the arts; using that latter word as widely as possible, so as to include all products of labour which have any claims to be considered beautiful. I say as far as possible: for as all roads lead to Rome, so the life, habits, and aspirations of all groups and classes of the community are founded on the economical conditions under which the mass of the people live, and it is impossible to exclude socio-political questions from the consideration of aesthetics. Also, although I must avow myself a sharer in the above-mentioned reactionary regrets, I must at the outset disclaim the mere aesthetic point of view which looks upon the ploughman and his bullocks and his plough, the reaper, his work, his wife, and his dinner, as so many elements which compose a pretty tapestry hanging, fit to adorn the study of a contemplative person of cultivation, but which it is not worth while differentiating from each other except in so far as they are related to the beauty and interest of the picture. On the contrary, what I wish for is that the reaper and his wife should have themselves a due share in all the fulness of life; and I can, without any great effort, perceive the justice of their forcing me to bear part of the burden of its deficiencies, so that we may together be forced to attempt to remedy them, and have no very heavy burden to carry between us.

To return to our aesthetics: though a certain part of the cultivated classes of to-day regret the disappearance of handicraft from production, they are quite vague as to how and why it is disappearing, and as to how and why it should or may reappear. For to begin with the general public is grossly ignorant of all the methods and processes of manufacture. This is of course one result of the machine-system we are considering. Almost all

goods are made apart from the life of those who use them; we are not responsible for them, our will has had no part in their production, except so far as we form a part of the market on which they can be forced for the profit of the capitalist whose money is employed in producing them. The market assumes that certain wares are wanted; it produces such wares, indeed, but their kind and quality are only adapted to the needs of the public in a very rough fashion, because the public needs are subordinated to the interest of the capitalist masters of the market, and they can force the public to put up with the less desirable article if they choose, as they generally do. The result is that in this direction our boasted individuality is a sham; and persons who wish for anything that deviates ever so little from the beaten path have either to wear away their lives in a wearisome and mostly futile contest with a stupendous organization which disregards their wishes, or to allow those wishes to be crushed out for the sake of a quiet life.

Let us take a few trivial but undeniable examples. You want a hat, say, like that you wore last year; you go to the hatter's, and find you cannot get it there, and you have no resource but in submission. Money by itself won't buy you the hat you want; it will cost you three months' hard labour and twenty pounds to have an inch added to the brim of your wideawake; for you will have to get hold of a small capitalist (of whom but few are left), and by a series of intrigues and resolute actions which would make material for a three-volume novel, get him to allow you to turn one of his hands into a handicraftsman for the occasion; and a very poor handicraftsman he will be, when all is said. Again, I carry a walking-stick, and like all sensible persons like it to have a good heavy end that will swing out well before me. A year or two ago it became the fashion to pare away all walking-sticks to the shape of attenuated carrots, and I really believe I shortened my life in my attempts at getting a reasonable staff of the kind I was used to, so difficult it was. Again, you want a

piece of furniture, which the trade (mark the word, Trade, not Craft!) turns out blotched over with idiotic sham ornament; you wish to dispense with this degradation, and propose it to your upholsterer, who grudgingly assents to it; and you find that you have to pay the price of two pieces of furniture for the privilege of indulging your whim of leaving out the trade finish (I decline to call it ornament) on the one you have got made for you. And this is because it has been made by handicraft instead of machinery. For most people, therefore, there is a prohibitive price put upon the acquirement or the knowledge of methods and processes. We do not know how a piece of goods is made, what the difficulties are that beset its manufacture, what it ought to look like, feel like, smell like, or what it ought to cost apart from the profit of the middleman. We have lost the art of marketing, and with it the due sympathy with the life of the workshop, which would, if it existed, be such a wholesome check on the humbug of party politics.

It is a natural consequence of this ignorance of the methods of making wares, that even those who are in revolt against the tyranny of the excess of division of labour in the occupations of life, and who wish to recur more or less to handicraft, should also be ignorant of what that life of handicraft was when all wares were made by handicraft. If their revolt is to carry any hope with it, it is necessary that they should know something of this. I must assume that many or perhaps most of my readers are not acquainted with Socialist literature, and that few of them have read the admirable account of the different epochs of production given in Karl Marx' great work entitled 'Capital.' I must ask to be excused, therefore, for stating very briefly what, chiefly owing to Marx, has become a commonplace of Socialism, but is not generally known outside it. There have been three great epochs of production since the beginning of the Middle Ages. During the first or mediaeval period all production was individualistic in method; for though the workmen were combined into great

associations for protection and the organization of labour, they were so associated as citizens, not as mere workmen. There was little or no division of labour, and what machinery was used was simply of the nature of a multiplied tool, a help to the workman's hand-labour and not a supplanter of it. The workman worked for himself and not for any capitalistic employer, and he was accordingly master of his work and his time; this was the period of pure handicraft. When in the latter half of the sixteenth century the capitalist employer and the so-called free workman began to appear, the workmen were collected into workshops, the old tool-machines were improved, and at last a new invention, the division of labour, found its way into the workshops. The division of labour went on growing throughout the seventeenth century, and was perfected in the eighteenth, when the unit of labour became a group and not a single man; or in other words the workman became a mere part of a machine composed sometimes wholly of human beings and sometimes of human beings plus labour-saving machines, which towards the end of this period were being copiously invented; the fly-shuttle may be taken for an example of these. The latter half of the eighteenth century saw the beginning of the last epoch of production that the world has known, that of the automatic machine which supersedes hand-labour, and turns the workman who was once a handicraftsman helped by tools, and next a part of a machine, into a tender of machines. And as far as we can see, the revolution in this direction as to kind is complete, though as to degree, as pointed out by Mr. David A. Wells last year (1887),[1] the tendency is towards the displacement of ever more and more 'muscular' labour, as Mr. Wells calls it.

This is very briefly the history of the evolution of industry during the last five hundred years; and the question now comes: Are we justified in wishing that handicraft may in its turn supplant machinery? Or it would perhaps be better to put the question in another way: Will the period of machinery evolve

itself into a fresh period of machinery more independent of human labour than anything we can conceive of now, or will it develop its contradictory in the shape of a new and improved period of production by handicraft? The second form of the question is the preferable one, because it helps us to give a reasonable answer to what people who have any interest in external beauty will certainly ask: Is the change from handicraft to machinery good or bad? And the answer to that question is to my mind that, as my friend Belfort Bax[2] has put it, statically it is bad, dynamically it is good. As a condition of life, production by machinery is altogether an evil; as an instrument for forcing on us better conditions of life it has been, and for some time yet will be, indispensable.

Having thus tried to clear myself of mere reactionary pessimism, let me attempt to show why statically handicraft is to my mind desirable, and its destruction a degradation of life. Well, first I shall not shrink from saying bluntly that production by machinery necessarily results in utilitarian ugliness in everything which the labour of man deals with, and that this is a serious evil and a degradation of human life. So clearly is this the fact that though few people will venture to deny the latter part of the proposition, yet in their hearts the greater part of cultivated civilized persons do not regard it as an evil, because their degradation has already gone so far that they cannot, in what concerns the sense of seeing, discriminate between beauty and ugliness: their languid assent to the desirableness of beauty is with them only a convention, a superstitious survival from the times when beauty was a necessity to all men. The first part of the proposition (that machine-industry produces ugliness) I cannot argue with these persons, because they neither know, nor care for, the difference between beauty and ugliness; and with those who do understand what beauty means I need not argue it, as they are but too familiar with the fact that the produce of all modern industrialism is ugly, and that whenever anything which is old

disappears, its place is taken by something inferior to it in beauty; and that even out in the very fields and open country. The art of making beautifully all kinds of ordinary things, carts, gates, fences, boats, bowls, and so forth, let alone houses and public buildings, unconsciously and without effort, has gone; when anything has to be renewed among these simple things the only question asked is how little it can be done for, so as to tide us over our responsibility and shift its mending on to the next generation.

It may be said, and indeed I have heard it said, that since there is some beauty still left in the world and some people who admire it, there is a certain gain in the acknowledged eclecticism of the present day, since the ugliness which is so common affords a contrast whereby the beauty, which is so rare, may be appreciated. This I suspect to be only another form of the maxim which is the sheet-anchor of the laziest and most cowardly group of our cultivated classes, that it is good for the many to suffer for the few; but if any one puts forward in good faith the fear that we may be too happy in the possession of pleasant surroundings, so that we shall not be able to enjoy them, I must answer that this seems to me a very remote terror. Even when the tide at last turns in the direction of sweeping away modern squalor and vulgarity, we shall have, I doubt,[3] many generations of effort in perfecting the transformation, and when it is at last complete, there will be first the triumph of our success to exalt us, and next the history of the long wade through the putrid sea of ugliness which we shall have at last escaped from. But furthermore, the proper answer to this objection lies deeper than this. It is to my mind that very consciousness of the production of beauty for beauty's sake which we want to avoid; it is just what is apt to produce affectation and effeminacy amongst the artists and their following. In the great times of art conscious effort was used to produce great works for the glory of the City, the triumph of the Church, the exaltation of the citizens, the quickening of the

devotion of the faithful; even in the higher art, the record of history, the instruction of men alive and to live hereafter, was the aim rather than beauty; and the lesser art was unconscious and spontaneous, and did not in any way interfere with the rougher business of life, while it enabled men in general to understand and sympathize with the nobler forms of art. But unconscious as these producers of ordinary beauty may be, they will not and cannot fail to receive pleasure from the exercise of their work under these conditions, and this above all things is that which influences me most in my hope for the recovery of handicraft. I have said it often enough, but I must say it once again, since it is so much a part of my case for handicraft, that so long as man allows his daily work to be mere unrelieved drudgery he will seek happiness in vain. I say further that the worst tyrants of the days of violence were but feeble tormentors compared with those Captains of Industry who have taken the pleasure of work away from the workmen. Furthermore I feel absolutely certain that handicraft joined to certain other conditions, of which more presently, would produce the beauty and the pleasure in work above mentioned; and if that be so, and this double pleasure of lovely surroundings and happy work could take the place of the double torment of squalid surroundings and wretched drudgery, have we not good reason for wishing, if it might be, that handicraft should once more step into the place of machine-production?

I am not blind to the tremendous change which this revolution would mean. The maxim of modern civilization to a well-to-do man is, Avoid taking trouble! Get as many of the functions of your life as you can performed by others for you! Vicarious life is the watchword of our civilization, and we well-to-do and cultivated people live smoothly enough while it lasts. But, in the first place, how about the vicars, who do more for us than the singing of mass for our behoof for a scanty stipend? Will they go on with it for ever? For indeed the shuffling off of responsibilities from

one to the other has to stop at last, and somebody has to bear the burden in the end. But let that pass, since I am not writing politics, and let us consider another aspect of the matter. What wretched lop-sided creatures we are being made by the excess of the division of labour in the occupations of life! What on earth are we going to do with our time when we have brought the art of vicarious life to perfection, having first complicated the question by the ceaseless creation of artificial wants which we refuse to supply for ourselves? Are all of us (we of the great middle class I mean) going to turn philosophers, poets, essayists —men of genius, in a word, when we have come to look down on the ordinary functions of life with the same kind of contempt wherewith persons of good breeding look down upon a good dinner, eating it sedulously however? I shudder when I think of how we shall bore each other when we have reached that perfection. Nay, I think we have already got in all branches of culture rather more geniuses than we can comfortably bear, and that we lack, so to say, audiences rather than preachers. I must ask pardon of my readers; but our case is at once so grievous and so absurd that one can scarcely help laughing out of bitterness of soul. In the very midst of our pessimism we are boastful of our wisdom, yet we are helpless in the face of the necessities we have created, and which, in spite of our anxiety about art, are at present driving us into luxury unredeemed by beauty on the one hand, and squalor unrelieved by incident or romance on the other, and will one day drive us into mere ruin.

Yes, we do sorely need a system of production which will give us beautiful surroundings and pleasant occupation, and which will tend to make us good human animals, able to do something for ourselves, so that we may be generally intelligent instead of dividing ourselves into dull drudges or duller pleasure-seekers according to our class, on the one hand, or hapless pessimistic intellectual personages, and pretenders to that dignity, on the other. We do most certainly need happiness in our daily work,

content in our daily rest; and all this cannot be if we hand over the whole responsibility of the details of our daily life to machines and their drivers. We are right to long for intelligent handicraft to come back to the world which it once made tolerable amidst war and turmoil and uncertainty of life, and which it should, one would think, make happy now we have grown so peaceful, so considerate of each other's temporal welfare.

Then comes the question, How can the change be made? And here at once we are met by the difficulty that the sickness and death of handicraft is, it seems, a natural expression of the tendency of the age. We willed the end, and therefore the means also. Since the last days of the Middle Ages the creation of an intellectual aristocracy has been, so to say, the spiritual purpose of civilization side by side with its material purpose of supplanting the aristocracy of status by the aristocracy of wealth. Part of the price it has had to pay for its success in that purpose (and some would say it is comparatively an insignificant part) is that this new aristocracy of intellect has been compelled to forgo the lively interest in the beauty and romance of life, which was once the portion of every artificer at least, if not of every workman, and to live surrounded by an ugly vulgarity which the world amidst all its changes has not known till modern times. It is not strange that until recently it has not been conscious of this degradation; but it may seem strange to many that it has now grown partially conscious of it. It is common now to hear people say of such and such a piece of country or suburb: 'Ah! it was so beautiful a year or so ago, but it has been quite spoilt by the building.' Forty years back the building would have been looked on as a vast improvement; now we have grown conscious of the hideousness we are creating, and we go on creating it. We see the price we have paid for our aristocracy of intellect, and even that aristocracy itself is more than half regretful of the bargain, and would be glad if it could keep the gain and not pay the full price for it. Hence not

only the empty grumbling about the continuous march of machinery over dying handicraft, but also various elegant little schemes for trying to withdraw ourselves, some of us, from the consequences (in this direction) of our being superior persons; none of which can have more than a temporary and very limited success. The great wave of commercial necessity will sweep away all these well-meant attempts to stem it, and think little of what it has done, or whither it is going.

Yet after all even these feeble manifestations of discontent with the tyranny of commerce are tokens of a revolutionary epoch, and to me it is inconceivable that machine-production will develop into mere infinity of machinery, or life wholly lapse into a disregard of life as it passes. It is true indeed that powerful as the cultivated middle class is, it has not the power of re-creating the beauty and romance of life; but that will be the work of the new society which the blind progress of commercialism will create, nay, is creating. The cultivated middle class is a class of slave-holders, and its power of living according to its choice is limited by the necessity of finding constant livelihood and employment for the slaves who keep it alive. It is only a society of equals which can choose the life it will live, which can choose to forgo gross luxury and base utilitarianism in return for the unwearying pleasure of tasting the fulness of life. It is my firm belief that we shall in the end realize this society of equals, and also that when it is realized it will not endure a vicarious life by means of machinery; that it will in short be the master of its machinery and not the servant, as our age is.

Meantime, since we shall have to go through a long series of social and political events before we shall be free to choose how we shall live, we should welcome even the feeble protest which is now being made against the vulgarization of all life: first because it is one token amongst others of the sickness of modern civilization; and next, because it may help to keep alive memories of the past which are necessary elements of the life of the future,

and methods of work which no society could afford to lose. In short, it may be said that though the movement towards the revival of handicraft is contemptible on the surface in face of the gigantic fabric of commercialism; yet, taken in conjunction with the general movement towards freedom of life for all, on which we are now surely embarked, as a protest against intellectual tyranny, and a token of the change which is transforming civilization into socialism, it is both noteworthy and encouraging.

Notes

1 David Ames Wells (1828–98), American economist, who was one of the earliest to realize the economic and social significance of unemployment caused by machines displacing workers. He published widely for a general readership. Morris may have had in mind his book, *Practical Economics*, which was published in New York in 1885.

2 E. Belfort Bax (1854–1926) was one of the most intellectual of Morris's colleagues in the Social Democratic Federation and the Socialist League. He taught Morris Marxist economics and together they wrote a series of articles for *The Commonweal*, later published as *Socialism, its Growth and Outcome* (1893).

3 Doubt is used here in its obsolete sense of to fear.

SELECT BIBLIOGRAPHY AND FURTHER READING

i) Editions of Morris's own works

Boos, F. (ed.), *William Morris's Socialist Diary* (London: The Journeyman Press, 1985).

Henderson, P. (ed.), *The Letters of William Morris to his Family and Friends* (London: Longmans, 1950).

Kelvin, N. (ed.), *The Collected Letters of William Morris* (4 vols, Princeton, NJ: Princeton University Press, 1984-96).

LeMire, E. (ed.), *The Unpublished Lectures of William Morris* (Detroit: Wayne State University Press, 1969).

Morris, M. (ed.), *The Collected Works of William Morris* (24 vols, London: Longman, Green & Co., 1910-15).

—(ed.), *William Morris: Artist, Writer, Socialist* (2 vols, Oxford: Basil Blackwell, 1936).

Peterson, W.S. (ed.), *The Ideal Book: Essays and Lectures on the Arts of the Book by William Morris* (Berkeley: University of California Press, 1982).

Salmon, N. (ed.), *Political Writings* (Bristol: Thoemmes Press, 1994).

—(ed.), *Journalism* (Bristol: Thoemmes Press, 1996).

ii) Biographies and surveys

Bradley, I., *William Morris and his World* (London: Thames & Hudson, 1978).

Dore, H., *William Morris* (London: Pyramid, 1990).

Faulkner, P. (ed.), *William Morris: The Critical Heritage* (London: Routledge & Kegan Paul, 1973).

—*Against the Age: An Introduction to William Morris* (London: Allen & Unwin, 1980).

Glasier, J.B., *William Morris and the Early Days of the Socialist Movement* (London: Longmans, Green & Co., 1921).

Henderson, P., *William Morris: His Life, Work and Friends* (London, Thames & Hudson, 1967).

Lindsay, J., *William Morris: His Life & Works* (London: Constable, 1975).

MacCarthy, F., *William Morris: A Life for Our Time* (London: Faber & Faber, 1994).

Mackail, J.W., *The Life and Work of William Morris* (2 vols, London: Longmans, 1899).

Poulson, C., *William Morris* (London: The Apple Press, 1989).

Thompson, E.P., *William Morris: Romantic to Revolutionary* (London: Lawrence & Wishart, 1955).

Thompson, P., *The Work of William Morris* (London: Heinemann, 1967).

Vallance, A., *William Morris: His Art, his Writings and his Public Life* (London: George Bell & Sons, 1897).

iii) Works on Morris's family and friends

Burne-Jones, G., *Memorials of Edward Burne-Jones* (2 vols, London: Macmillan, 1904).

Cowley, J., *The Victorian Encounter with Marx: A Study of Ernest Belfort Bax* (London: British Academic Press, 1992).

Faulkner, P. (ed.), *Jane Morris to Wilfrid Scawen Blunt* (Exeter: University of Exeter, 1986).

Fitzgerald, P., *Edward Burne-Jones: A Biography* (London: Michael Joseph, 1975).

Lethaby, W.R., *Philip Webb and his Work* (London: Oxford University Press, 1935).

Marsh, J., *Jane and May Morris: A Biographical Story 1839–1938* (London: Pandora, 1986).

iv) Other important works

Arnot, R.P., *William Morris: A Vindication* (London: Martin Lawrence, 1934).

—*William Morris: The Man and the Myth* (London: Lawrence & Wishart, 1964).

Banham, J. & Harris, J. (eds.), *William Morris and the Middle Ages* (Manchester: Manchester University Press, 1984).

Clark, F., *William Morris: Wallpapers and Chintzes* (London: Academy Editions, 1974).

Cockerell, S. (ed.), *A Note by William Morris on his aims in founding the Kelmscott Press, together with a short history of the press* (London: Kelmscott Press, 1898).

Fairclough, O. & Leary, E., *Textiles by William Morris and Co. 1861–1940* (London: Thames & Hudson, 1981).

Harvey, C. & Press, J., *William Morris, Design and Enterprise in Victorian Britain* (Manchester: Manchester University Press, 1991).

Hodgson, A., *The Romances of William Morris* (London: Cambridge University Press, 1987).

Meier, P., *William Morris: The Marxist Dreamer* (Sussex: Harvester Press, 1978).

Needham, P., *William Morris and the Art of the Book* (London: Oxford University Press, 1976).

Oberg, C., *A Pagan Prophet: William Morris* (Charlottesville: University Press of Virginia, 1978).

Parry, L., *William Morris Textiles* (London: Weidenfeld & Nicolson, 1983).

Peterson, W.S., *The Kelmscott Press: A History of William Morris's Typographical Adventure* (Oxford: Clarendon Press, 1989).

Pevsner, N., *Pioneers of the Modern Movement* (London: Faber & Faber, 1936).

Robinson, D., *William Morris, Burne-Jones and the Kelmscott Chaucer* (London: Fraser, 1982).

Robinson, R., & Wildman, S., *Morris and Company in Cambridge* (Cambridge: Cambridge University Press, 1980).

Sewter, A.C., *The Stained Glass of William Morris and his Circle* (2 vols, New Haven: Yale University Press, 1974–75).

Sparling, H.H., *The Kelmscott Press and William Morris Master-Craftsman* (London: Macmillan, 1924).

Stansky, P., *Redesigning the World: William Morris, the 1880s and the Arts and Crafts Movement* (Princeton NJ: Princeton University Press, 1985).

Watkinson, R., *William Morris as Designer* (London: Studio Vista, 1967).

THE WILLIAM MORRIS SOCIETY

The life, work and ideas of William Morris are as important today as they were in his lifetime. *The William Morris Society* exists to make them as widely known as possible.

The many-sidedness of Morris and the variety of his activities bring together in the *Society* those who are interested in him as designer, craftsman, businessman, poet, socialist, or who admire his robust and generous personality, his creative energy and courage. Morris aimed for a state of affairs in which all might enjoy the potential richness of human life. His thought on how we might live, on creative work, leisure and machinery, on ecology and conservation, on the place of the arts in our lives and their relation to politics, as on much else, remains as challenging now as it was a century ago. He provides a focus for those who deplore the progressive dehumanization of the world in the twentieth-century and who believe, with him, that the trend is not inevitable.

The *Society* provides information on topics of interest to its members and arranges lectures, visits, exhibitions and other events. It encourages the reprinting of his works and the continued manufacture of his textile and wallpaper designs. It publishes a journal twice a year, free to members, which carries articles across the field of Morris scholarship. It also publishes a quarterly newsletter giving details of its programme, new publications and other matters of interest concerning Morris and his circle. Members are invited to contribute items both to the journal and to the newsletter. *The William Morris Society* has a

world-wide membership and offers the chance to make contact with fellow Morrisians both in Britain and abroad.

Regular events include a Kelmscott Lecture, a birthday party held in March, and visits to exhibitions and such places as the William Morris Gallery, Red House, Kelmscott Manor and Standen. These visits, our tours and our short residential study courses, enable members living abroad or outside London to participate in the *Society's* activities. The *Society* also has local groups in various parts of Britain and affiliated Societies in the USA and Canada.

For further details, write to:
The Hon. Membership Secretary, Kelmscott House, 26 Upper Mall, Hammersmith, London W6 9TA.